Dear Pops,

Now that you have some free time to enjoy yourself we thought you might like to flip through and choose some fabulous hotels to visit!

Love Johnny
Alicia + Angus
2013

THE LUXURY COLLECTION

HOTEL STORIES

© 2013 Assouline Publishing
601 West 26th Street, 18th Floor
New York, NY 10001, USA
Tel: 212-989-6769 Fax: 212-647-0005
www.assouline.com
ISBN: 9781614281320
Printed in China.

WITH FRANCISCA MATTÉOLI

THE LUXURY COLLECTION

HOTEL STORIES

ASSOULINE

CONTENTS

6 INTRODUCTION BY FRANCISCA MATTÉOLI
8 STORY OF THE LUXURY COLLECTION

A

10 HOTEL ALFONSO XIII
14 AL MAHA *by Francisca Mattéoli*
16 THE ANDAMAN
17 ARION RESORT & SPA, ASTIR PALACE
18 THE ASTOR HOTEL *by Francisca Mattéoli*

B

20 THE BALLANTYNE
21 BLUE PALACE
22 HOTEL BRISTOL, VIENNA
24 HOTEL BRISTOL, WARSAW

C

26 COSTA SMERALDA HOTELS
HOTEL CALA DI VOLPE / HOTEL PITRIZZA /
HOTEL ROMAZZINO
30 CASTILLO HOTEL SON VIDA
34 THE CHATWAL
36 CONVENTO DO ESPINHEIRO

D

38 HOTEL DANIELI *by Francisca Mattéoli*
40 HOTEL DES INDES

E

42 ECHOES & LILIANFELS RESORTS
46 HOTEL ELEPHANT *by Francisca Mattéoli*
48 THE EQUINOX
50 HOTEL EXCELSIOR

F

52 THE FAIRFAX AT EMBASSY ROW
53 HOTEL FUERSTENHOF

G

54 HOTEL GOLDENER HIRSCH
56 HOTEL GRANDE BRETAGNE *by Francisca Mattéoli*
58 THE GRITTI PALACE *by Francisca Mattéoli*
60 GROSVENOR HOUSE

H

62 THE HACIENDAS *by Francisca Mattéoli*
HACIENDA PUERTA CAMPECHE / HACIENDA
SAN JOSE / HACIENDA SANTA ROSA /
HACIENDA TEMOZON / HACIENDA UAYAMON
66 THE HONGTA HOTEL

I

68 HOTEL IMPERIAL
70 ITC HOTELS
ITC GRAND CENTRAL / ITC GRAND CHOLA /
ITC KAKATIYA / ITC MARATHA / ITC MAURYA /
ITC MUGHAL / ITC RAJPUTANA / ITC ROYAL
GARDENIA / ITC SONAR / ITC WINDSOR
76 HOTEL IVY

K

78 HOTEL KÄMP
80 KERATON AT THE PLAZA

L

82 THE LAGUNA
84 THE LIBERTY
86 LUGAL

M

88 HOTEL MARIA CRISTINA *by Francisca Mattéoli*
90 HOTEL MARQUÉS DE RISCAL
92 METROPOL PALACE
94 MYSTIQUE

N

96 THE NAKA ISLAND
100 HOTEL NATIONAL *by Francisca Mattéoli*
102 THE NINES

P

104 PALACE HOTEL *by Francisca Mattéoli*
106 HOTEL PARACAS
108 PARK TOWER
110 THE PARK TOWER KNIGHTSBRIDGE
112 THE PHOENICIAN
114 HOTEL PRESIDENT WILSON
116 PRINCE DE GALLES
118 HOTEL PULITZER

R

120 THE ROMANOS
121 THE ROYAL BEGONIA
122 THE ROYAL HAWAIIAN

S

126 SAN CRISTOBAL TOWER *by Francisca Mattéoli*
127 SANTA MARINA
128 SCHLOSS FUSCHL
130 THE SHERATON ADDIS
131 THE SHERATON ALGARVE
132 THE SHERATON GRANDE SUKHUMVIT
134 THE SHERATON KUWAIT
136 SLS HOTEL AT BEVERLY HILLS
137 SOFIA HOTEL BALKAN

T

138 TAMBO DEL INKA
142 TURNBERRY
144 TWELVE AT HENGSHAN

U

146 THE US GRANT

V

148 VANA BELLE
149 VEDEMA
150 VILLARRICA PARK LAKE

152 DIRECTORY OF THE LUXURY COLLECTION HOTELS
160 CREDITS & ACKNOWLEDGMENTS

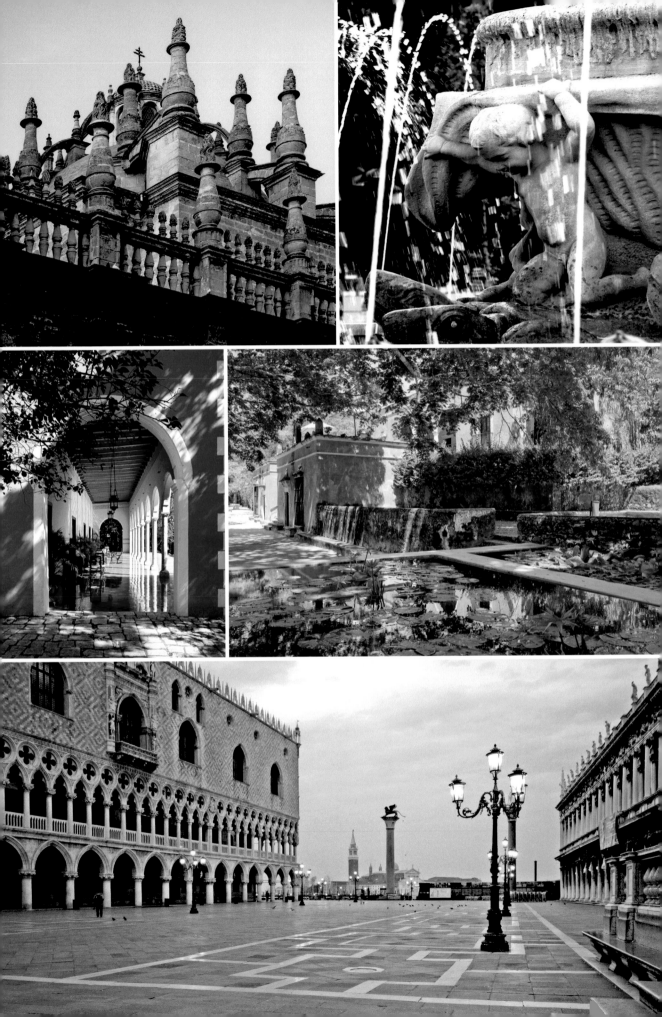

INTRODUCTION BY
FRANCISCA MATTÉOLI

Doors that swing open or doors that revolve, décor that lets you forget the rest of the world and escape reality, the intense excitement that comes from discovering an unknown place, a new world. Entering a hotel is an adventure in itself. Whether in Paris, New York, Santiago, London, Mexico, or elsewhere, we have all felt that feeling of elation on stepping inside a hotel door. Each time I think about it, the feeling returns. The strange tingling sensation, that exquisite, childlike excitement. What is going to happen? What will I discover? Whom will I meet? Suddenly, anything is possible; anything can happen. Whether you are dining in the hotel restaurant, walking quietly across the lobby, passing through a corridor, entering the hotel bar, standing between two elevators, or admiring a particularly splendid view of a city from the terrace—what awaits you? That is the attraction of hotels. They ignite the imagination, and each hotel has its own special story. In one hotel, you feel like you are in a movie from the 1950s. In another one, you have the impression that you have entered a spy novel. Still another gives you the feeling that you have entered a historic, turn-of-the-twentieth-century palace. And if the décor and setting are exceptional, it is even better. You can experience unusual, unexpected, and extraordinary things—thrilling, moving moments that are, in a word, unforgettable.

Which hotels give these fabulous, unique experiences? Where are they? They are all types of hotels, all over the world. They can be found in sprawling, ultramodern cities or in serene, completely isolated oases; in the heart of glorious, unspoiled nature, or in a hidden alleyway in a fantastic historical city. The terrace and legendary bar of The Gritti Palace continue to inspire travelers from all countries. The Hotel Alfonso XIII in Seville has drawn some of the world's most famous people to its stunning grounds. There are also the Haciendas in Mexico, with their startling beauty, which have kept all the mystery and ambience of their origins. Modern hotels thrust upward in the air like arrows, moving travelers to imagine new worlds. Exotic hotels set in the middle of luxuriant, magical gardens, or in plain sight of the world's most extraordinary landmarks, seamlessly integrating with their surroundings. Where they are located doesn't matter. What matters is the ambience they offer us when we enter them, the atmosphere they convey when we walk into the lobby for the first time, a home away from home for travelers, as well as a place for locals to gather and meet. This feeling may come from the sophistication or luxury of the place, from its setting or history, or from the people passing through the hotel or those who work there. Call it charm. Call it magic. The main thing is that all these hotels have this unique blend, so difficult to define, that makes all the difference—this elegant and rare poetry that starts off on a new journey each time. It is everything that makes me want to return, to walk those corridors, to once again enter through that well-known door, with a smile on my lips, telling myself that the time I spend there will give me precious memories for the rest of my life.

Top row: Sevillian sites near the Hotel Alfonso XIII; *middle row, from left:* Hacienda Santa Rosa and Hacienda Uayamon; *bottom:* View of Venice, home to The Gritti Palace.

STORY OF
THE LUXURY COLLECTION

The Luxury Collection is an ensemble of more than eighty of the world's finest hotels and resorts, each noteworthy for its architecture, art, furnishings, and amenities. Our properties share a dedication to immaculate service and comfort, and each has a unique heritage inextricably tied to its destination.

The collection has been curated for its unique spirit of diversity and genre—each Luxury Collection property has a story to tell. In this volume, you will find some of the singular histories and fascinating narratives that both set these great hotels and resorts apart—and also draw them together as a collection.

There is the venerable Equinox, which once played host to Revolutionary War figures and presidential vacationers, whose original tavern is still serving diners a piece of New England history. Then there is the opulent Sevillian Hotel Alfonso XIII, whose roster of guests has read as an international *Who's Who* since it was built to house international dignitaries for the 1929 Ibero-American Exhibition. The Royal Hawaiian, built on a legendary plot of King Kamehameha I's gardens, hosted a different kind of royalty—the "King" himself, Elvis Presley.

Nearly all of The Luxury Collection's historic properties have hosted diplomats, heads of state,

and royalty—some in historically crucial moments, and in unlikely pairs. Czechoslovakia's President Benes and the Soviet Union's Nikita Khrushchev both conducted important negotiations in Vienna's Hotel Imperial; both Elizabeth Taylor and Che Guevara were invited guests of Yugoslav revolutionary and statesman Josip Broz Tito in Belgrade's Metropol Palace; and Salzburg's Schloss Fuschl hosted meetings between Egyptian President Anwar Sadat and United States President Gerald Ford.

Many have hosted historic moments: the Hotel Bristol in Warsaw, Poland, was the first-ever hotel to throw a New Year's Eve ball (a tradition back in full force today). The Fairfax at Embassy Row was the unofficial gathering place for President Kennedy's "Camelot."

And some properties have rediscovered their unique histories through renovation and renewal: Boston's Liberty Hotel, with its sweeping views of the Charles River, was once the Charles Street Jail—adapted and reused, its 90-foot-tall central rotunda is now a stunning centerpiece streaming with natural light.

Each of The Luxury Collection's properties offers the opportunity to meet a new destination in a completely unique way. We hope you will enjoy the stories our collection has to tell.

THE LUXURY COLLECTION®

Hotels & Resorts

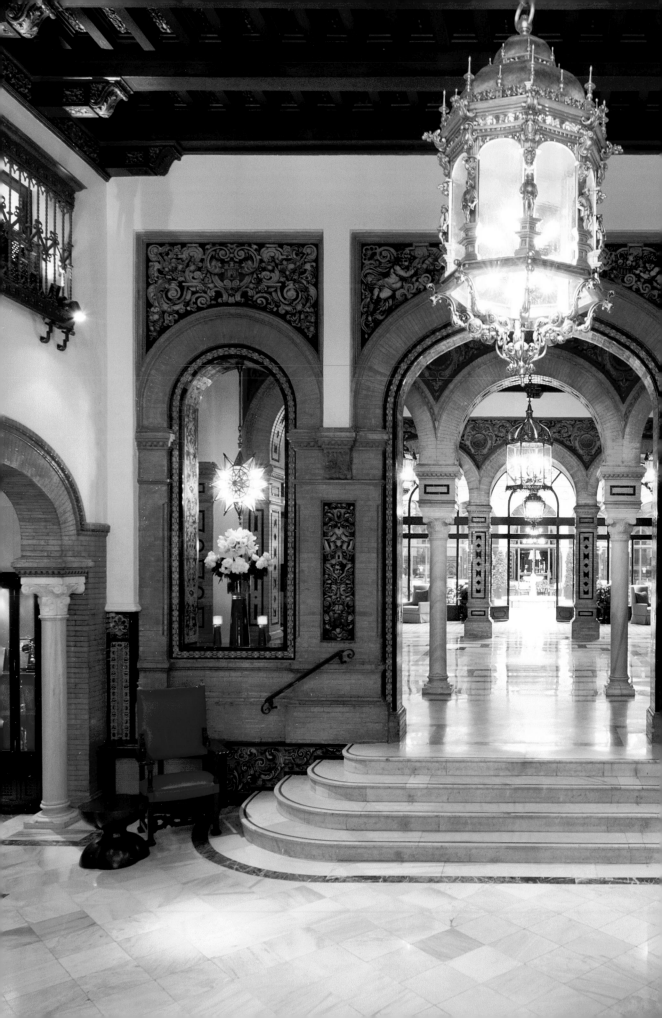

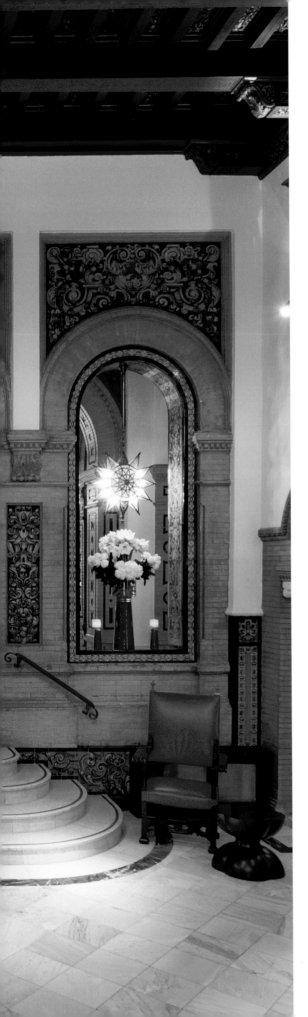

HOTEL ALFONSO XIII
Seville, Spain

Hotel Alfonso XIII, named after the king, was conceived to be the grandest hotel in Europe when it was built to house international dignitaries for the 1929 Ibero-American Exhibition. A true tribute to the area, the building has an ornate richness that is remarkable. Its recessed ceramic friezes refer to regional tastes inspired by Arab architecture and a fusion of Andalusian and Castilian styles. Stately photographs of its inauguration by the king show the royal family clad in gala uniforms, silk dresses, and tiaras. Ensuing years brought further renovations—in 1976 and then in 1991—to prepare for another international gathering, the Universal Exhibition of 1992. Most recently, the hotel reopened after yet another sweeping restoration in 2012, including renovations to its 151 guestrooms.

Hotel Alfonso XIII's opulence and exoticism have attracted a steady stream of dignitaries throughout its history, among them Prince Charles and Princess Diana, and the kings of Sweden, Norway, Morocco, Nepal, Denmark, Jordan, Belgium, the Netherlands, Greece, Spain, and more. The hotel's roster of guests, past and present, reads like an international *Who's Who* of celebrities, among them Ernest Hemingway, Eva Perón, Orson Welles, Audrey

The grand Mudejar-style lobby.

Hepburn, Jackie Kennedy, Sophia Loren, Plácido Domingo, José Carreras, Brad Pitt, Mikhail Gorbachev, and Shakira.

But to get an authentic taste of the character of this grand hotel, guests must at least visit the signature Reales Alcazares Suite, a darkly glamorous contemporary suite that recalls a royal romance. The seductive room is inspired by the story of Maria de Padilla, the secret lover of King Pedro I "The Cruel," who imprisoned his new bride, Blanca of Bourbon, in the Alcazar of Toledo in 1353 to reunite with his lover. With the support of Pope Inocencio VI and the people, Blanca of Bourbon escaped from her prison to find refuge in the cathedral.

Mystery, exotic architecture, and an ideal location in the historic heart of the city have made Hotel Alfonso XIII emblematic of Seville.

> 66 Elegance is the only beauty that never fades. 99
>
> Audrey Hepburn

PLÁCIDO DOMINGO
Conductor and tenor

WHY IS SEVILLE SPECIAL TO YOU? For its people and the great emphasis they put on life and the arts. As an opera singer, I have surrendered to Seville's magical spell, like many great writers and composers of the past. Some of the most emblematic operas inspired by and conceived in Seville are *The Marriage of Figaro*, *The Barber of Seville*, and *El Gato Montés*.

WHAT IS YOUR FAVORITE GETAWAY SPOT TO RELAX IN SEVILLE? For peace of mind and to pamper the soul, there is nothing more soothing than visiting the magnificent Seville Cathedral.

MOST ADMIRED SPANISH ARTIST? Many artists come to mind, but the ultimate ageless cultural international ambassador is Miguel de Cervantes y Saavedra, who gave life to the multifaceted epic character Don Quixote de la Mancha, the archetypal Spaniard.

WHICH IS YOUR FAVORITE SPANISH DISH? In Spain, to eat is yet another form of art, and each region is proud of its own diversely rich cuisine. But my favorite would have to be the jamón de Jabugo, which is an authentic treasure throughout Spain.

DO YOU PREFER TRAVELING ALONE OR WITH OTHERS? I am fortunate to almost always travel with my wife and a personal assistant, but what I enjoy the most is when my grandchildren are on vacation and we can travel the whole family together to embark on what they call "Great Adventures," and share their experiences and fantasies.

ELABORATE ON YOUR EXPERIENCE AT ALFONSO XIII. My many stays at the Alfonso XIII have always been memorable and exceeded all of my expectations. The magnificent palace was built for the 1929 Ibero-American Expo, which mysteriously still enchants the grounds. The romanticism is felt in each and every corner; a twinkle bounces off its shiny tiles; the soft murmur of its fountain and the magic light that floods its central patio are lulling. But this majestic scene would be incomplete without the excellence of the men and women who work in it every day.

Clockwise from top left: The Seville Cathedral is one of many nearby attractions; Alfonso XIII, King of Spain; American Bar, one of the hotel's four restaurants; view of the ornately designed winding staircase.

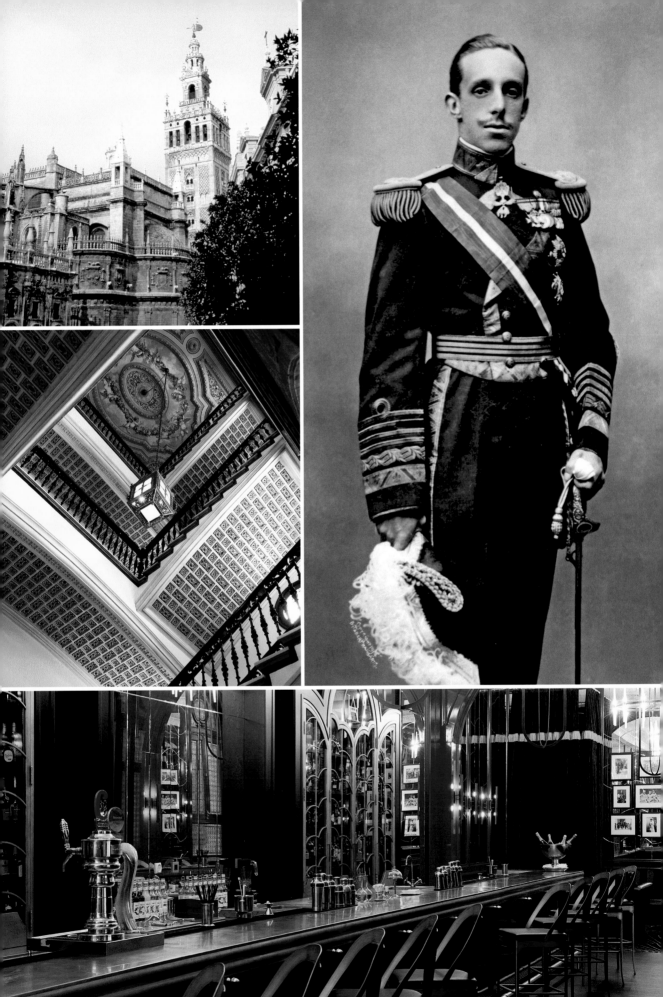

AL MAHA

Dubai, United Arab Emirates

Just forty-five minutes from the city of Dubai, the Al Maha—Arabic for "Arabian oryx," a desert antelope—is hidden away in a remote part of the Arabian desert that is as golden as in a painting by Eugène Delacroix. It is a world of dreams just a few minutes from one of the realest cities in the world. The silence is absolute, and the sky is an intense blue. Everything seems unreal, like something out of a story from *One Thousand and One Nights*. Bedouin tents stand out against the landscape of dunes that undulate in golden waves. Cool patios look like mirages. Corners of unexpected shade, luxurious salons, and faces remind one

of Scheherazade. Here we are inside one of these magnificent countries that a thousand lifetimes would not be sufficient to visit, as Arthur Rimbaud wrote about the world and its beauties. Here one can contemplate a landscape made for adventurers: each of the Al Maha's forty-two individual luxury suites is decorated with antiques from the region, surrounding the guest with the authenticity of the land. One can mount a horse in the middle of the desert. One can walk between the sand dunes. One can admire nature that slowly unveils itself, with its wildlife and floating lights, always changing. One can witness the flight of falcons as the Bedouin

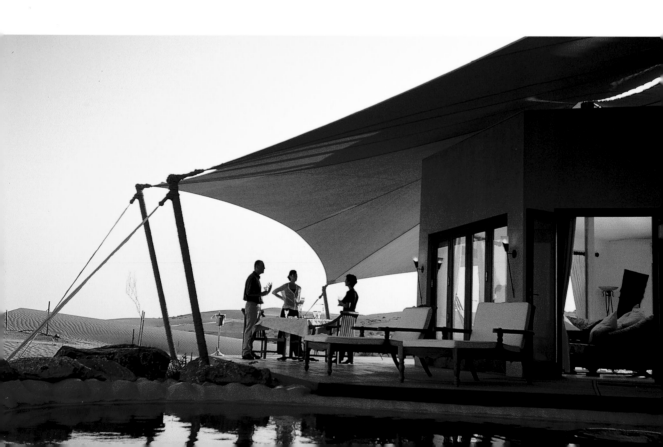

nomads did more than two thousand years ago, in a time when it took days to get from one place to another and when no one could have imagined seeing such a place, a hotel so incredible that it might have come straight out of Aladdin's lamp. *Text by Francisca Mattéoli*

66 The silence is absolute, and the sky is an intense blue. 99

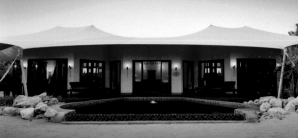

Opposite: The luxurious Emirates Suite at sunset. *This page, from top:* Entranceway to the idyllic Timeless Spa; the superluxe Royal Suite, where guests may catch a glimpse of native wildlife such as a gazelle or an Arabian oryx from their private deck or swimming pool; camel rides in the desert reserve and horseback riding in the nearby dunes are some of the unique draws to this desert oasis.

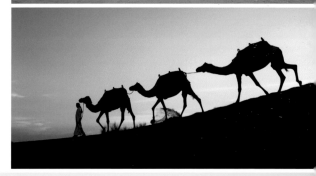

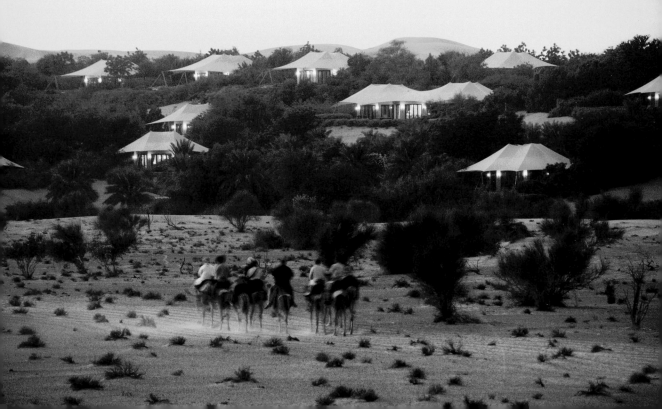

THE ANDAMAN

Langkawi, Malaysia

Located on one of the world's most beautiful beaches, abundant with rare wildlife and exotic flora, The Andaman was designed to be a magnificent gateway to its surroundings. Designed in harmony with nature, the hotel has a three-tiered roof and vast open spaces—with touches of Malay architecture—that look onto the massive trees of the rainforest, teeming with hornbills, flying lemurs, and monkeys.

Not only is the local landscape special, so is The Andaman's own bit of ocean. Around 200 million years ago, the supercontinent Pangaea tore in half, dividing the northern and southern hemispheres.

In the process, the Tethys Ocean was formed (and eventually eliminated in the collision of Africa and India with Asia, which created the Himalayas). The only portion of the Tethys that still exists is here—its crystal-clear waters said to have given birth to much of the world's marine life.

The most beautiful way to reflect on this place: stand on a private balcony from one of the 186 rainforest-, treetop-, or sea-view rooms, and absorb sweeping views of the Andaman Sea and the vibrant jungle.

Reserve a private dinner on the beach at sunset.

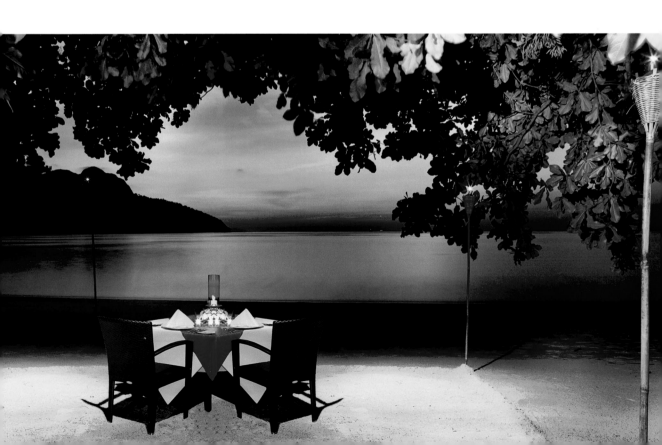

ARION RESORT & SPA ASTIR PALACE

Athens, Greece

In 1960, Astir Palace opened, its bungalows accommodating a quietly elite clientele. News of the glamorous Athenian Riviera palace spread, and to host an ever-growing number of heads of state, industrialists, and stars, the Arion was added in 1967. Stepping into the Arion's lobby and lounge, guests are dazzled by its monumental crystal chandelier. Even after the hotel was renovated in 2004 for the opening of the Olympic Games, the original marble staircase still presides over the gracious split-level lobby.

It is said that everyone who is anyone has summered at the resort, starting with Charlton Heston and Aristotle Onassis and Jackie Kennedy. Frank Sinatra was spirited through the kitchen door to avoid adoring crowds at the entrance. Brigitte Bardot arrived barefoot at the restaurant for dinner, and her appearance so rocked the community she had to send a body double to the table instead.

These days, Arion is still the domain of the elite luxury vacationer. Its 123 guestrooms—in addition to its fifty-eight newly renovated, natural-hued bungalows and villas—all face the crystal-clear waters of the Saronic Gulf.

The resort occupies its own peninsula on the Athens Riviera.

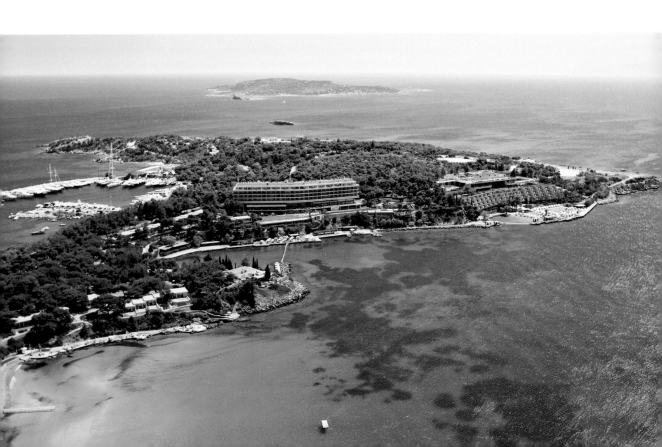

THE ASTOR HOTEL

Tianjin, China

During the festival of lanterns, Tianjin arrays itself in fantastic colors—vivid reds, yellows, and blues. The streets of the city are full of people. There is joy, laughter, and dancing; there are crazy dragons, fans that twirl from the tips of agile, graceful fingers, and an endless line of red lanterns suspended in the air to celebrate the festivities of the new year. Tianjin, 75 miles from Beijing, is bringing its legendary heritage back to life.

The Astor Hotel, which opened in 1863 on the shores of the Haihe River, was the first hotel in the north of China to open to foreigners. Zhou Enlai particularly loved the spot and went there regularly when he was in the city. The Emperor Puyi danced in its ballroom. The Canadian adventurer Aloha Wanderwell, who was the first woman to go from Paris to Beijing—behind the steering wheel of her Model T Ford—stopped at the hotel in 1924. The Astor is a hotel made for adventurers and great travelers enamored with fabulous journeys. It was superbly renovated in 2010 and today offers outstanding services. But its 152 rooms, with their original furnishings and installations, and its onsite museum, which recounts 150 years of its history, honor everything that makes the hotel an icon. Travelers have only to look at the photos

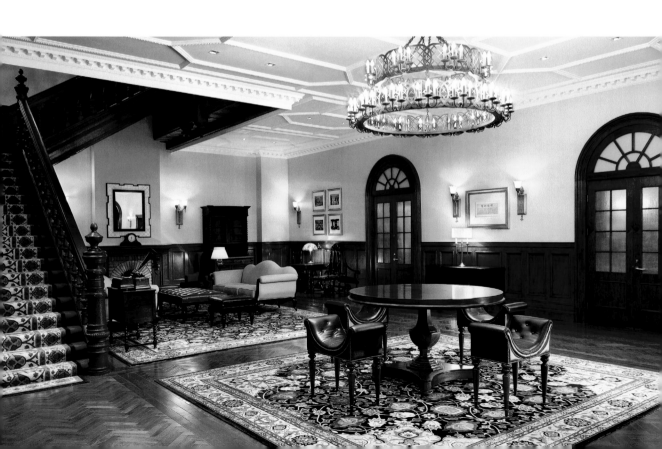

that decorate the lobby, the silk curtains, the elegant furniture that marries Chinese and English cultures, and the suites that pay homage to distinguished guests, in order to relive the heyday of legendary journeys in their imaginations. *Text by Francisca Mattéoli*

66 The Astor is a hotel made for adventurers and great travelers enamored with fabulous journeys. 99

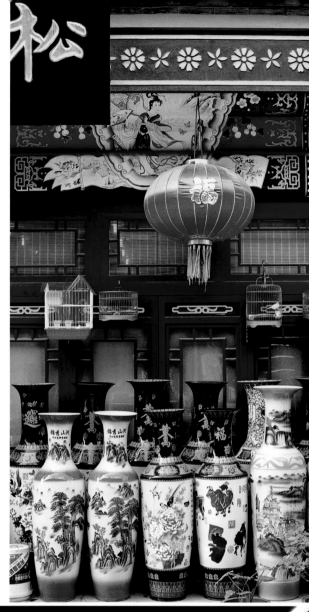

Opposite: The Victorian era–designed hotel lobby. *This page, top:* Some of the many treasures found on Ancient Culture Street, the gateway to experiencing old Tianjin; *bottom:* View of the iconic Century Clock and Jiefang Bridge in the heart of Tianjin.

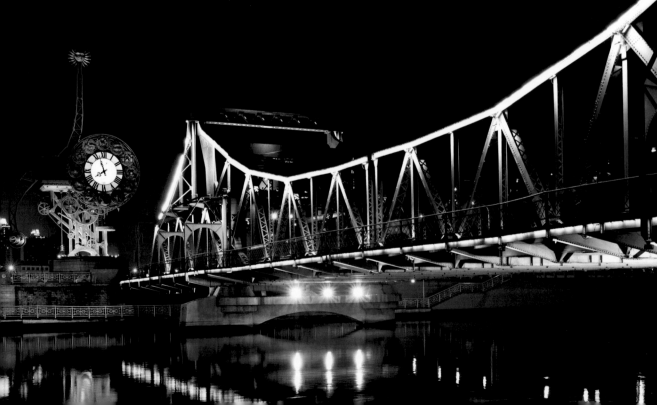

THE BALLANTYNE

Charlotte, North Carolina, USA

A majestic private golf course, a destination spa, pools, tennis courts, salons—touchstones of a painstakingly conceived, master-planned mixed-use resort. But The Ballantyne, with its 250 guestrooms and 14 suites, manages to stay true to its origins: a bastion of true Southern hospitality on the lush, undulating hills of Charlotte family farmland.

This grand hotel is barely more than a decade old, and continuous reinvestment already keeps the hotel, which has the feel of a historic country resort, fresh. The Gallery Restaurant exudes modern luxury, with dark mahogany walls and rustic hardwood floors; banquettes in British racing green leather surround the room's anchor—a beautiful white onyx bar. In 2009, the hotel added a chic outdoor pool and a superbly appointed four-bedroom residence, The Cottage at Ballantyne, overlooking the first tee of the championship golf course.

Still, should the hotel's many features begin to overwhelm, look to the elegant Southern bedroom sanctuaries and the resort's connection to its land to be transported back to its roots. Local farms supply the restaurant, and the hotel aspires to operate as its own sustainable community.

The Golf Club at Ballantyne.

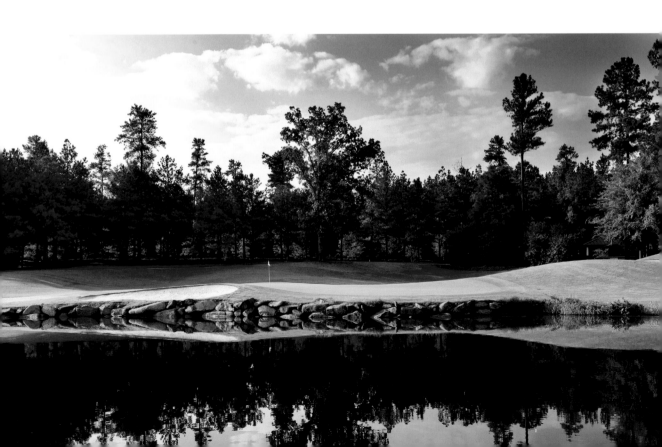

BLUE PALACE

Crete, Greece

To the celebrities and power brokers who vacation on the island of Crete, the place is special for the unsurpassed privacy it affords. Crete is renowned for its rich history, enchanting beaches, traditional villages, lush emerald forests, and incandescent blue coastlines. The resort area sits peacefully on the water, completely assimilated into its natural environment.

Before ground was broken on the 251-room resort, which opened in 2003, its architects set these priorities: a minimum impact on the natural surroundings, and a design that would blend into the Mediterranean landscape, with no main building, and villas grouped in small clusters, ensuring an uninterrupted view to the Elounda Gulf from each. The architecture of the hotel itself is a product of careful study of Crete's past, represented here in a mix of Eastern and Western influences. For example, the lobby's faithful replica of the Venetian Arsenali (shipyards) in the harbor of Heraklion: at thirty-six feet high, it is an imposing entrance to a world of understated elegance. And what restful elegance—original Arabic pieces from Morocco and large divans are spread about the property, and private pools with waters sparkling under the hot Cretan sun give a sense of coolness.

The exquisite Arsenali Lounge Bar.

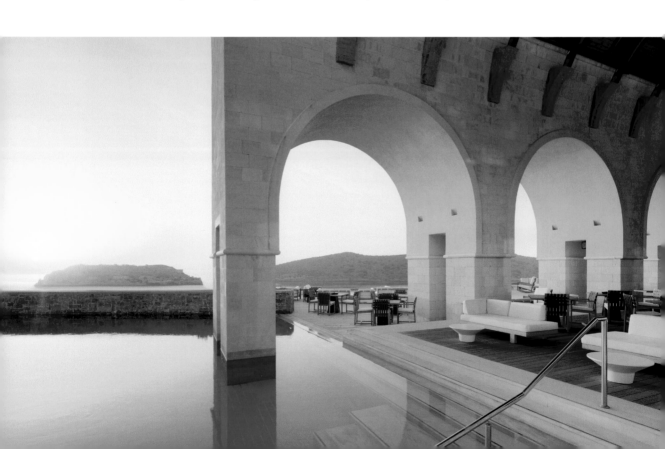

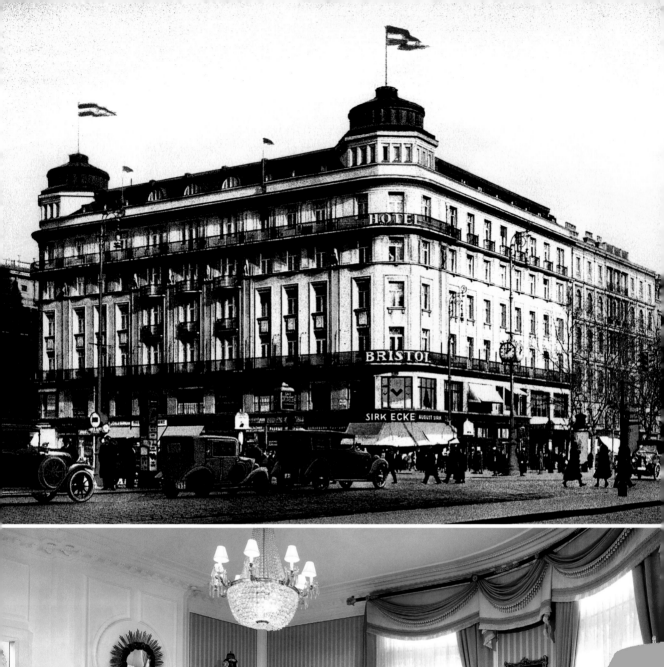
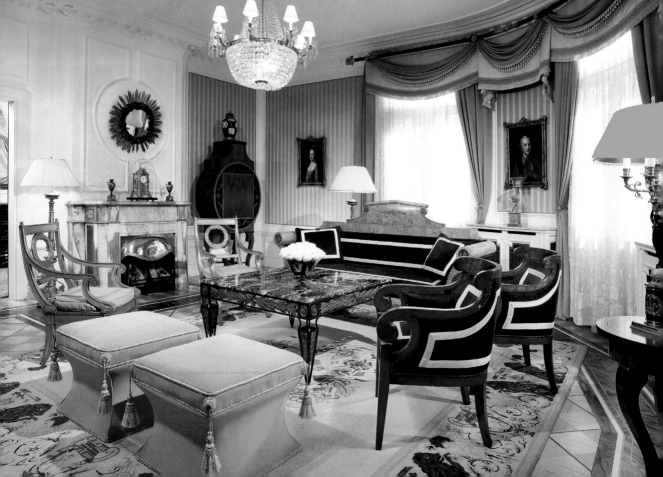

HOTEL BRISTOL

Vienna, Austria

Right in the heart of Vienna, next to the Vienna State Opera, the Hotel Bristol has been an enchanting destination for dignitaries, musicians, and Nobel Prize winners since it opened more than a century ago. It remains all that today, as well as an example of authentic Viennese charm for history-loving luxury travelers.

The 140-room hotel opened in 1892, at the city's finest hour, in the midst of the blossoming fin de siècle era. At that time, Vienna was one of the world's most popular and beloved capitals, the center of the Hapsburg Empire. Opened as Vienna's most modern hotel (with its first self-operating elevator), it instantly became a popular meeting spot for Vienna's society and the city's famous visitors.

What more romantic place for the Prince of Wales and Wallis Simpson to have vacationed at the height of their affair? The Bristol is also where Nobel Peace Prize winner Bertha von Suttner met her rival, Theodore Roosevelt; where George Gershwin worked on "An American in Paris"; and artists from Rubinstein to Puccini stayed for performances at the opera.

In fact, it is the hotel's proximity to the opera—one of the oldest and longest-running music venues in Europe—that has inspired much of its décor. Rooms with a direct view of the Vienna State Opera are named after the opera house's directors; guests may stay in the Gustav Mahler or Herbert von Karajan rooms, in oval salons with precious antiques and opulent interiors. A grand renovation between 2007 and 2009 emphasized its carefully restored elegant art nouveau architecture and ornate interiors inspired by its turn-of-the-century beginnings.

But perhaps more than any renovation, the Hotel Bristol's role in so many historic events continues to lure those seeking to stay within the same walls as its famous former visitors. Peek in the guestbook, and you will see Vladimir Horowitz, who married Wanda Toscanini, the daughter of another regular at the Hotel Bristol, Arturo Toscanini, both of whom entered their names in the guestbook on the same day as Richard Strauss. Enrico Caruso and Sergey Rachmaninoff lived here during performances at the State Opera.

> **It instantly became a popular meeting spot for Vienna's society and the city's famous visitors.**

Top: Illustration of the hotel; *bottom:* Named for one of the hotel's most famous guests, the Prince of Wales Suite is legendary in size, comfort, and luxury. It even boasts its very own library.

HOTEL BRISTOL

Warsaw, Poland

Hotel Bristol's art nouveau silhouette is an iconic sight on Warsaw's fashionable Royal Route, the road that leads through the historic area of the capital city. The hotel is central to the spots sacred to Poland. Right next to the presidential palace, it looks out on the monument of the country's famous general Józef Poniatowski and sits within a city block of a monument to Poland's most famous poet, Adam Mickiewicz. Nearby are the National Theatre and the country's most revered monument—the Tomb of the Unknown Soldier.

The grand masterpiece was opened in 1901 and has become such a landmark that it and its Paderewski Suite—named after the former Polish prime minister and famous composer Ignacy Paderewski—are protected national monuments in Poland.

Within weeks of its opening, Warsaw's newest hotel became an "it" destination for statesmen, composers, and artists, among them Edvard Grieg, Richard Strauss, Enrico Caruso, and the physicist and chemist Marie Sklodowska-Curie, to name only a few. And then there were the parties. In 1907, the first New Year's Eve ball ever to be held in a hotel was at the Hotel Bristol, beginning a grand tradition for the hotel that

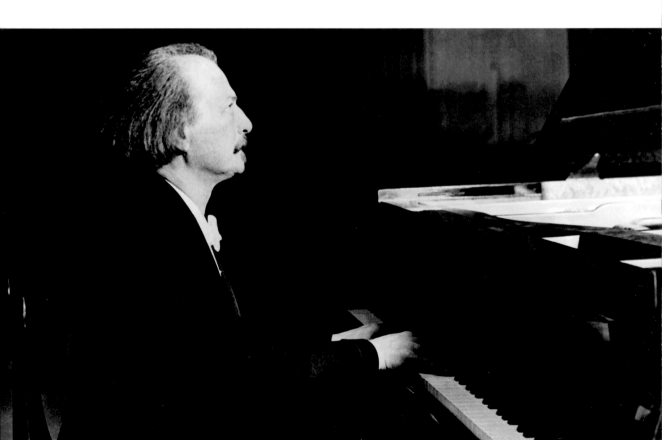

lasted many decades and has been reprised today in all its opulence.

The story of the Hotel Bristol is one of optimism and hope for Warsaw. The city and the hotel both survived not only the Warsaw Uprising in 1944, but the First and Second World Wars, the Polish-Soviet War of 1920, and the Great Depression. Then in 1981, eighty years after it opened, the grand hotel was closed. In 1991 it underwent a massive renovation—the first effort by conservationists to restore it to its original glory. Armed with photographs and a few original elements, such as the iron lift shaft and parts of the balustrade of the staircase, conservationists set about re-creating Warsaw's gem. In 1992, the beautifully reborn Hotel Bristol was ready for business, and one of the first guests to stay in the newly renovated Paderewski Suite was Baroness Margaret Thatcher, who officially opened the hotel on April 17, 1993.

These days, the polished 206-guestroom, art nouveau treasure is once again playing host to an international crowd, its façade unchanged, its graceful interior transformed into a thoroughly modern hotel, firmly ensconced in its historic tradition, peacefully holding up its portion of the Warsaw skyline.

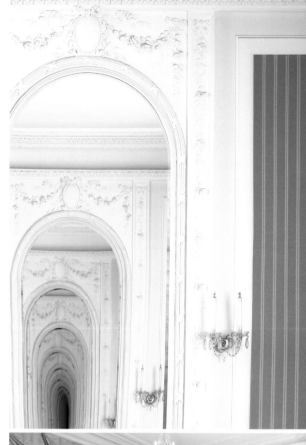

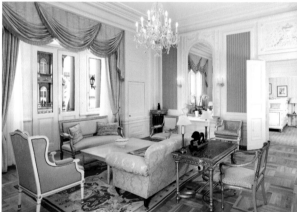

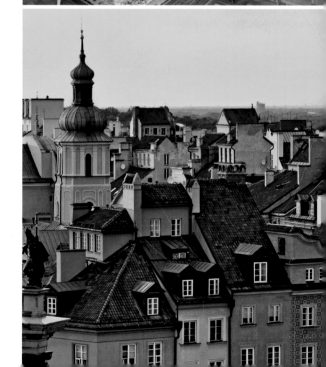

> 66 The story of the Hotel Bristol is one of optimism and hope for Warsaw. 99

Opposite: Former prime minister of Poland Ignacy Paderewski, circa 1930. *This page, from top:* The beautiful art nouveau interior; the Paderewski Suite; the historic Warsaw Old Town Square.

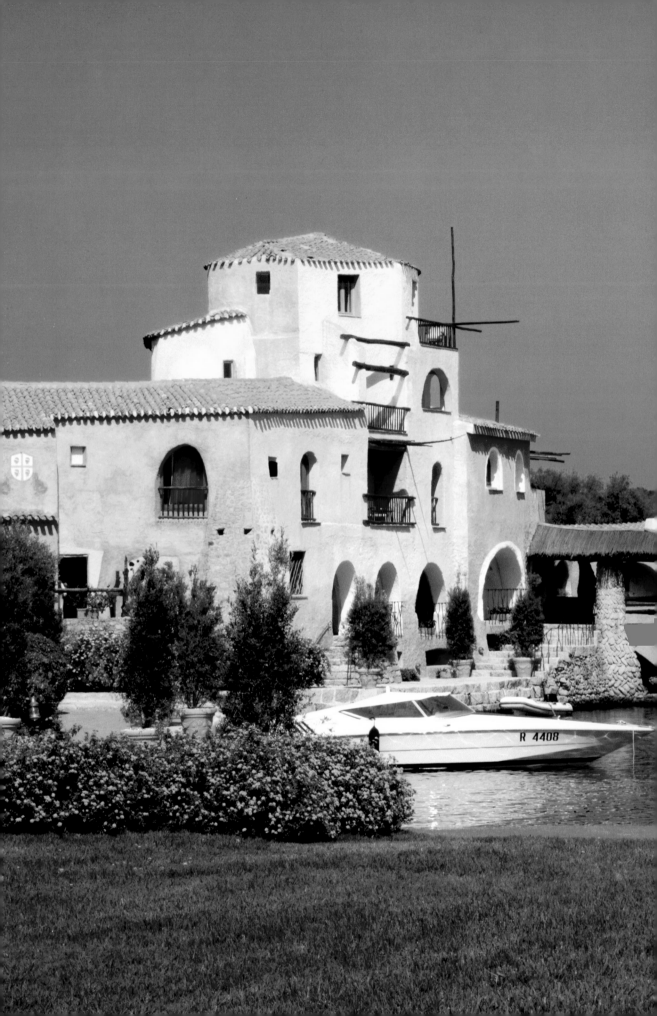

HOTEL CALA DI VOLPE

HOTEL PITRIZZA

HOTEL ROMAZZINO
Costa Smeralda, Italy

In 1958, Sardinia was a sparsely inhabited island—undeniably beautiful, but also wild, its breathtaking promontories and pristine bays carved by sea and wind. It was this almost savage beauty that attracted Prince Karim Aga Khan IV, who transformed the northeast quadrant—the Emerald Coast—from farmland and fishing villages into an incomparable resort for an international jet set. What resulted from his vision was the town of Porto Cervo, a luxury interpretation of a medieval Moorish village, which has now lured a steady stream of boldface names for more than fifty years. Original luminaries like King Juan Carlos of Spain and Brigitte Bardot once attended the annual Polo Gold Cup; visitors and attendees of its many events (among them, famous regattas of show-stopping sailboats) are no less visible today—although the resort prides itself on unparalleled discretion.

Hotel Cala di Volpe was the first to open, in 1962. Designed in the form of an ancient fishing village, its canopy of archways, porticoes, and turrets sets a staggeringly beautiful stage facing the sea. A wooden bridge plunges into crystalline waters, and the beach is surrounded by juniper and myrtle bushes. Each year, in July and August, the 124-guestroom hotel hosts one of the biggest Costa Smeralda events—a concert

Hotel Cala di Volpe.

27

of international stars (Elton John, Donna Summer, Anastacia, and Duran Duran, among many others, have passed through the Cala di Volpe stage).

The construction of Hotel Pitrizza followed closely on Cala di Volpe's heels, blending fluidly into its sublime landscape, its rustic stonework belying the luxury within. Guests can enjoy staying in one of its fifty-six spacious rooms or one of its renowned tranquil villas (it has added five villas in the past two years). Each opens up to the striking white sand beaches and aquamarine waters of the coast, and the hotel's fresh, local cuisine—now overseen by Chef Maurizio Locatelli—is fabled in the resort.

Seen from above, Hotel Romazzino appears as a white star in the middle of the wild Mediterranean landscape. The brilliant white stucco hotel houses seventy-eight guestrooms and is surrounded by fragrant gardens full of the myrtle and juniper that are the scent of the craggy coast. This haven is pure indigenous luxury, handcrafted from Cerasarda tiles, artistic iron details, and native juniper wood. Timeless and elegant, each hotel pays homage to its Sardinian home.

ANDREA FAZZARI
Photographer and Luxury Collection Global Explorer

WHAT IS YOUR FAVORITE GUIDE OR BOOK ABOUT TRAVEL? *Falling Off the Map* by Pico Iyer.

WHAT INSIGHTS HAVE YOU GAINED FROM TRAVELING? There are innumerable insights from my life of travel. Profound insights into human nature, constant lessons in humility, beauty in unexpected places, appreciation of different ways of life, a heightened state of awareness, and constant opportunities for learning. I notice the smallest of details, which also provide incredible insights into the places I visit and the people I meet.

ONE THING PEOPLE DO NOT KNOW ABOUT SARDINIA: People may not know that many of the longest-living centenarians live in Sardinia.

NAME THE MOST PHOTOGENIC SCENERY IN SARDINIA. The roaming shepherds in the mountains.

FAVORITE ITALIAN DISH? *Fiori di zucca ripieni* and *risotto allo speck e asparagi.*

WHAT IS YOUR FAVORITE GETAWAY SPOT OR WAY TO RELAX IN SARDINIA AND/OR ITALY? Never just one: Porto Ercole and Porto Santo Stefano, Asolo, and the Dolomites, especially in summer.

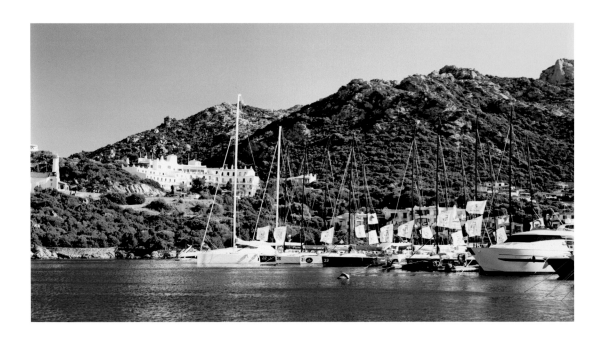

Above: The calm Mediterranean is ideal for boating, fishing, and diving. *Opposite:* Experience local culture on the beautiful island of Sardinia.

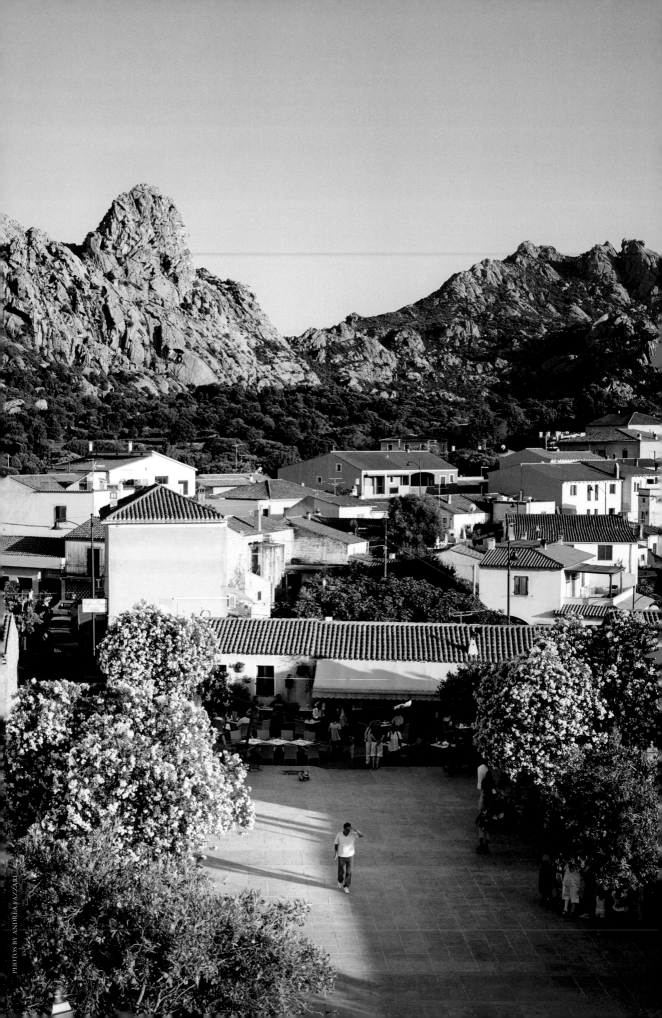

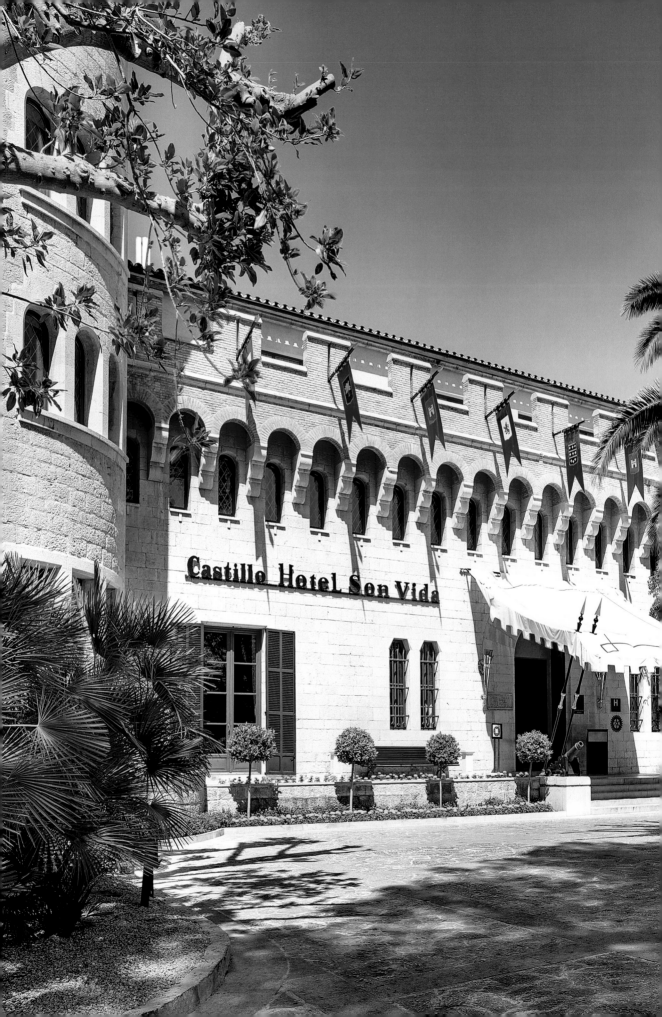

CASTILLO HOTEL SON VIDA

Mallorca, Spain

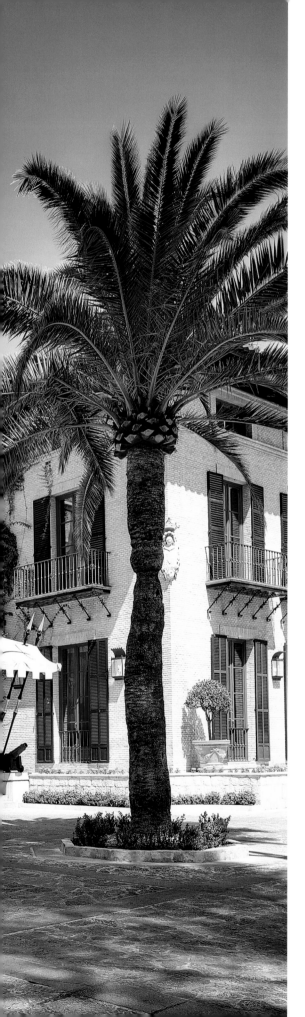

On the magnificent island of Mallorca, renowned for its nearly perfect year-round weather, a thirteenth-century castle sits in the exclusive Son Vida Hills over the cobalt Bay of Palma, a symbol of opulence and grace. Within its thick walls and its impressive architecture, guests experience the unique feeling of sleeping in an ancient, art-filled castle.

The castle has a long history of entertaining guests, beginning when it was the traditional private Mallorcan manor of Mateu Vida. The castle's subsequent owners, the aristocratic Desmás and Truyols families, kept its distinctive name, marking the beginning of a proud heritage of elaborate feasts and elite service for their private guests, among them dignitaries and royal family members. Near the turn of the twentieth century, an extravagant renovation took place as a gift to Magdalena Villalonga, the then-owner's wife, resulting in the building's current iteration—a beautiful villa with the look of a castle, complete with a tower. When the castle opened its doors as a luxury hotel in 1961, it became a landmark for Mallorcan society. Prince Rainier and Grace Kelly, along with Aristotle Onassis and Maria Callas, hosted a glamorous opening

Guests experience the royal treatment from the moment they arrive at the former castle.

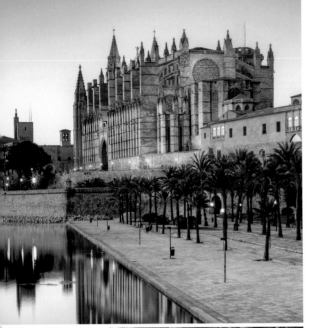

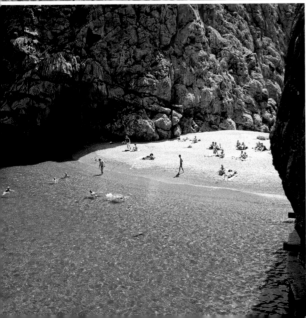

party for friends including the Maharani von Baroda, French champagne magnate Crovetto (Veuve Clicquot), Montgomery Clift, and Elsa Martinelli. The festive, now-legendary party ended with a spontaneous musical quartet, with Elsa Maxwell on piano, Prince Rainier on drums, and Onassis and Callas singing in a rousing performance of jazz and Greek songs. The next morning, guests brunched on mussels in the gardens with Rainier and Onassis in their midst.

The Castillo's spectacular setting and overwhelming popularity with the most glamorous set of the day established it as a premier host, welcoming everyone from the Italian ex-king Umberto and Grand Duke Vladimir of Russia to Prince Aly Khan and Emperor Haile Selassie of Ethiopia in the 1960s, to Palestinian leader Yasser Arafat and Chinese president Li Xiannian, in the 1980s. But it is the castle's absolutely serene surroundings of olive and almond groves, unspoiled beaches, and luxurious appointments (it reopened after another grand renovation in 2006) that have cemented its reputation as a haven for artists. Spanish Oscar-winner Pedro Almodóvar escaped to one of its 164 serene rooms to write the screenplay for *Live Flesh,* American director Martin Ritt relaxed after filming *The Spy Who Came in from the Cold,* and Yehudi Menuhin took a holiday after a demanding concert tour. For politicos, artists, and pure escapists, the castle—steeped in history and surrounded by luxury—will always be a refuge.

This page, from top: The distinguished La Seu Cathedral, one of many architectural treasures close to the hotel; indulge in poolside refreshments at the Sa Font Pool Bar; the Torrent de Pareis Beach, one of Mallorca's exotic beaches. *Opposite:* Prince Rainier and Princess Grace, Mallorca, 1961.

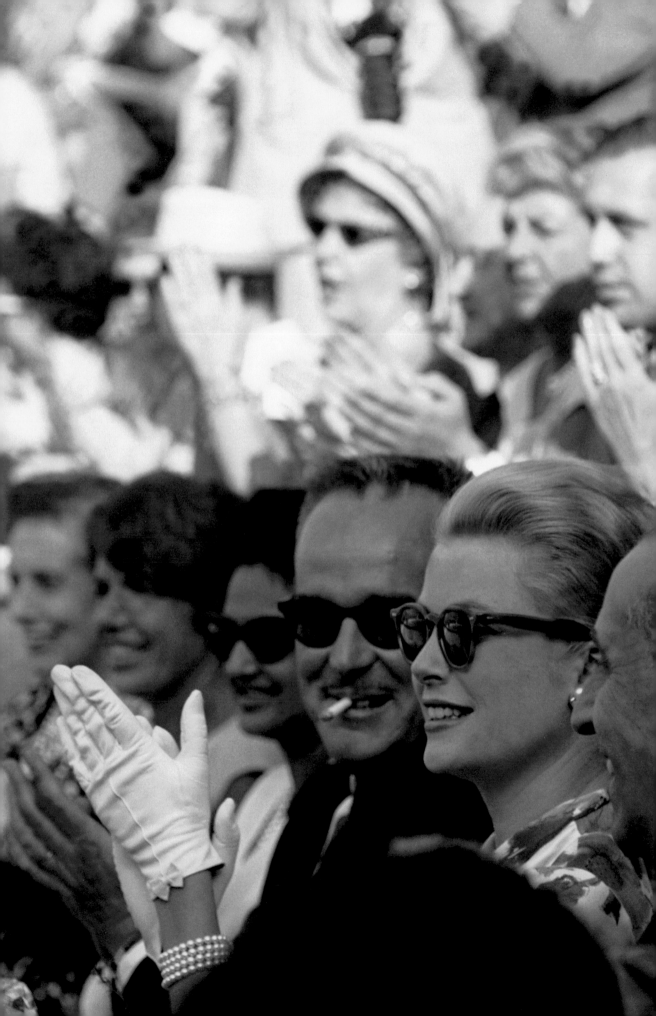

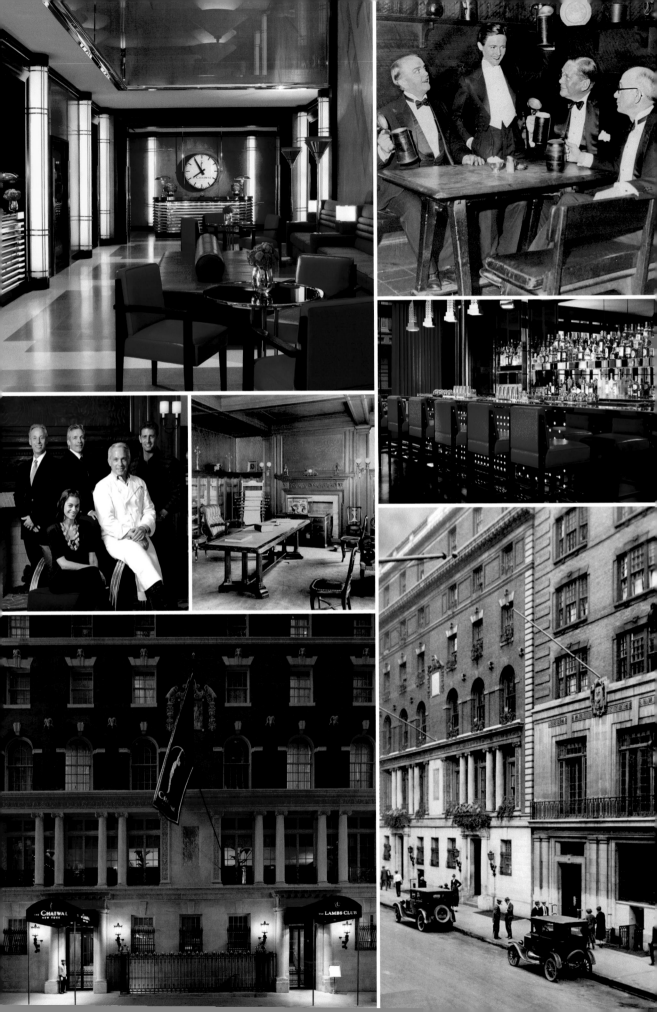

THE CHATWAL

New York City, New York, USA

Imagine being transported to the golden years of New York City theater, when Empire Deco reigned and stars of the Great White Way swapped tales in a clubby atmosphere. Now imagine that atmosphere optimized for today, and what one gets is The Chatwal.

The Chatwal occupies the landmark Stanford White–designed Lambs Clubhouse building, originally opened in 1905, and was a home away from home for notable members like Charlie Chaplin, W. C. Fields, John Barrymore, Spencer Tracy, and Fred Astaire.

The building has been newly reinvigorated by master architect Thierry Despont, known for his work on the centennial restoration of the Statue of Liberty and the galleries at the Getty Center in Los Angeles. Here, he took the building's iconic original features and brilliantly folded them into the new design—hearkening back to the best of an era. From the restoration of the façade and the striking floor-to-ceiling fireplace reinstated in the restaurant to its decidedly deco chrome metal details, fine suede walls, and leather detailing, The Chatwal has all the clubby masculinity of its predecessor—and then some.

The restaurant is an homage to this building's theater roots. The built-in red leather banquettes and bright chrome fittings are the perfect environment in which to enjoy the modern American food of celebrated chef Geoffrey Zakarian. Upstairs in the Bar at the Lambs Club, a resplendent lounge overlooking 44th Street, bartenders craft classic cocktails using fresh-pressed juices and hand-cut ice. And while every element of the seventy-six guestrooms in this "baby grand" hotel is thoroughly of the moment, each room and suite is a pitch-perfect tribute to the best of yesteryear, transporting guests right into the middle of their own golden era.

GEOFFREY ZAKARIAN
Restaurateur and Chef

WHAT IS YOUR MOST MEMORABLE TRAVEL EXPERIENCE? A small charter boat through the Aeolian Islands in Italy. We stopped along the way, hiked volcanoes, explored black sand beaches, and ate in family-owned restaurants. The caperberries, lemon leaves, caponata—all memories from these special places.

NAME A DESTINATION THAT HAS MOST RECENTLY INSPIRED YOU. Paris. I find continual inspiration every time I visit. Even though I know the streets well, they seem to constantly lead me to new destinations.

ELABORATE ON YOUR EXPERIENCE AT THE CHATWAL: When I enter The Chatwal, I feel as though I am in a small London hotel. Thierry Despont achieved the perfect balance here between old and new—what a true luxury to have a restaurant and bar designed by this architectural master.

ANY HIDDEN GEMS IN NEW YORK? Neue Galerie, Martial Vivot men's salon, Kalustyan's spice emporium.

WHY IS NEW YORK SPECIAL TO YOU? This vibrant city has given me so many opportunities, allowing me to learn the craft of cooking and presenting an environment where anything is possible. You can make your way here—it's endless.

Clockwise from top right: Lois Moran, the first woman to enter the Lambs Club, with Victor Moore, A. O. Brown, and R. W. Peck; the polished Bar at the Lambs Club; the famed building that served as a meeting place for the Lambs Club; the building today, transformed into the luxurious Chatwal, located in the heart of the theater district; Geoffrey Zakarian and hotel proprietors; the original library, now the Stanford White Studio; the art deco lobby.

CONVENTO DO ESPINHEIRO

Évora, Portugal

Bordered to the north by the Tagus River and to the south by the Algarve region, the city of Évora a UNESCO World Heritage Site, presides over the Alentejo region of Portugal. Here, *pentimenti* from two millennia trace the city's history back to its origins as a Celtic stronghold, later conquered by the Romans in 57 B.C. Vestiges of its pivotal periods remain: a Roman temple and baths; a mosque and related architecture from Moorish rule beginning in 715; and palaces and monuments from its early Portuguese heritage. Évora was one of the most dynamic cities in the Kingdom of Portugal during the Middle Ages.

It was during that time, in the fifteenth century, that a convent was built near the city to commemorate the legend of an apparition of the Virgin Mary appearing above a thorn bush (*espinheiro*). Visitors to the pilgrimage site during the fifteenth and sixteenth centuries included King John II (who held court here in 1481), King Manuel I, King Afonso V, and King Sebastiao, who stayed as a guest of the monks.

In 1999, the Camacho family, from the Portuguese island of Madeira, bought the convent and spent two years restoring and transforming it into a five-star hotel. Set within nearly twenty

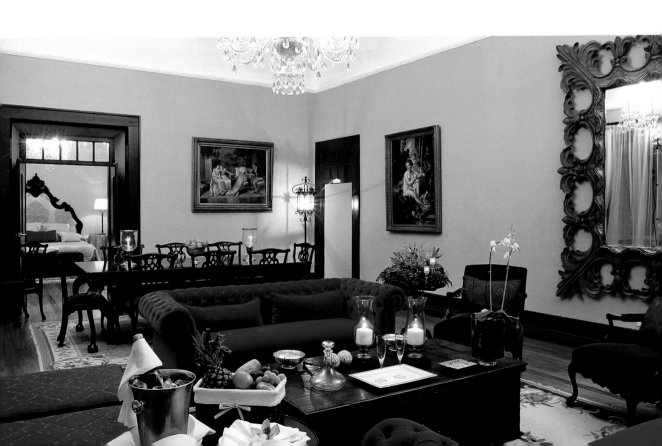

acres of beautiful gardens, the spectacular white convent now hosts guests in twenty-three original convent rooms and suites, with design reminiscent of their original purpose in hosting Portuguese royal families. Newer wings offer ninety-two rooms with a modern, glamorous 1950s feel.

These days, though the convent has every modern convenience expected of a top luxury property, guests are also steeped in its heritage: They take bread-baking classes using the ancient oven used by its monks until the nineteenth century, pick olives from the grove that produces the hotel's own oil, listen to haunting Gregorian chants in its church, and enjoy medieval banquets and stunning opera concerts in its cloisters.

Opposite: The Royal Suite's living room, named in honor of King John II of Portugal and reserved for prestigious guests. *This page, from top:* Our Lady of Espinheiro Church, located at the hotel; ruins of the Roman Temple in Évora, which is within walking distance of the hotel; the town of Évora.

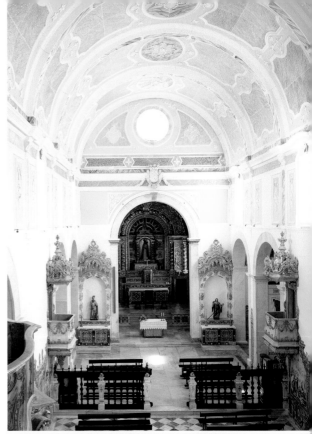

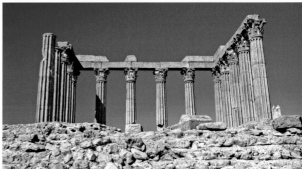

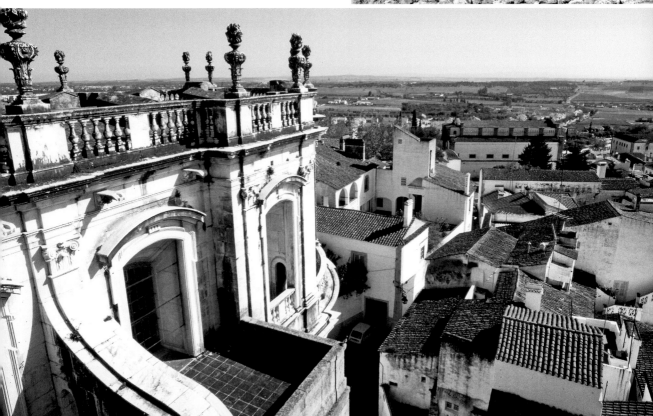

HOTEL DANIELI

Venice, Italy

This fourteenth-century palace, located in one of the most prestigious areas of Venice, is just steps away from the Piazza San Marco and the Palazzo Ducale, with its ancient dungeons connected by the famous Bridge of Sighs. In 1895, following its restoration, Hotel Danieli was established as *the* place for distinguished visitors to stay. Inside, one will find hand-carved marble columns, ceilings adorned with gold leaf, precious fabrics, tapestries, and elegant chandeliers. And in the morning, when day is breaking, the incredible Venetian light envelops everything and adorns this unique setting that Henry James described as "a mighty magician . . . a lustrous compound of wave and cloud and a hundred nameless local reflections." Many writers and artists have been dazzled by this light, by this atmosphere, and by this setting: John Steinbeck, F. Scott Fitzgerald, Charles Dickens, Gabriele d'Annunzio, Marcel Proust, and the adventurer and writer Pierre Loti, who loved to open his window to see the setting sun aflame over Venice. All were delighted by the spectacle that so perfectly embodies the magic and the splendor of Venetian life.

Originally built to satisfy the vows of the doge Enrico Dandolo, this magnificent building sheltered lovers Alfred de Musset and George Sand in 1833. The English painter William Turner has reproduced the hotel in magical, marvelously refined watercolors, bathed in a divine mist that suits it perfectly. Hotel Danieli resembles a dream, with its historic salons, its shimmering chandeliers, its sculptured doors, and its 221 guestrooms that look out over the brilliant, silvery lagoon. *Text by Francisca Mattéoli*

LAPO ELKANN
Entrepreneur

WHAT TRAVEL ITEM CANNOT YOU LEAVE HOME WITHOUT? My passport!

WHAT IS YOUR FAVORITE WAY TO RELAX ON VACATION? Being far from a telephone, preferably at sea, with good food and great friends.

FAVORITE PART OF YOUR STAY AT HOTEL DANIELI. The greeting when you return after a long absence.

WHAT ARE YOUR FAVORITE LANDMARKS OR ATTRACTIONS IN VENICE OR ITALY? In Venice, I love to go on my Venetian cousins' topetta, their little boat, and stop for lunch at Bacaro's for the best tramezzini. I also love dining at Antiche Carampane. In Italy, some of my favorite places are Naples, the Costiera Amalfitana, Torino, my family homeland, and Palermo.

WHY IS VENICE SPECIAL TO YOU? I've always associated Venice with special moments I had with my father, siblings, and grandparents. My grandparents acquired, restored, and established the Palazzo Grassi into the incredible art foundation it is today. I am pleased that their legacy is very much alive and thriving and is run by François Pinault. I always visit when there are new exhibitions.

The fourteenth-century Palazzo Dandolo, shown here, is the foundation of this Venetian hotel. Originally owned by the Dandolos, a noble Venetian family, the opulent building eventually came into new ownership and was transformed into the Hotel Danieli, where today it houses the hotel's single-occupancy guestrooms.

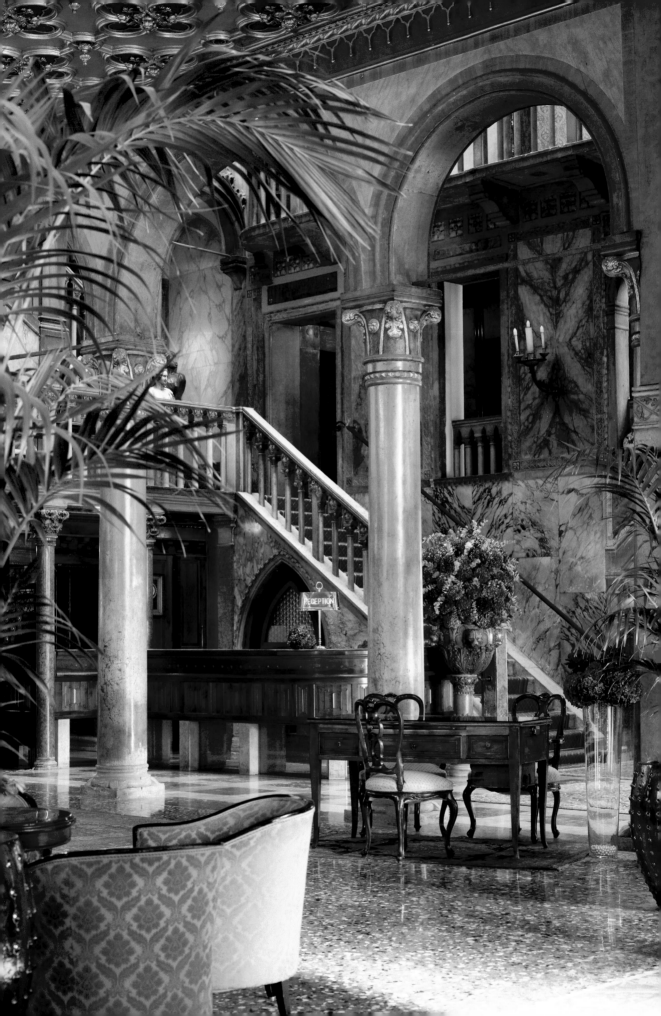

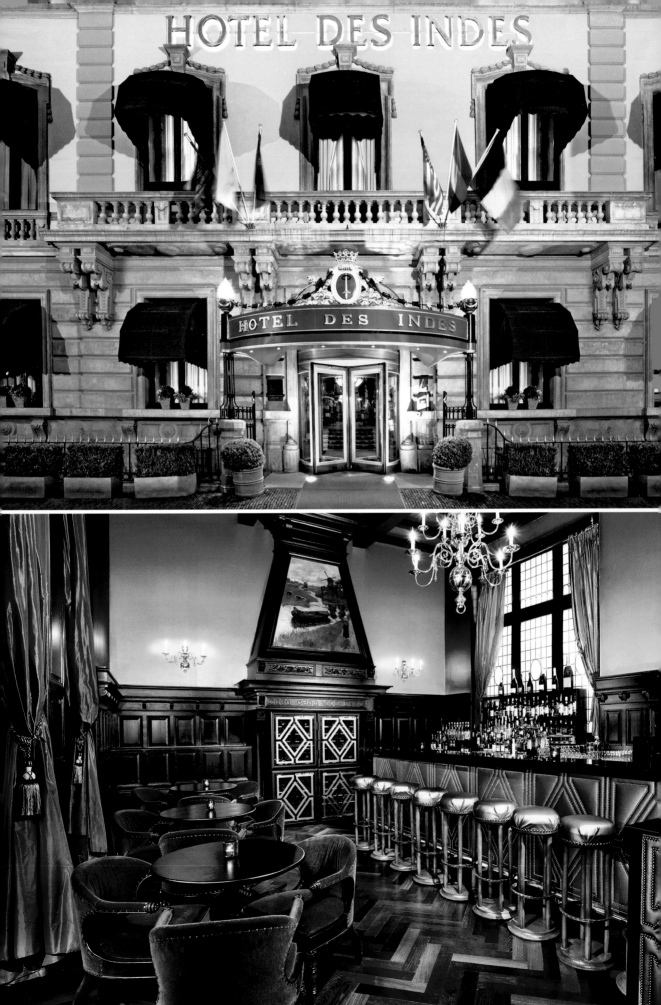

HOTEL DES INDES

The Hague, Netherlands

In 1858, a stately palace was built for Willem D.A.M. Baron van Brienen van de Groote Lindt en Dortsmunde. The chamberlain of King Willem III wished to have a more centrally located property than his Clingendael property he already owned in order to host huge parties and private functions. He could not have planned better. The palace, with its inner yard, stables, barn, servants' quarters, private quarters, and ballroom, served as a magnificent private entertaining complex for nearly twenty-three years. After he passed away, it found its way to the daughter of a prominent hotelier.

Thanks to the building's majestic ambience and many famous guests, there are many myths and anecdotes about the building on the Lange Voorhout. Over the past 155 years, it has hosted kings, emperors, artists, and scientists. Among the legends is the story of an Indian Maharaja who arrived with forty-five staff members to stay for two months, with thirty servants sleeping on mats in front of his room every night, and farmers from all over the country gathered on the Lange Voorhout vying to supply him milk. Hotel Des Indes gained its first renown at the turn of the twentieth century, when it was the base of a peace conference held by Tsar Nicholas II.

However steeped in history, the hotel has always had an eye toward progress. Its current remarkable iteration—the product of a 35-million-euro renovation in 2006, at the hands of famous designer Jacques Garcia—restored and even improved upon its original magnificence. Garcia's signature rich jewel tones and luxurious fabrics drape the opulent restored palace and its ninety-two guestrooms, fitting surroundings for the many heads of state who come to this critically important world city.

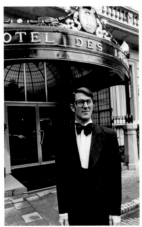
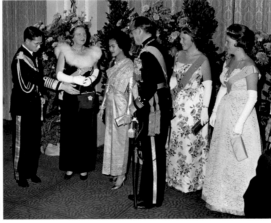
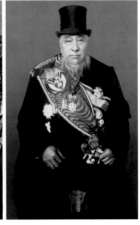

Opposite, top: The elegant and inviting hotel entrance; *bottom:* Lounge in the plush chairs and enjoy a signature cocktail, such as the Anna Pavlova, at Bar DesInDes. *Above, from left:* Mr. Thom Olschansky, maître d'hôtel for over forty years; Queen Juliana and Prince Bernhard with the king and queen of Thailand at the hotel; Paul Kruger, president of the Transvaal, South Africa, stayed at the hotel for one month in 1900 to conduct political business.

ECHOES
&
LILIANFELS RESORTS
Blue Mountains, Australia

Guests of Echoes are staying in rare air, indeed. Australian writer Thomas Keneally knew the value of this site and developed it as a private home in 1990—and a fourteen-room guest house in 2006. It was the last new structure permitted on the edge of the Jamison Valley, and it allowed guests uninterrupted and breathtaking views of the dramatic landscape.

Spacious, elegant rooms are contemporary and spare; the focus is on the massive windows leading out to pure natural drama. From patios jutting right into the deep Blue Mountains, guests are immersed, with as few barriers as possible, into the land. The property is a private showcase (so small it is a natural sanctuary for the very famous) for the chiseled sandstone outcrops, blue-hued eucalyptus forests, and national parks that surround it. Nearby, the famous rock formation Three Sisters promises incredible views, and the Giant Stairway offers access to many lookout points. Here, one will find the steepest incline railway in the world, which descends deep into the Jurassic rainforest floor of the Jamison Valley. In the comfort of tranquil guestrooms, however, one might have the best lookout point.

Echoes is nestled in the Australian wilderness and surrounded by magnificent views of the Jamison Valley's lush eucalyptus forests.

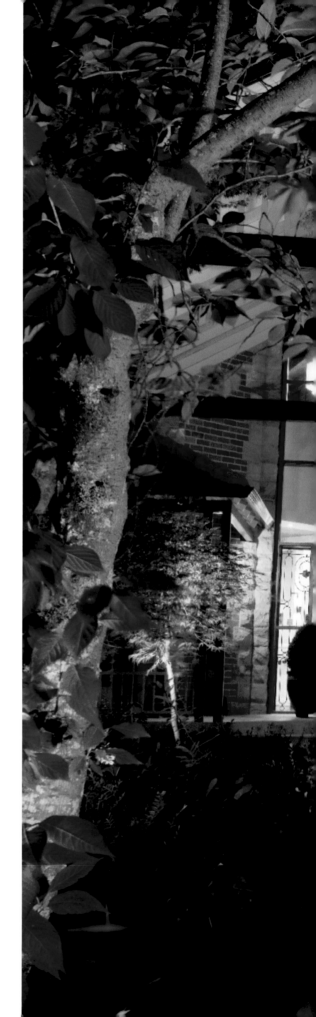

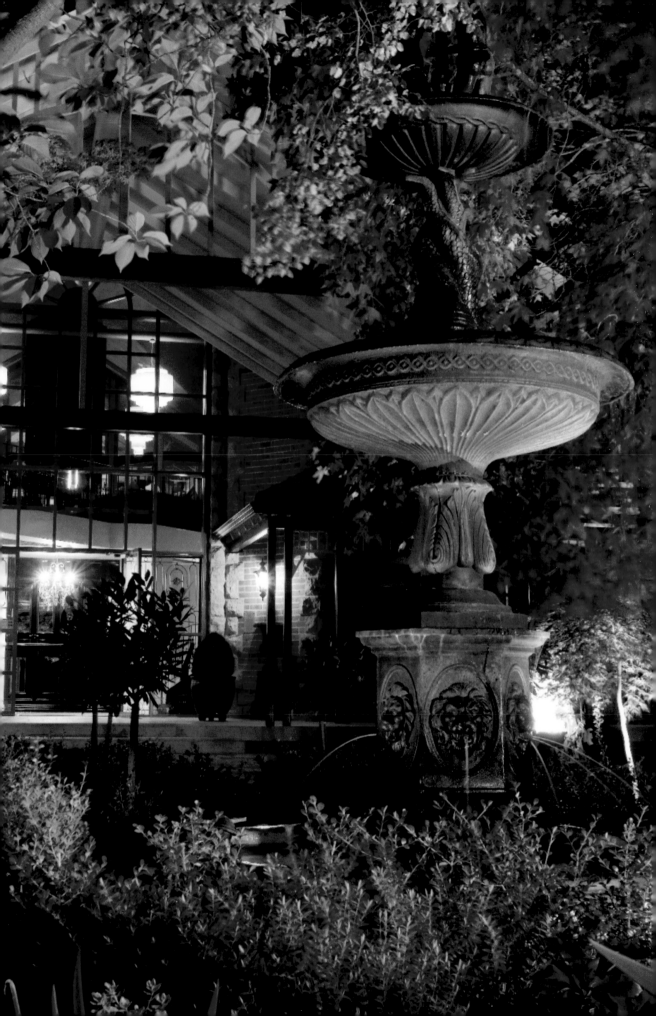

Another area country estate offers a similar view into the Blue Mountains. Lilianfels, with its eighty-five guestrooms, occupies a historic country mansion set amid two acres of manicured gardens, affording guests the feel of their own fabulous country estate adjacent to the iconic Echo Point lookout.

What guests will experience on arrival is something similar to what they might have in the early 1920s, when the hotel first opened. An impressive gated entry marks the beginnings of a drive through its gardens, from which glimpses of the Jamison Valley peek through. Light and airy, the lounge's plush, large couches and wing armchairs invite weary travelers to sink right in, read a book, and enjoy a traditional Lilianfels High Tea. Like any good sibling, the resort shares its indoor and outdoor swimming pools, billiards room, and spa with Echoes Resort. Both share the chic, Australian menus with their neighbors in paradise.

In fact, the illusion that you might be staying in a very hospitable person's guest home is quite purposeful—because that was the intention of Samuel George Baker, the Sydney manufacturer who operated it until 1952. And although it went through a few owners, Lilianfels has always been carefully maintained and loved—a tribute to its history and location in one of the most revered landscapes of the world.

> **" From patios jutting right into the deep Blue Mountains, guests are immersed, with as few barriers as possible, into the land. "**

Below: The dramatic view of Mount Solitary, one of the mountains that can be seen from Lilianfels. *Opposite, clockwise from top right:* The iconic mascot of Australia, the kangaroo, is one of many indigenous creatures guests might encounter roaming the beautiful New South Wales landscape; the outdoor heated infinity pool or, on a cooler day, the indoor pool at Lilianfels, are perfect places to unwind at this historic country mansion; experience private dining at Echoes; the middle lobby at Lilianfels.

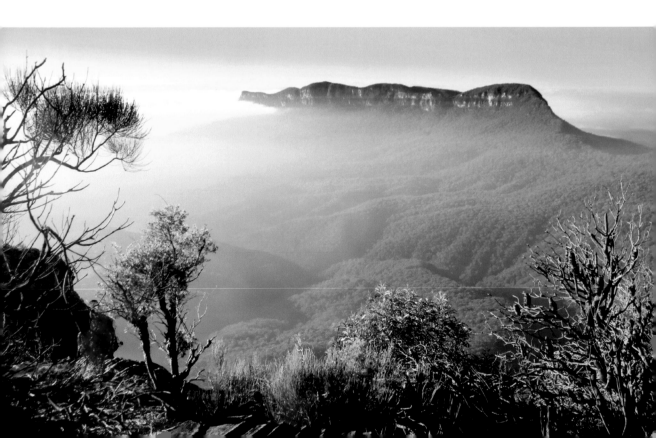

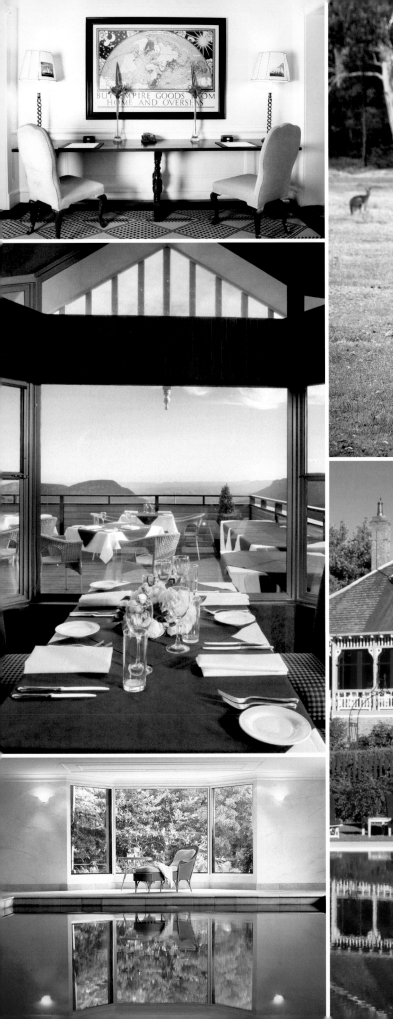
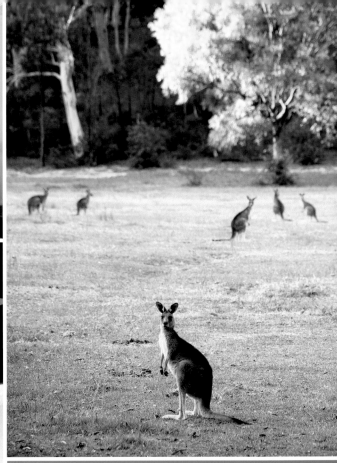
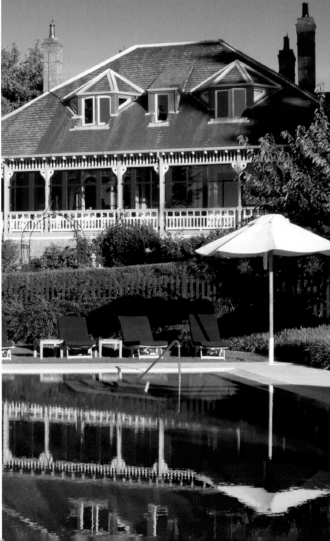

HOTEL ELEPHANT

Weimar, Germany

The Elephant has been a meeting place for poets, musicians, and artists since it opened its doors in 1696. Liszt, Bach, and Wagner, among others, have stayed there. In 1939, Thomas Mann made the hotel famous when he chose it for the setting of his novel *Lotte in Weimar. Lotte in Weimar* was inspired by the love story of the famed writer Johann Wolfgang von Goethe, who was passionately in love with Charlotte Buff, also known as Lotte. In *Lotte in Weimar,* Mann created a narrative where Lotte goes in search of Goethe in Weimar, forty-four years after they first meet. The story begins with Charlotte's arrival at the Hotel Elephant, with her daughter, also named Charlotte. In reality, Goethe finally did settle in Weimar, a town that has since been declared a World Heritage Site by UNESCO and which has become a place of pilgrimage for all those who love Goethe. It is said that he used to enjoy a glass of Madeira at the hotel and wanted to celebrate his eightieth birthday there. Although it has been renovated several times since, the hotel keeps souvenirs of its illustrious past. The Thomas Mann Suite today pays homage to the many artists who have been coming to the hotel for the past three hundred years. They would certainly have appreciated the defining Bauhaus and art deco

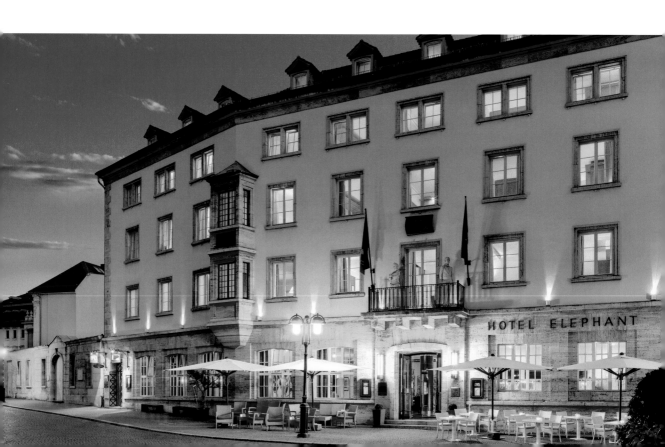

elements in today's ninety-nine finely furnished and individually styled guestrooms and suites, the sculptures that adorn the corridors, the selection of artwork in the rooms, the calm modernity, and the terrace—planted with trees and plants to resemble a secret garden—a place where poets can find inspiration. *Text by Francisca Mattéoli*

❝We are shaped and fashioned by what we love.❞

Johann Wolfgang von Goethe

Opposite: This urban hotel has been a retreat for artists, philosophers, and authors for more than three hundred years. *This page, top:* Thomas Mann; *center, left: Lotte in Weimar; center, right:* The celebrated bronze sculpture of famed German authors Johann Wolfgang von Goethe and Johann Christoph Friedrich von Schiller in Weimar; *below:* The luxurious Thomas Mann Suite, which features a series of paintings by Armin Mueller-Stahl entitled "Die Manns" (The Manns).

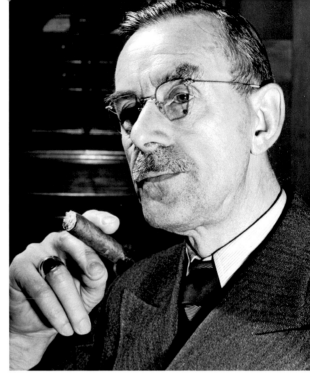

Thomas Mann
LOTTE IN WEIMAR
Roman

Bermann-Fischer Verlag
STOCKHOLM

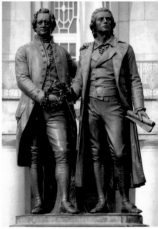

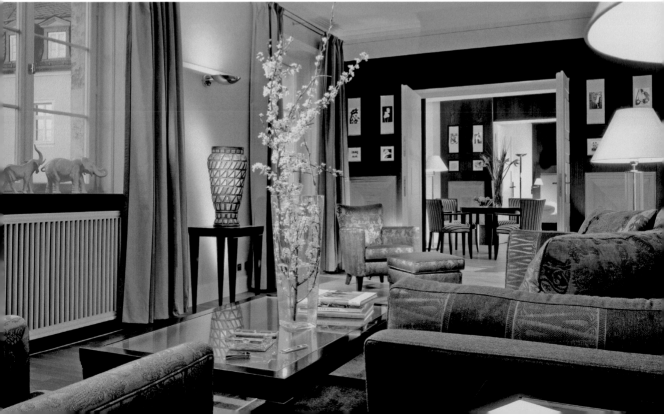

THE EQUINOX

Manchester Village, Vermont

The 244-year-old Equinox Golf Resort & Spa has been central to the well-documented history of Manchester, Vermont, since the town was less than a decade old. Nestled in a valley between the Taconic and Green Mountains, it offers the same dazzling winter scenery and blazing fall foliage that historically made this scenic village a playground for the rich and famous.

The resort's gradual expansion to today's magnificent, 2,300-acre estate and 195 guestrooms began from humble origins—the two-story wooden Marsh Tavern (still serving hearty New England fare today as a restaurant). Locals gathered here, many of whom would become memorable Revolutionary War figures—including the legendary "Green Mountain Boys"—and it was the first Tory property seized by revolutionaries to support their war effort.

In 1853, Franklin Orvis opened his own hotel, the "Equinox House," in his father's home next door to the Marsh Tavern, and the combined resort's reputation as a premier summer destination was solidified ten years later, when Mrs. Abraham Lincoln and her two sons vacationed there. (Her third scheduled trip, with her husband, prompted construction of a new suite that would befit a sitting president, according to the hotel's records.)

Today, after a 2007 refurbishment and the acquisition of the 1811 House—the former home of Abraham Lincoln's granddaughter—the resort, with its soothing neutral palette and subtle décor, has merged its rich history with elegant modernity.

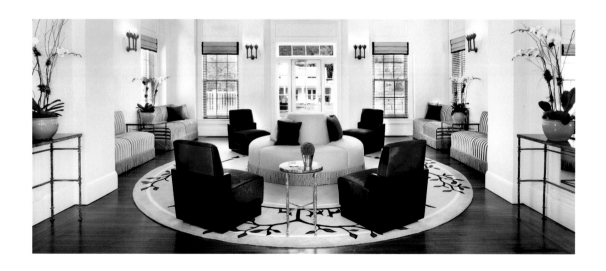

Opposite: Take fly-fishing lessons at the Orvis Fly Fishing School, and enjoy the serene fall foliage on Equinox Pond. *This page:* The sleek and modern Great Room, one of many spaces renovated in 2007.

HOTEL EXCELSIOR

Naples, Italy

It took only two years to plan, build, and furnish the gleaming white Hotel Excelsior, beginning in 1907—an exceptional feat, considering that Naples's most prestigious hotel was at that time a part of the sea. Shortly after the unification of Italy, the land in front of the small church of Santa Lucia and Via Chiatamone was drained to make way for a monumental building process.

Now, it seems the Hotel Excelsior has always been a key part of the magnificent Bay of Naples' shore. Guests can see spectacular views of Mount Vesuvius, the island of Capri, and the Sorrento coastline from one of its 120 beautifully decorated guestrooms.

Crossing the threshold of the Hotel Excelsior into its grand entrance hall is like stepping back in time. On one wall, a 1775 engraving commissioned by Giovanni Carafa, Duke of Noja, and completed for Ferdinand IV, depicts a map with a view of the city and the layout of the ancient seafront. Antique carpets grace the floors, and sparkling chandeliers from Murano illuminate the marble drawing room. One can imagine the parties and banquets for royal families, aristocrats, financiers, and actors who stayed here. It is a litany of famous names, among them the King of Sweden, the royal family of Greece, the Aga Khan, the Sovereigns of Denmark, the Duke and Duchess of Windsor, Prince Umberto of Savoy, and the Royal Duke of Aosta. It has also been a mandatory stop for many visiting musical, artistic, and political personalities, among them Alexander Fleming, Alfred Hitchcock, Sir Laurence Olivier, Charles Boyer, Sophia Loren, Clark Gable, Humphrey Bogart, Sir Winston Churchill, Hillary Clinton, and Luciano Pavarotti.

But the striking coastal palace has not always stayed as pristine as it is today. The bombardment of August 1943 seriously damaged the hotel. It was rebuilt and reopened in 1947, with careful attention to its original style. Now, sitting at La Terrazza to savor the justifiably famous Neopolitan cuisine against the stunning backdrop of the illuminated Castel dell'Ovo or looking out from a private upper-floor terrace, guests easily feel a part of the century-old tradition of this coastal palace.

> **66** One can imagine the parties and banquets for royal families, aristocrats, financiers, and actors who stayed here. **99**

Stunning view of the Bay of Naples from one of the opulent guestrooms.

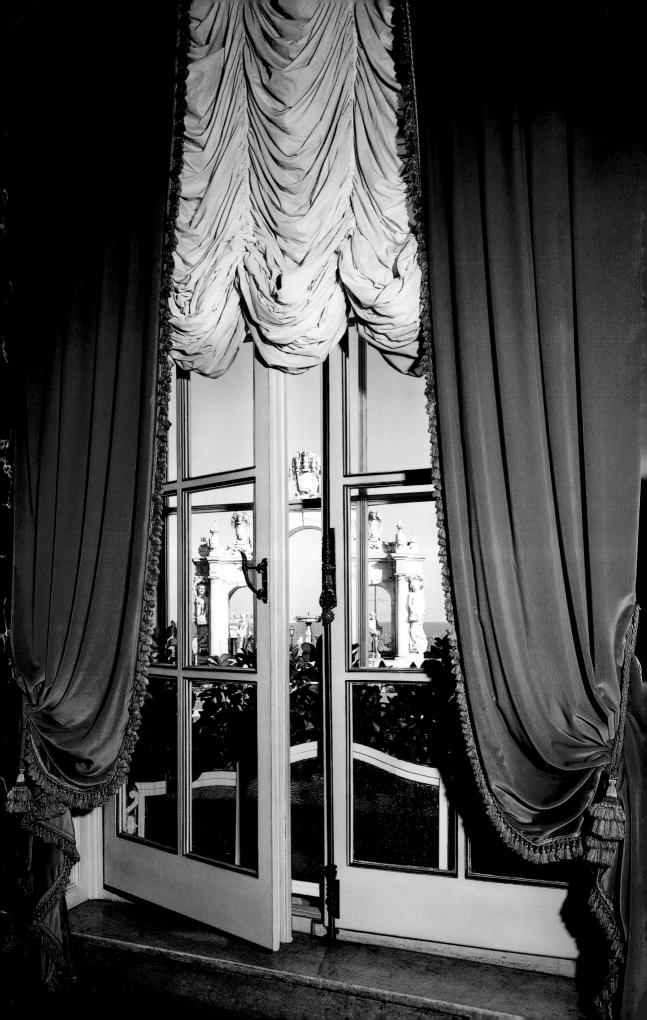

THE FAIRFAX AT EMBASSY ROW

Washington, District of Columbia, USA

When The Fairfax opened its doors in 1927, distinguished guests were drawn to its stately elegance and its location, nestled among the stately mansions of Dupont Circle. Colonel H. Grady Gore and his wife purchased the hotel in 1932, and during their first decade, congressmen, senators, and ambassadors began to make the hotel their permanent residence. Storied tenants of the 259-guestroom hotel included Mrs. Henry Cabot Lodge, Admiral and Mrs. Chester William Nimitz, as well as a young George H. W. Bush and his parents, Senator and Mrs. Prescott Bush.

In the 1950s and 1960s, glamour reached new heights at The Fairfax, sealing the hotel's destiny as a Washington, D.C., trendsetter. To accommodate the growing masses and celebrity guests, Col. Gore's children launched 2100 Prime—inspired by New York's legendary 21 Club—and it became the gathering place for President Kennedy's "Camelot."

In 2006, the hotel changed hands and underwent a major renovation. Updated for a new age, it is receiving today's power players in beautifully revived Georgian-style guestrooms. And 2100 Prime stays true to its roots as it serves dishes from the regions' finest purveyors and farms.

Even after the renovation, the distinctive natural wood that adorns the glamorous lobby remains.

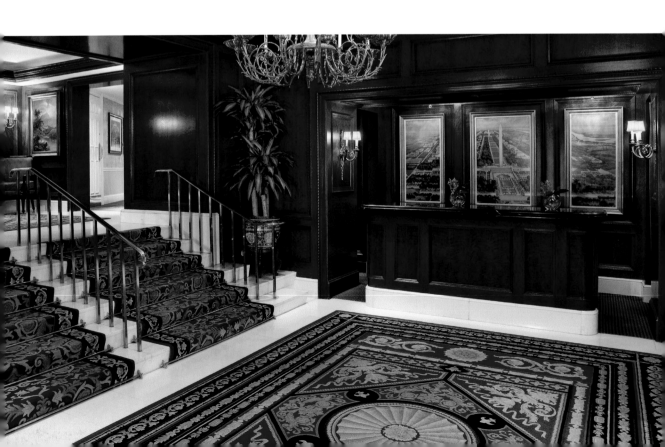

HOTEL FUERSTENHOF

Leipzig, Germany

This eighteenth-century patrician's palace in a historic center of trade still appears to be just that, with its vast marble floors, gold-rimmed archways, and soaring ceilings. In 1889, the then nearly century-old palace was transformed into a ninety-two-guestroom hotel, its opulence remaining undimmed. Now its gardens can be shared by visitors, for events, dinners, and festivities in spectacular surroundings, looking up to the magnificent steeple of the adjacent Evangelical Reformed church.

Just as the hotel's earliest guests would have experienced it, the Serpentine Hall has been restored to its original 1865 condition, a magnificent parlor lined in the precious stone serpentine—known locally as "the marble of Saxon kings"—making this historical work of art the only one of its kind in the world.

All this preserved luxury does not mean the palace has forsaken the pleasures of a more modern age. Amid uniquely carved boulders, a luxurious spa, AquaMarin, beckons today's guests. The Hotel Fuerstenhof's overarching old-is-new ambience has intrigued a roster of international stars.

This jewel of a hotel is centrally located in Leipzig's cultural treasure trove.

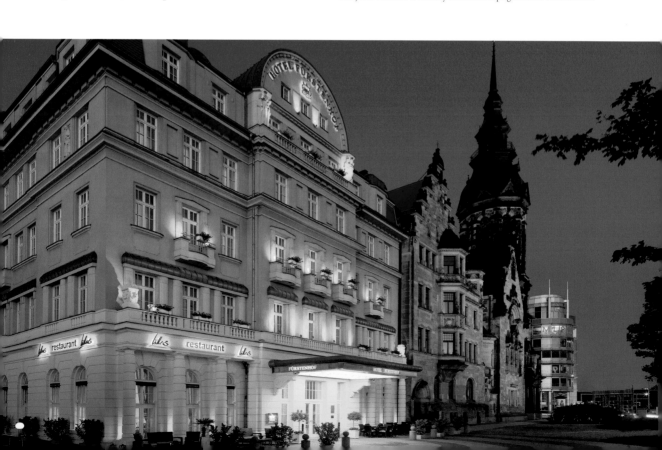

HOTEL GOLDENER HIRSCH

Salzburg, Austria

Behind the bulky, ancient doors and unassuming façade on Salzburg's renowned Getreidegasse road, the Hotel Goldener Hirsch appears much as it would have when it was built six hundred years ago. The house that would later become the hotel was first established in 1407. By 1564 it was an inn called the Güldener Hirsch. Soon Salzburg became the blossoming residence of archbishops, where the leading European architects designed fantastic houses of worship, such as the Franciscan Church and the splendid baroque Collegiate Church.

Architecturally, the heart of the old city has changed little since that time. The cathedral was already there then, and so were the wonderful baroque buildings around it. A stroll along the Salzach, Salzburg's picturesque river, shows the city's earliest and most influential layers of Romanesque, Baroque, and Renaissance architecture.

Central Europe at the end of the eighteenth century revolved around Vienna, so much so that even Salzburg-born composer Wolfgang Amadeus Mozart (whose home is a minute away) decided to move there in order to entertain the Imperial Court. Salzburg flourished again with the founding of the Salzburg Festival in 1920. And in 1939, as the Second World War began, Harriet Walderdorff and her husband Count Emanuel Walderdorff bought the Goldener Hirsch. The countess spent the war collecting the rustic furniture that still fills its halls and planning the restoration of the dilapidated old house to its original grandeur. Along the way, she earned her reputation as one of the first to preserve Salzburg's original architecture, and a pioneer of the "farmhouse style." To find the distinctive pink of the building's façade, she secretly flaked paint from a house near Salzburg for her painter to copy; the poor man created fifty shades of green for the inn's distinctive shutters. She also handpicked the Salzburg-style décor for its seventy guestrooms.

In April of 1948, the countess opened her hotel, Goldener Hirsch, which became a near-instant haven for the artists who appeared at the nearby festival house. The energetic conductor Herbert von Karajan brought a nightly crowd to the restaurant. Here, they introduced the custom of applauding artists when they entered the restaurant after a performance at the most celebrated music festival in the world. Today, in this city that has inspired and hosted some of the most memorable moments in history—Einstein's first presentation of his theory of relativity, the first performance of "Silent Night," the capturing of the city's essence in *The Sound of Music*—the Goldener Hirsch continues to preside.

Clockwise from top right: The unique room key that opens the door to the spacious guestrooms; an illustration of Hotel Goldener Hirsch, 1901; an eighteenth-century painting of the back of the hotel; a portrait of young Mozart, born in Salzburg; the captivating nighttime view of Salzburg, on the Salzach River.

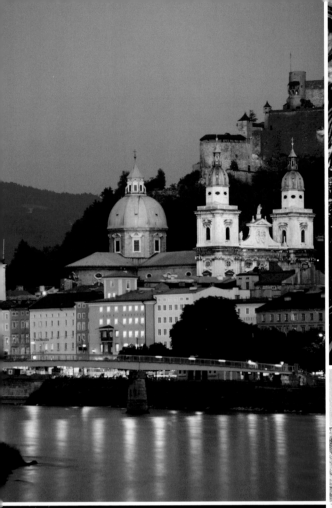

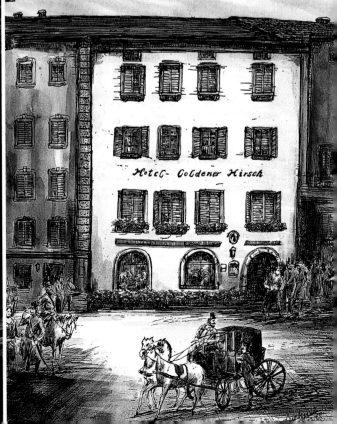

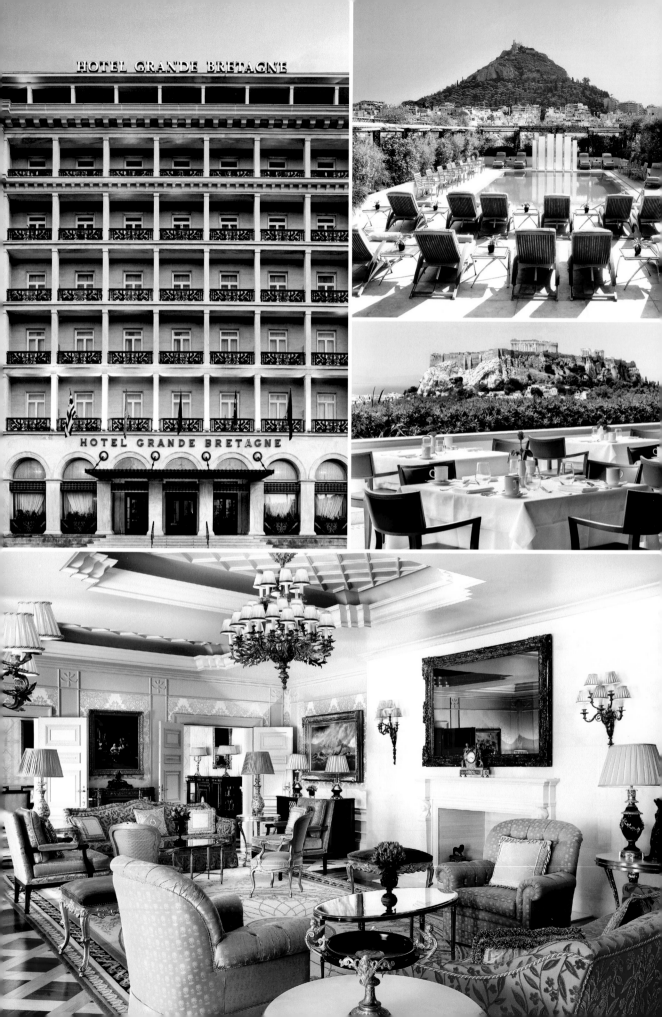

HOTEL GRANDE BRETAGNE

Athens, Greece

Few hotels can boast, as can the Hotel Grande Bretagne, of being destinations unto themselves.

In 1842, the hotel was the home of Antonis Dimitriou, an affluent Greek from the island of Limnos. Dimitriou decided to buy a plot of land in Athens to build the first "Stadtpalais," later transformed into what is known today as the Hotel Grande Bretagne, featuring 320 guestrooms. The hotel quickly became the strategic center of Athenian life and, for the most part, Greek social and political life.

Upon entering the imposing lobby, one breathes in the air of the hotel's distinguished life and past splendor. Since the hotel opened in 1874, Athenians have always visited there, keeping up the reputation of the hotel as the most luxurious in the city. But what makes this place unique and truly outstanding can be seen mainly at night, when everything is calm, on the roof garden. Unexpectedly, a miracle occurs. The restaurant becomes the domain of the gods, of Athena, of Poseidon, of all of Greek mythology. Standing out against the somber blue sky is a spectacular view of one of the most incredible monuments of the world, a monument built in the middle of the fifth century B.C. that is the universal symbol of the mind and of classical civilization—the Acropolis— suddenly bringing its absolute, fantastic sumptuousness to this already magnificent place.

Text by Francisca Mattéoli

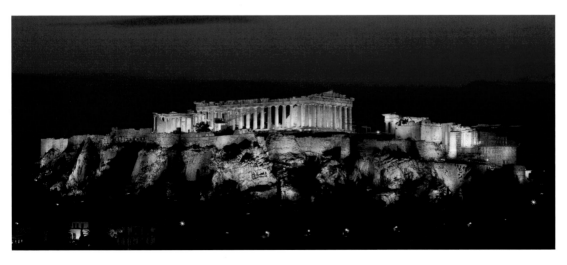

Opposite, clockwise from top right: Set against the Lycabettus Hill, the Pool Bar offers a stunning view of Athens; dine at the GB Roof Garden Restaurant & Bar while taking in the view of the nearby Acropolis and Parthenon; the Royal Suite, a home-away-from-home for the hotel's affluent visitors; known as "The Royal Box," the hotel has been the only choice for royalty, heads of state, and celebrities when staying in Athens. *This page:* The Acropolis and Parthenon lit up at night.

THE GRITTI PALACE
Venice, Italy

The ambience of The Gritti Palace is still as astonishing as when Andrea Gritti, seventy-seventh Doge of Venice, made it his personal home in 1525 and decorated it with unique Venetian antiques, precious rugs, tapestries, and lamps handmade by master glassworkers from the nearby island of Murano. Gritti, who had learned the art of diplomacy from his grandfather by following him around embassies, loved to contemplate the view of the Grand Canal from its windows.

This year, after a two-year-long extensive restoration, the palace has reopened as a hotel renowned worldwide. And the view, which its visitors can still see, defines not only this very special city but also a way of life. Charles Dickens said he worked better at the Gritti than anywhere else. Hemingway went back and forth between the hotel and Harry's, the nearby bar, and amused himself by playing cricket on the expensive rugs. Raoul Dufy painted famous watercolors inspired by the landscape he saw from his room. The hotel—including its eighty-two distinctive guestrooms—is still bathed in these mellow, golden, strangely floating, typical Venetian colors. The salons have this inexplicable, mysterious knowledge that is the soul of the city. The antique furniture, the luxury of the décor produced by great local artisans, the marvelous

STANLEY TUCCI
Actor

WHAT IS YOUR MOST MEMORABLE TRAVEL EXPERIENCE? Living in Florence for a year when I was 12. My father, an art teacher, had a sabbatical and studied at the Academia delle Belle Arti. I went to an Italian school, learned the language, and we traveled by train throughout Italy. It was life-changing.

WHAT INSIGHTS HAVE YOU GAINED FROM TRAVELING? The places to which I have traveled, the things I have seen, and the people I have met have given me the inspiration for what I do as an actor, writer, and director.

NAME A DESTINATION THAT HAS RECENTLY INSPIRED YOU. Amsterdam is a city I find inspiring because of its devotion to the betterment of its cultural institutions and its very friendly, relaxed, and tall inhabitants.

FAVORITE PART OF YOUR STAY AT HOTEL GRITTI PALACE. A morning coffee by the window, watching the canal and the multitudes it carries.

ANY HIDDEN GEMS IN VENICE? The thing about Venice that I love is that one can get lost very easily in its labyrinth of canals. Along every canal are architectural gems. Each building is different from the next. Those that are in a state of decay are as beautiful as those that are preserved. Regarding restaurants, there was a trattoria that I found very late at night years ago where I had the most delicious shrimp risotto. Having forgotten the name, I tried to find it again by memory but the byzantine streets would not allow it. So let's say, Harry's Bar.

Clockwise, from top: Heritage Suites are embellished with private balconies that afford glimpses of the Grand Canal; *center, left:* Charles Dickens; *center, right:* Titian's illustrious painting of Doge Andrea Gritti; explore Venice on a romantic gondola ride along the city's Grand Canal.

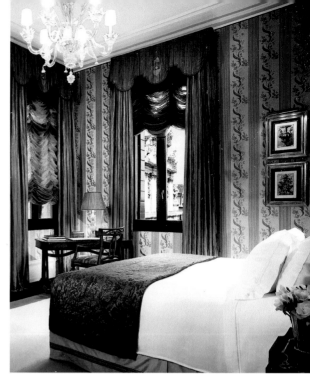

light that, come evening, bathes the Salute just across the water, have inspired some of the world's greatest writers and artists. Take a taxi boat to get there, sit on the terrace facing the fantastic panorama, and order a bottle of Valpolicella, as Hemingway did. And then, forgetting the rest of the world, happily and silently savor the moment. *Text by Francisca Mattéoli*

❝The salons have this inexplicable, mysterious knowledge that is the soul of the city. ❞

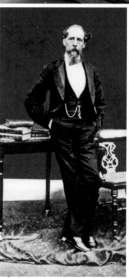

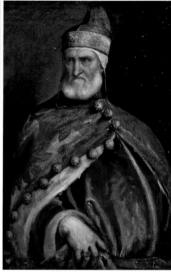

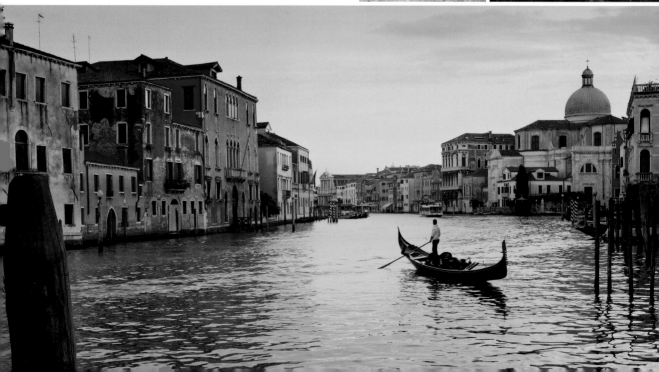

GROSVENOR HOUSE

Dubai, United Arab Emirates

Grosvenor House is something of an institution in Dubai. The first hotel on Dubai Marina, it instantly became a landmark when it opened in 2005, its tower standing forty-five stories high and casting a blue glow over the night sky that could be seen from land and sea. The success of its first tower led to Tower Two, which opened in 2011. Now these two dramatic towers anchor what has become one of the city's most cosmopolitan areas.

Since its beginnings, Grosvenor House Dubai has set the standard for the hospitality industry in the Middle East. Sixteen bars and restaurants pay homage to cultures from Turkey to the Mediterranean to India. The hotel set benchmarks in 2005 with partnerships with Michelin-starred chefs such as Gary Rhodes and Vineet Bhatia and brought the first of the wildly popular Buddha Bars to the Middle East.

And while Grosvenor House is well established as one of the premier see-and-be-seen venues in this glittering city, once it is time to not be seen, guests can escape the fray to one of 749 impeccable rooms and suites, combining the sleekest of technology with a gently mystical Arabian influence.

This page: The hotel lobby displays the aesthetic of refined heritage, suave elegance, and effortless chic. *Opposite:* The two towers are now an integral part of the Dubai skyline.

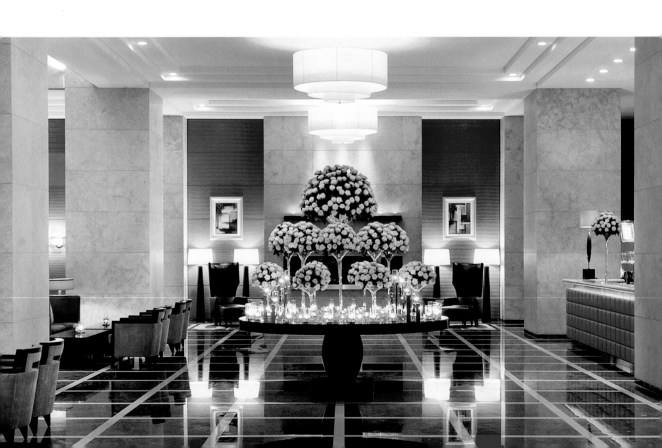

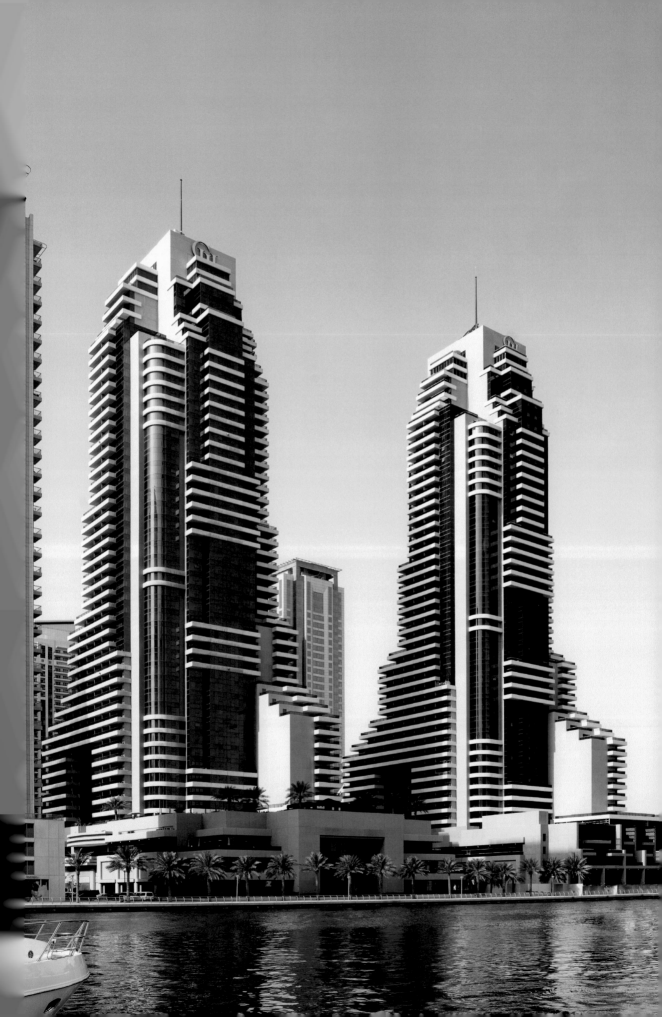

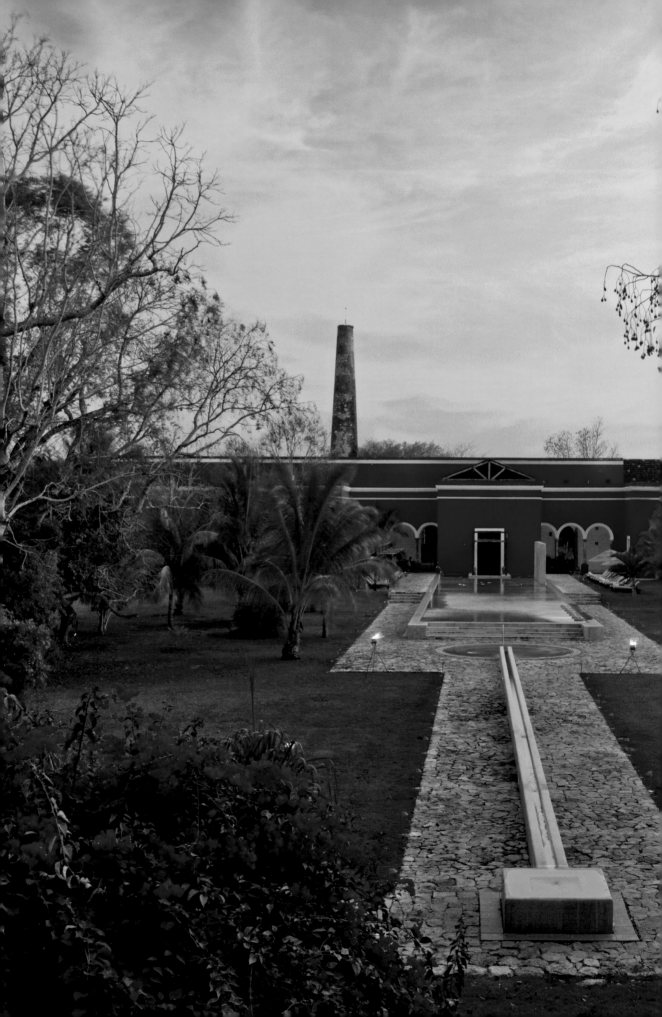

THE HACIENDAS

PUERTA CAMPECHE

SAN JOSE

SANTA ROSA

TEMOZON

UAYAMON

Yucatán Peninsula, Mexico

Temozon, Uayamon, Puerta Campeche, Santa Rosa, San Jose . . . magical places, magical names. There are few places that make one dream as much as the Haciendas in Yucatán, with their arcades, terraces, and colonnades that create an ambience of exotic, remote luxury. Everything gives the feeling of returning to a time when the grand owners made their homes in these tropical palaces. The gardens, teeming with plants like a jungle, recall the wild, luxuriant Yucatán. The golden ochre of the roads one has to travel to get there pays homage to the ancient land of the Maya and its treasures, in the legendary cities of Uxmal, Campeche, Mérida, Izamal, and so many other marvels. Each hacienda is magical. They provide much more than hotels, each one a true experience, every time. They are an opportunity to discover the Mexico of the seventeenth and eighteenth centuries, to be immersed in a place and time

The Casa de Maquinas at the Hacienda Temozon.

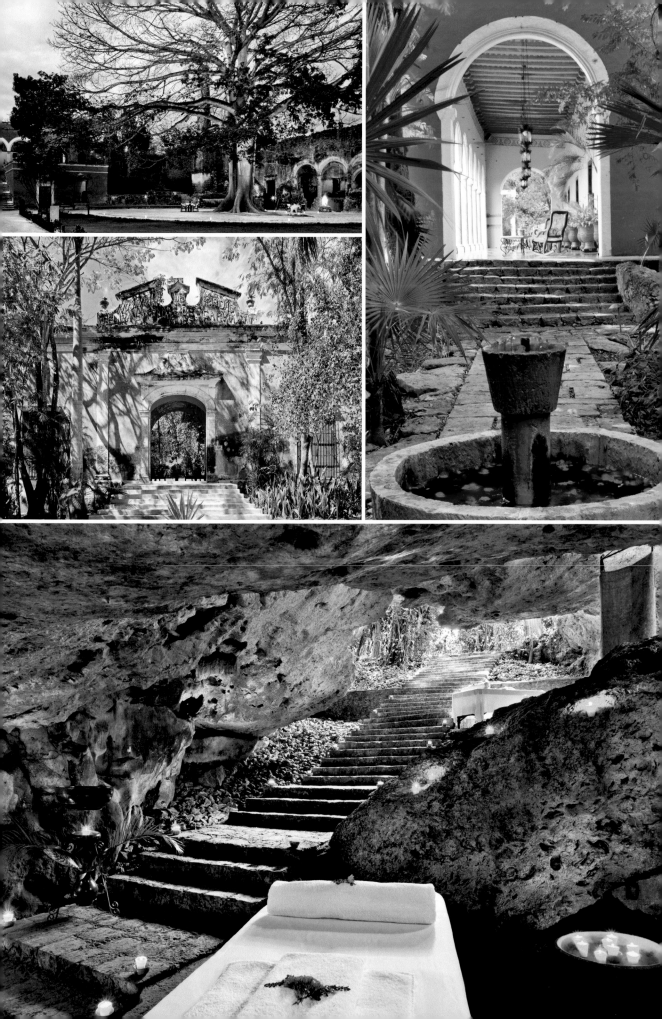

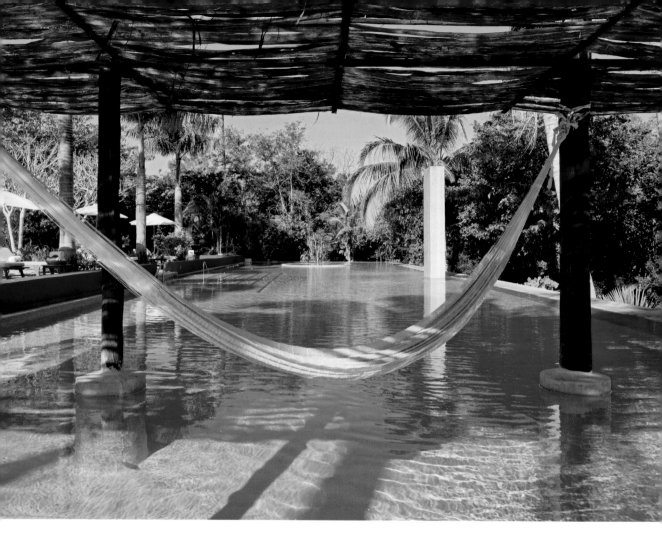

of inconceivable luxury, without needing to tour extensively. One can be completely content taking a morning walk in one of the gardens overflowing with flowers and plants, or following the sun's path from room to room, as it illuminates objects, paintings, and furniture imported from Europe. In the sixteenth and seventeenth centuries, the Haciendas represented another world. Some were abandoned for decades before coming back to life. Today the old house, school, chapel, dispensary, and "pay house," where salaries were distributed, have been transformed into rooms. In these rooms, it is hard not to think of the passionate owners who made these resurrections possible and those who walked there in the seventeenth century, who also loved these places, when there were no extraordinary swimming pools, when the sun struck the red ochre of the walls and the columns invaded by the jungle. It is a truly unique experience. *Text by Francisca Mattéoli*

❝ Magical places, magical names… There are few places that make one dream as much as the Haciendas. ❞

Opposite, clockwise from top right: Hacienda Santa Rosa; escape to the spa cave at the Hacienda Temozon; the Hacienda Uayamon; entrance to the luxurious Colonial Deluxe Suite at the Hacienda Uayamon, designed by architect Jaya Ibrahim. *This page:* Outdoor pool, with hammock, at the Hacienda San Jose.

THE HONGTA HOTEL

Shanghai, China

Imagine the theatricality of Western opera fused with the delicate elegance of traditional Chinese design. What you will discover is the opulent—but not overdone—aesthetic of this red granite–clad building in the center of Pudong. Close to the Bund and Century Park, the hotel (whose name translates to "red pagoda") makes a dramatic impact on Shanghai's skyline.

Two slender stone-faced buildings appear to slide past each other, bracketing a central, naturally lit glass hallway at each level. The tops of the buildings are sheared off in gently curved arcs that give The Hongta its signature profile.

But its interior is the true experience: the hotel lobby is structured to feel like a theater circle, with glassed-in levels for the many functions it hosts. Here, too, is where you will see tradition echoed in the motif of Shanghai's city flower—the white magnolia—graphically formed in the contrasting marble of the lobby floor and echoed in the tiers of the glass atrium. The result is a blend of modern design (look for the Herman Miller Aeron chairs) in an elegant, palatial, Asian-inflected atmosphere. The hotel, which features 328 beautifully decorated guestrooms, may nod to Western grandeur, but The Hongta is thoroughly and beautifully Chinese.

The dramatic hotel lobby.

HOTEL IMPERIAL
Vienna, Austria

The magnificent Hotel Imperial began its days in 1863 as the Vienna residence of the prince of Württemberg. The stately 138-room palace on the magnificent Ring Boulevard was transformed into the Hotel Imperial for the universal exhibition in 1873.

That was the same year that one of Vienna's most celebrated sweets came into being, courtesy of the hotel. According to Hotel Imperial lore, a young apprentice baker created the Imperial Torte in honor of his Imperial Highness, Emperor Franz Josef I. While its exact origins may be a bit hazy, its flavor is renowned: cocoa cream beaten to an ethereal lightness is layered between almond pastry wafers and enveloped in marzipan and milk chocolate, dispatched in its lovely wooden box around the world to those who long for a taste of the Imperial.

Meticulously maintained in the same beautiful style in which it was designed, the Imperial transports its guests to another time. Guests in the Elisabeth Suites (named after the great empress to Emperor Franz Josef I) are escorted by personal butler up the ceremonial staircase and past the empress's portrait, to their high-ceilinged parlors. Imperial "Schönbrunn" yellow is the star in the sunny, two-floor Maisonette Suites; guests enter

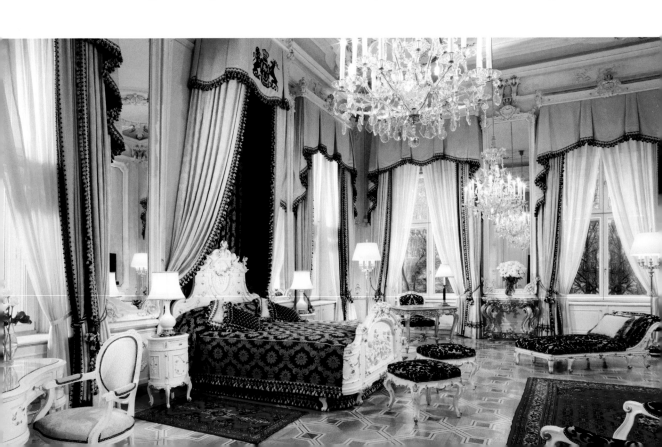

over extravagantly patterned parquet floors and descend to a romantic bedroom below.

But it is the Imperial's heritage as a meeting place for emperors and kings, delegates and ambassadors, that separates it from many of the grand hotels of the world—particularly as it has hosted some of the most discreet talks behind closed doors. In 1879, Prince Bismarck discussed an alliance with Count Andrássy of Hungary in one of the parlors on the second floor, witnessed only by Bismarck's dog Tyras. Czechoslovakia's president Benes conducted talks in the Imperial, as did the Soviet Union's Nikita Khrushchev. And Mussolini was shepherded through a back door in 1943, shortly after his escape from an Italian prison.

In recent years, the grand hotel has been renovated and expanded. A 130-year-old stucco from the Palais Württemberg has been lovingly restored to its original glamour; guestrooms have been added and expanded; the façade has had a lovely facelift. All are actions befitting one of the world's grandest hotels.

66 The Imperial transports its guests to another time. 99

Opposite: With design inspired by the Schönbrunn Palace, the Royal Suites offer luxury and service fit for a king.
This page, from top: The Royal Staircase, once used by royalty to go to their private apartments, now used by guests to ascend to their luxurious rooms; portrait of Emperor Franz Josef I, by F. X. Winterhalter; the handmade Imperial Torte is an authentic Viennese treat for guests.

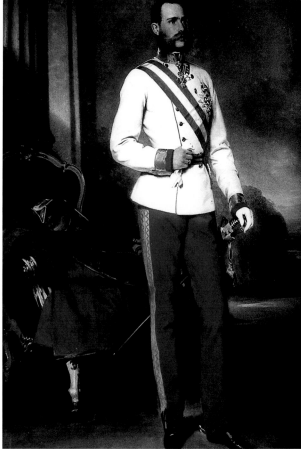

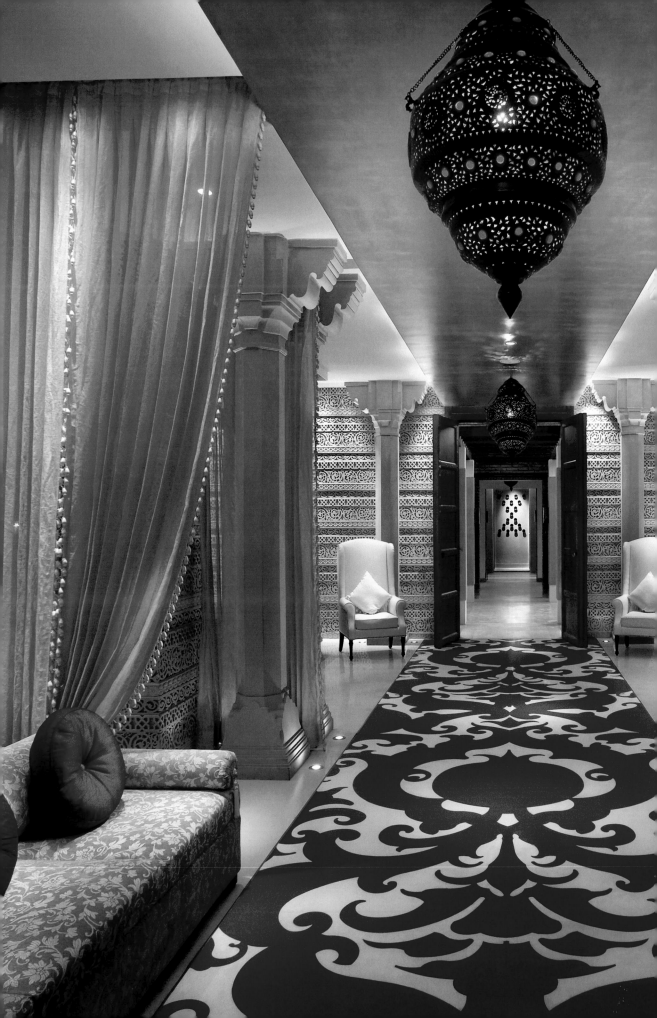

ITC GRAND CENTRAL

ITC GRAND CHOLA

ITC KAKATIYA

ITC MARATHA

ITC MAURYA

ITC MUGHAL

ITC RAJPUTANA

ITC ROYAL GARDENIA

ITC SONAR

ITC WINDSOR

India

A Luxury Collection partner for more than thirty years, ITC Hotels is India's premier chain of luxury hotels, blending traditional Indian hospitality with contemporary international standards. Among other accolades, the group is the first hospitality chain to achieve LEED Platinum certification for all its luxury hotels, making it the world's greenest luxury hotel chain. Among the other attributes that knit these hotels together, each is rooted in the architecture and ambience of India's dynasties. Their restaurants showcase the best of regional Indian cuisine. And a homegrown spa brand, Kaya Kalp, highlights treatments and rituals of India.

Each of the ITC hotels has a unique story. ITC Royal Gardenia is inspired by the garden city of Bangalore, Karnataka—its architecture, arts, and artifacts reference the fragrant white flower so commonly found in the city.

The reception room of the 99,000-square-foot Kaya Kalp, the Royal Spa, at the ITC Mughal.

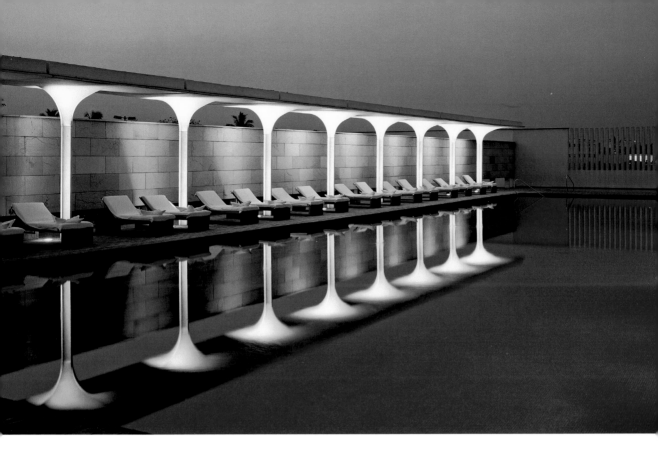

ITC Grand Central celebrates the historic spirit of Bombay through a splendid blend of British colonial style and modern contemporary design. Guests enter a beautiful cobble courtyard with a fountain in the center, under arched niches inspired by local Gothic architecture of the colonial period. And its corridors are inspired by those in the Indian Institute of Science building in Kala Ghoda.

In Chennai, ITC Grand Chola, the newest in the collection, is influenced by the many temples of the Chola Dynasty, with four entrances—a feature unique to South Indian temples. The entire hotel was built with the ethos of the great ancient empire in mind, from the lavishness of its décor to its smallest details, a perfect base from which to explore nearby UNESCO World Heritage sites.

ITC Kakatiya is in the heart of Hyderabad, overlooking the beautiful Hussain Sagar Lake. A favorite of visiting heads of state—from the Dalai Lama to George Bush to Prince Philip—the hotel's rich décor is inspired by the time of the grand Kakatiya Dynasty, a remarkable period defined by its cultural exuberance.

In the scant decade it has been open, ITC Maratha has become an iconic part of the skyline, with its striking Indo-Saracenic-style dome and elaborate stone carving made entirely by hand. Inspired by the seventeenth-century Maratha dynasty founded by the warrior King Shivaji, its special details include cornices carved in Jodhpur pink sandstone and coffered ceilings reflecting the Portuguese churches that influenced the architecture of the west coast.

Nestled in greenery, in the heart of Delhi's exclusive diplomatic enclave, ITC Maurya is a tribute to the golden age of the Mauryan Dynasty —the first dynasty of India's empire builders, dating back to the third century B.C. The hotel was built

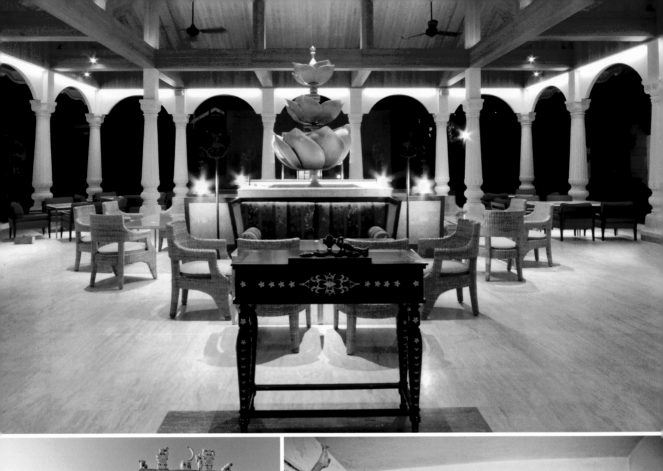

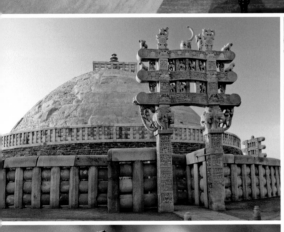

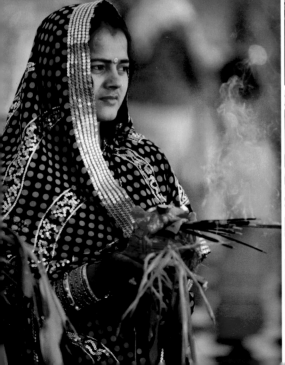

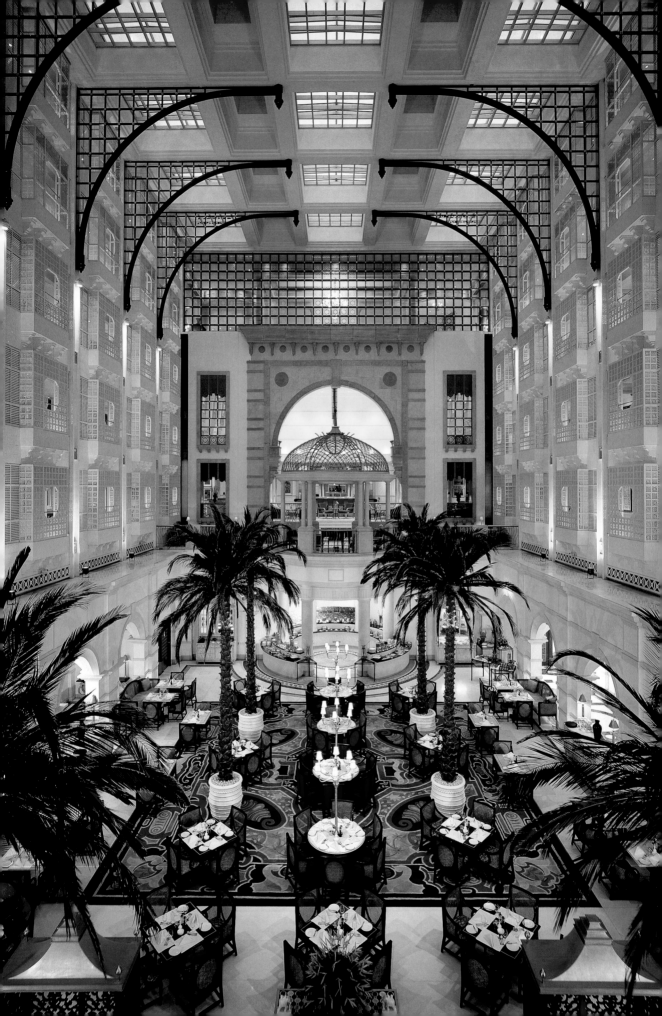

according to Mauryan architecture standards and is one of very few examples of authentic Mauryan design in the world (another being the library at Oxford in the United Kingdom). It is an imposing structure of superb luxury, and its central lobby re-creates the paneled dome of a Chaitya, or Buddhist hall of worship, with a splendid painted mural showing India in all its diversity.

The famed Mughal Empire ruled India for more than two hundred years, up to the eighteenth century, and ITC Mughal—designed as a resort and spa on thirty-five acres—takes its inspiration from Fatehpur Sikri, a city created by Mughal Emperor Akbar, and the Agra Fort, from whose battlements generations of Mughal emperors ruled India. Planned as a cool haven for a hot, dusty climate, the 233 guestrooms are grouped around three landscaped courtyards, loaded with symbolic references to three powerful Mughal emperors.

Designed to echo the traditional *havelis* (private mansions) of the region, ITC Rajputana's red brick exterior rises to different levels around a central area, housing the long corridors, secluded courtyards, and latticework of Rajasthani architecture in an uncluttered, thoroughly modern way. It is a beautiful base for exploring Jaipur, "The Pink City," with its magnificent forts, palaces, and bustling bazaars, along gracious avenues and dotted with spacious gardens.

ITC Sonar embodies the contradiction that is Kolkata, where water and greenery fill the landscape, just as technology informs the interior. A tribute to the golden era of Bengal, ITC Sonar is lavishly spread over acres of lush green gardens and reflecting pools—but designed in startlingly contemporary form. Spare, modern lines sweep skyward; through an entire wall of glass, guests look directly onto an enormous sheet of still water, all within minutes of Kolkata's "Salt Lake City" Sector V technology hub.

With its tall colonnades, balustrades, and chandeliers, ITC Windsor is sprawled on a promontory, its upper story overlooking the rolling greens of the Bangalore Golf Club. Imposing Regency architecture, Victorian décor, and unobtrusive service bespeak old-world charm. Along with the other ITC hotels, it adheres to the highest standards of environmental responsibility: these hotels are an extension of yesterday and a pedestal for tomorrow.

WARIS AHLUWALIA
Jewelry designer and Luxury Collection Global Explorer

WHAT IS YOUR MOST MEMORABLE TRAVEL EXPERIENCE? It is almost impossible to pick my most memorable experience. They all come together as little memories sprinkled on top of glorious birthday cake—dancing under the stars in Frescati with Anjelica Huston, watching the world go by on the Grand Canal from the patio of the Gritti in Venice, crossing the Bosphorus for dinner in a little speedboat, having something sweet at Andrea Pansa's in Amalfi, getting lost among what seemed to be hundreds of columns at the Jain temple in Ranakpur—one after another, memories for life.

ELABORATE ON YOUR EXPERIENCE WITH THE BUKHARA POP-UP. We flew in the whole kitchen team from New Delhi to prepare dinner at the Park Tower Knightsbridge in London for two weeks. I've grown very fond of Chef Manjit Singh Gill and knew we were all in great hands. For the space, the idea was to create an oasis in the middle of the city, a magic garden of sorts. I wanted to celebrate the beauty of nature in India, a country of vast and varied landscapes that has the ability to transport people to the magical garden that my heart sees.

NO ONE SHOULD VISIT INDIA WITHOUT... Walking around the sarovar of the Golden Temple in Amritsar. It is where I took my first steps.

WHY IS INDIA SPECIAL TO YOU? India calls me back several times a year. It is the land of my birth and is of course in everything I do.

The Peshwa Pavilion at the ITC Maratha, with its skylight and soaring ceilings, is open 24 hours a day.

HOTEL IVY
Minneapolis, Minnesota, USA

One of the most unusual icons in Minneapolis, Hotel Ivy has breathed new life into a cherished historic landmark, with signature elegance and style. Even before the building was finished in 1930, it was clear that the Ivy Tower would be very different from the popular skyscrapers rising around the country.

Architect Thomas R. Kimball envisioned the Ziggurat-style tower—the most exotic design Minneapolis had ever seen—drawing on the design of temples common to the people of the ancient Mesopotamian Valley. After years of iterations, it was boarded up in 1993 and made its final transformation into a luxury hotel in 2008.

Now listed on the National Register of Historic Places and newly made over, Hotel Ivy is received as a fresh bastion of luxury today. Seven miles of skyway take guests right to the Convention Center, Nicollet Mall, Orchestra Hall, and Guthrie Theatre. The hotel's 136 guestrooms, with their rich mahogany desks, leather headboards, and hardwood floors, nod toward yesteryear but are built for contemporary travelers. Wide open spaces, a sleek spa, a modern American restaurant—Hotel Ivy is evidence that everything old can be made new.

This page: The welcoming reception area; *opposite:* the distinct exterior.

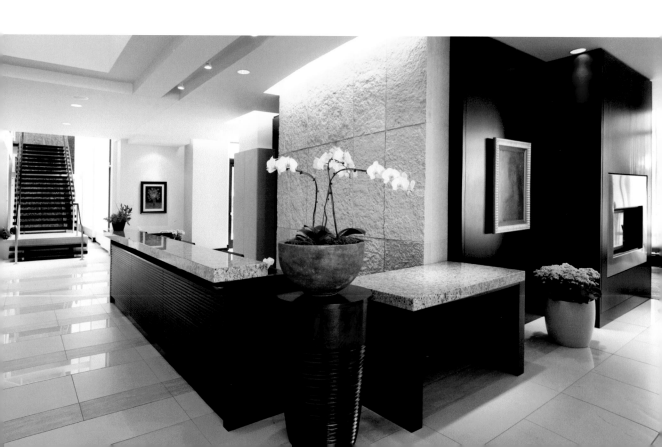

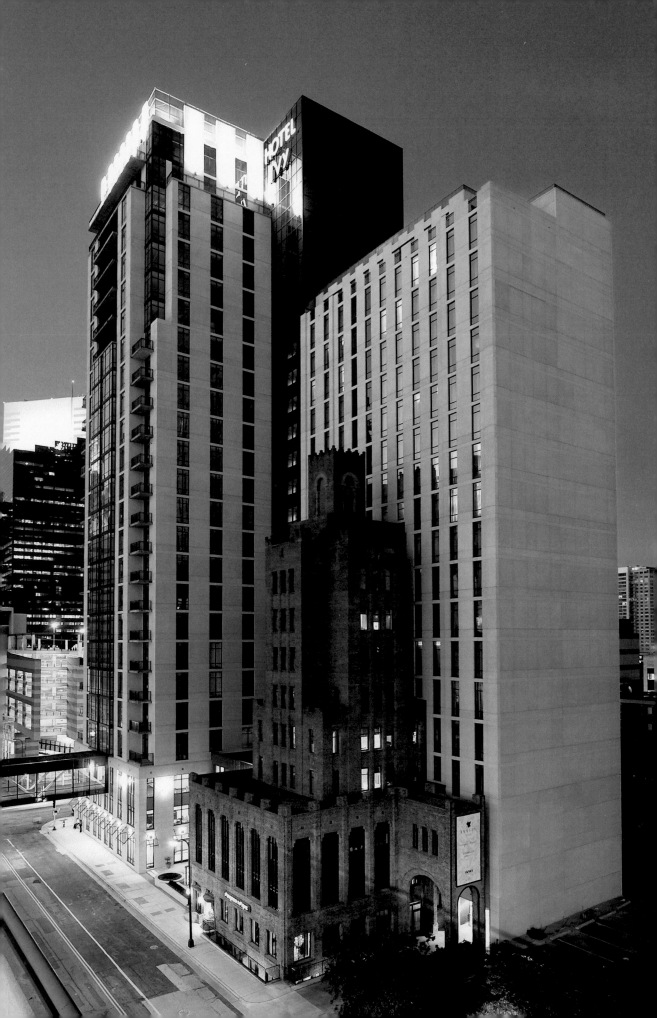

HOTEL KÄMP

Helsinki, Finland

To stay in Hotel Kämp is to look through an important window in European history—this has been a homebase for word-class international artists, heads of state, and royals, and even a center for historical events during the early twentieth century.

Restaurateur Carl Kämp first opened the hotel in 1887. Finland was a country on the threshold of independence, and it was here that guests could have a taste of the kind of luxury and refinement that the great European cities might offer. The hotel—which features 179 luxurious guestrooms—became an integral part of Finnish history, blending Eastern and Western European art, politics, and business life. Its architect, Theodor Höijer, designed a main entrance on the Esplanadi Park side that opened into an elegant lobby, where a richly decorated, pillared staircase climbed five levels. Luxurious rooms had their own private vestibules and guests were fascinated by the lift—a modern wonder!—which carried them from one floor to the next. Soft carpets, well-upholstered furniture, and glittering Venetian chandeliers established this beautiful hotel as a true European grand dame in refined Continental style.

Eventually, the hotel fell into disrepair and was nearly demolished, but its owners—a prominent

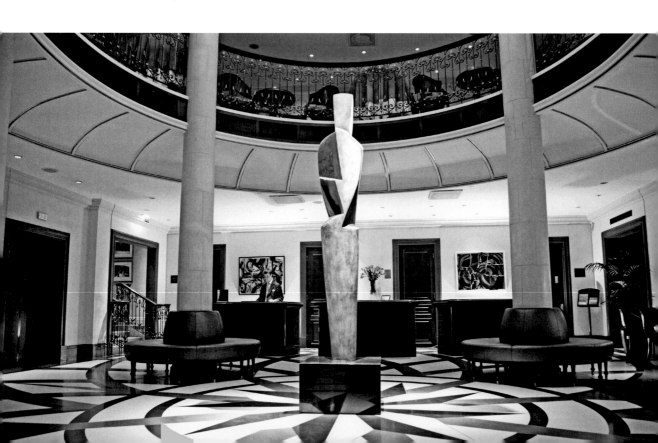

banking group—converted it into offices, preserving the old walls and interior structures. After years of work, they completed the new building in 1969, with a façade that was a near exact copy of the original building, plus a sixth story, replicating a level that had been added in 1914. These days, drapery has been faithfully replicated, as have the ornate chandeliers, twinkling brightly in the Mirror Room. Even furniture has been reproduced—copied from surviving examples—and frescoes by the artist Wetterstrand embellish what is now the elegant Kämp Café. Perhaps most important, guests can stay in the country's seminal luxury hotel, which captured the imagination of a nation that was just beginning to understand the meaning of a grand European tradition.

Opposite: The beautiful lobby, which fuses modern design with its traditional, classic European roots. *This page, from top:* The Mirror Room is perfect for galas, dinners, and celebrations; Hotel Kämp, located in the heart of Helsinki, celebrated its 125th anniversary last year; guests can explore this romantic city, day or night, and stumble upon historical and cultural attractions.

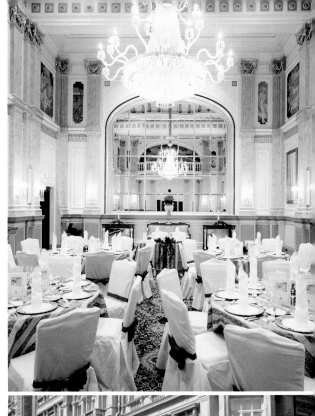

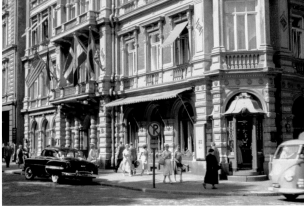

KERATON AT THE PLAZA

Jakarta, Indonesia

In an age when palaces are restored, not built, a thoroughly modern palace has risen in the booming capital of Jakarta. Keraton, which means "palace" in Javanese, celebrates its local influence, from an intricate mural of Javanese artwork displayed at the porte-cochère to an abstract piece, hand-carved from rich mahogany wood and adorned with antique gold, depicting a royal welcome.

This palace, poised as it is in the downtown business district of Thamrin, forms a seamless connection between Javanese royal heritage and the needs of the business traveling elite. The 140-room newcomer is connected to an opulent shopping center and surrounded by high-rise corporate buildings, embassies, and government offices.

The light-filled, contemporary space is a layered tribute to its heritage. An eclectic collection of art throughout the hotel and in a gallery is curated to showcase local artists. And throughout the hotel, elegant geometric Batik Kawung patterns grace furniture and textiles. In fact, the special pattern symbolizes the hope of remembering one's origin. In ancient times, only the royal family wore Batik Kawung, but Indonesian legend has it that a young peasant

boy is responsible for the pattern's origins. Because of his polite and wise behavior, the young man's reputation grew in the Mataram Kingdom (the Hindu-Buddhist kingdom of central Java between the eighth and tenth centuries), and he was brought to meet the king. When his mother heard about his honor, she made a special batik pattern that symbolized her hope that he would remember his humble origins and continue to be useful to society. It is this philosophy that Keraton at the Plaza follows to remind visitors that, while its interior is sumptuous, it has not forgotten its indigenous soul.

And as with any great central palace, Keraton at the Plaza is within walking distance of the city's best sites, including the iconic city landmark statue Selamat Datang (the Welcome Monument), the last wind-powered trading schooners at its picturesque seventeenth-century Dutch colonial port, and another palace—the official residence of the Indonesian president.

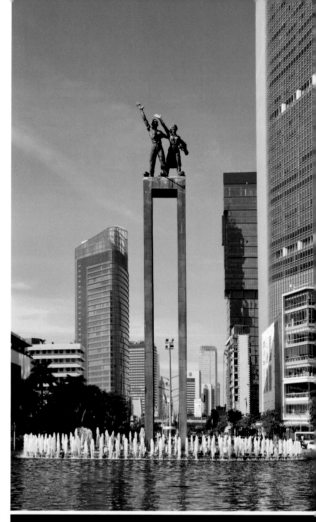

66 While its interior is sumptuous, it has not forgotten its indigenous soul. 99

Opposite: The intricately designed Javanese-inspired hotel lobby. *This page, from top:* Selamat Datang (the Welcome Monument) in Jakarta; *Growth Sculpture,* 2010, located in the hotel's art gallery; the Batik Kawung pattern seen throughout the hotel.

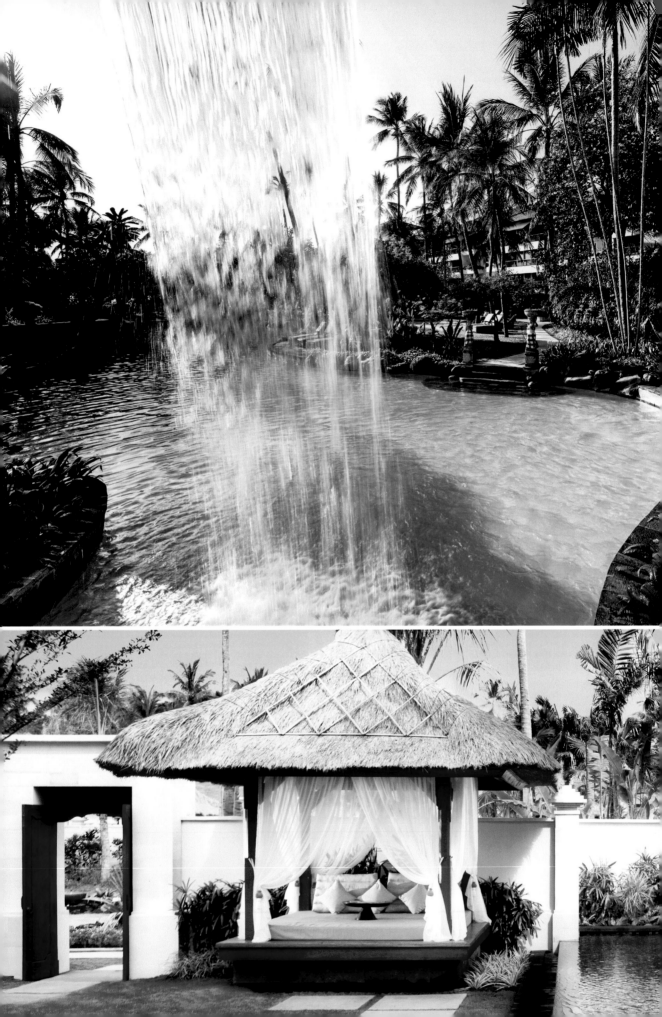

THE LAGUNA
Nusa Dua, Bali, Indonesia

When travelers envision an idyllic, secluded island vacation on a pristine beach in Southeast Asia, it is possible they are imagining The Laguna. The hotel is located in the exclusive Nusa Dua resort area, which lays claim to Bali's most beautiful beach—and looking out to the Indian Ocean from one's private balcony is almost impossibly cinematic. Clean, modern Balinese lines combine with evocative tropical garden and lagoon views, and, of course, the crystal clear waters of a private beachfront.

Bali is renowned for its friendliness, its rich arts and culture, and its cuisine. All of these things have been carefully incorporated into a 287-guestroom hotel, which seems less a hotel than the (expansive) home of a warm Balinese host. The beautiful batik creations of the island are worn by staff and are even incorporated into the design of the carpets. Enter the lobby, and one is greeted by traditional *rindik* music.

The Laguna is also something of a pioneer in Bali: the first to offer butler service, the first to feature an expansive swimming lagoon, and the first to offer rooms that open directly into the lagoon. It is this thoughtful service that has attracted everyone from Nelson Mandela to Chinese Prime Minister Wen Jiabao to its open arms.

Top: The 5,000-square-meter lagoon pool that surrounds the entire resort; *bottom:* One of the luxurious Laguna Pool Villas boasting a private pool and terrace.

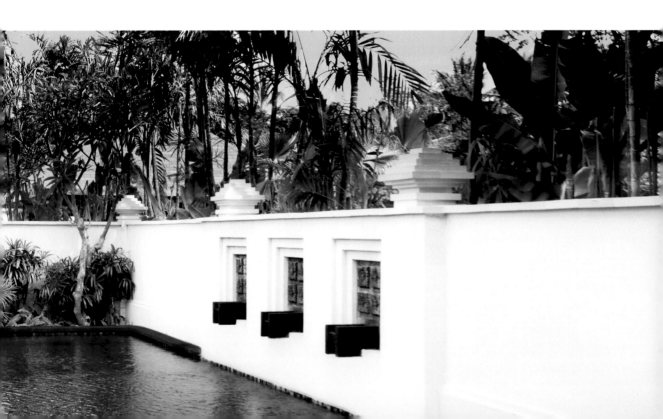

THE LIBERTY

Boston, Massachusetts, USA

An iconic national historic landmark with sweeping views of the Charles River: it sounds like the perfect luxury hotel address, and it is. Still, some of The Liberty's most famous residents stayed here, well, under duress.

In fact, The Liberty is the imaginative transformation of the Charles Street Jail into a luxury property, the result of a $150 million adaptive reuse and renovation project. Here, at the foot of Beacon Hill—a one-of-a-kind site that makes The Liberty the only hotel on the Charles River Esplanade—The Liberty looks over the city skyline and the river from one of Boston's toniest locations.

Built in 1851 from granite quarried in Quincy, Massachusetts, and transported to the site via rail car, this architectural gem was designed by Gridley Bryant, the father of Boston's granite architecture movement. At the time it was built, the Charles Street Jail was an international model for prison architecture. The cruciform-shape building's ninety-foot-tall central rotunda and four wings of jail cells were innovatively arranged so the tall exterior windows could provide ample light and air for prisoners without compromising security. What guests see today is a spectacular reconsideration of the structure: reopened after its refurbishment, the prison's atrium, catwalks, and signature oculus windows stream with natural light. Guests are welcomed into the hotel's central rotunda, which offers a breathtaking view of the "catwalk" floors rising five stories above the lobby level. One might imagine former residents, including Malcolm X and Frank Abagnale, Jr. sharing the same views from what are now 298 guestrooms (eighteen within the original landmark jail).

They did not, naturally, enjoy the same cuisine as its more enthusiastic current guests. At Clink,

JAMES BLAKE
Professional tennis player

WHAT INSIGHTS HAVE YOU GAINED FROM TRAVELING? My insight for traveling is to drink plenty of water and sleep whenever you can.

NAME A DESTINATION THAT HAS MOST RECENTLY INSPIRED YOU. Melbourne, Australia. I am inspired to get back there again to play the Australian Open.

ONE THING PEOPLE DO NOT KNOW ABOUT BOSTON: One thing people don't know about Boston is that there are over 60 colleges in the surrounding area, making it a wonderful place to be for young people.

FAVORITE PART OF YOUR STAY AT THE LIBERTY. The service. Anything we needed was at our fingertips.

WHAT IS YOUR FAVORITE GETAWAY SPOT OR WAY TO RELAX IN BOSTON? Boston Common. It's a beautiful little sanctuary.

Opposite, from top: The Charles Street Jail, circa 1851; the Alibi bar lounge is located in what used to be the "drunk tank" of the Charles Street Jail; guests can take a leisurely bike ride through the streets of Beacon Hill or along the Charles River Esplanade; the hotel lobby fuses its previous life as a jail, retaining its jail bars with modern-day design.

Chef Joseph Margate infuses French influences with locally sourced items from farms and fisheries in the Boston area. (Guests won't forget where they are; original jail bars and granite separate the dining sections, and cells provide cozy dining nooks.) Legendary chef Lydia Shire heads Scampo, where brick-oven pizzas, a house-made mozzarella bar, and an outdoor patio remind guests that sublime food is within, and freedom is mere steps away.

❝ The Liberty is the imaginative transformation of the Charles Street Jail into a luxury property. ❞

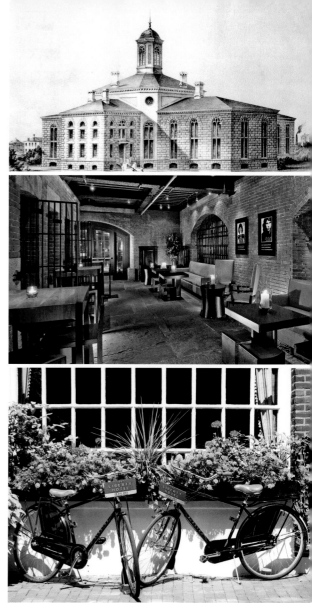

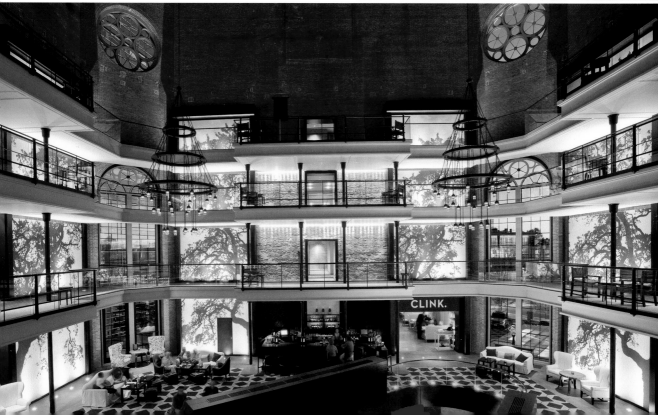

LUGAL
Ankara, Turkey

Following the Lugal's reopening in 2010, this hotel in the bustling Kavaklidere district of Turkey's capital has transformed into the city's most artfully modern hotel. The hotel is located in the contemporary quarter of the city, where hotels, theaters, high-rises, and shopping malls stand alongside government offices, celebrated palaces, and foreign embassies.

World-renowned architect Frank Solano designed the hotel interior, incorporating inviting contemporary décor. Solano turned his focus to the lobby, dining room, and winter garden, injecting a refreshing dose of natural, contemporary elegance, showcasing the hotel's original art by local artists.

In its first few years, the ninety-one-room Lugal has hosted powerful CEOs of *Fortune* 500 companies, the Malaysian Premier, and the Sultan of Brunei. And though this center of Turkish industry sees its share of powerful businesspeople and dignitaries, it is also an important base for exploring. Outside the city, archaeological and natural marvels such as Cappadocia's "Fairy Chimneys" beckon. And after a day of exploring some of the world's most ancient artifacts, the Lugal is a thoroughly modern place to return.

The elegant Solano-designed hotel lobby.

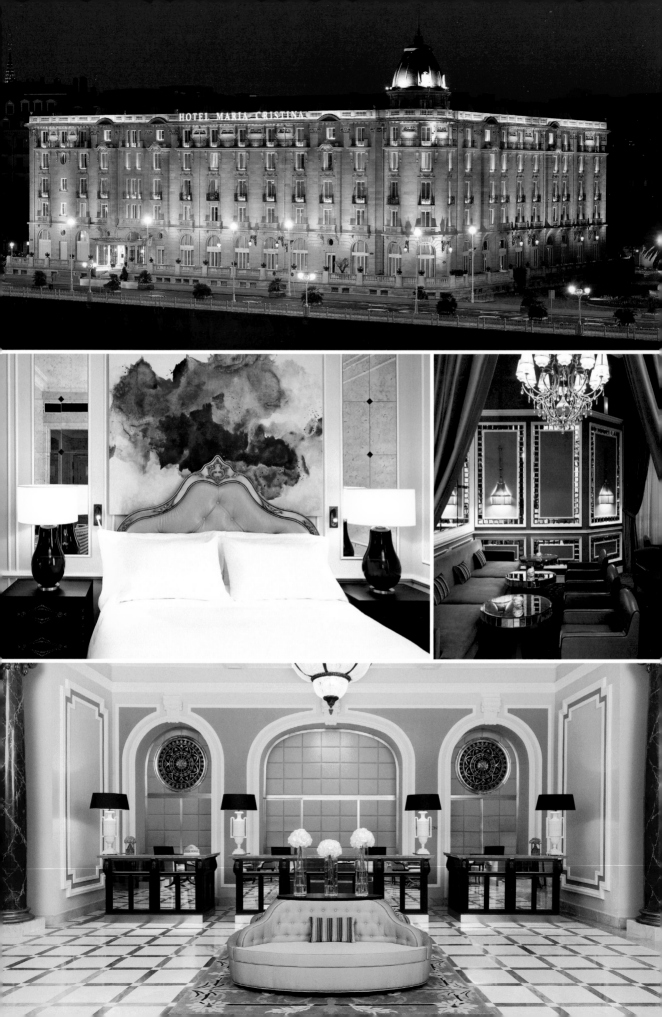

HOTEL MARIA CRISTINA

San Sebastián, Spain

In the spring, the Urumea River is an incredibly bright, clear blue-green color. The biting, salty breeze unique to this corner of the Spanish Basque country blows through the gardens and verandas. The Cantabrian Sea turns a beautiful turquoise hue and makes you want to spend your days on a boat. San Sebastián—"the city," as they used to say—with its beaches, Ondarreta, Zurriola, and La Concha, looks a little like Rio de Janeiro.

Hotel Maria Cristina's setting makes you dream of fantastic journeys, and its interior tells a thousand stories. These stories go back to the nineteenth century, the time of the Belle Époque, when the hotel first opened. Its first guest was Queen Maria Cristina, for one day, in 1912. She used to spend her summers in San Sebastián with her court and gave her name to the hotel. For a hundred years, its luxurious rooms have welcomed the entire world.

In 1953, the hotel gained worldwide recognition when it hosted some of the world's most famous people for the San Sebastián International Film Festival. Guests in its 107 guestrooms included Gregory Peck, Julie Andrews, Robert De Niro, and Sophia Loren, to name a few. Since then, the hotel has undergone major renovations, completing its restoration in 2012. Among the recent changes are a revived bar—where Bette Davis smoked her last cigarette—the installation of Carrara marble floors, and redecorated rooms adorned with art deco

moldings and details. The salons have been redone, displaying a décor fashioned from mahogany, and rosewood marquetry. It still makes you want to wait there for someone, and the ambience of the place still draws people in. *Text by Francisca Mattéoli*

FERRAN ADRIÀ
Chef

NAME A DESTINATION THAT HAS RECENTLY INSPIRED YOU. Peru. Getting to know the culture of this country has been a great inspiration.

ELABORATE ON YOUR EXPERIENCE AT MARIA CRISTINA. Maria Cristina is part of my travel DNA. The Congreso de Cocina de San Sebastian (one of the most influential events of the culinary world) occurred annually there. Maria Cristina was more than just our hotel; it was our home.

FAVORITE PART OF YOUR STAY AT MARIA CRISTINA. My favorite part is the bar where we [the chefs] all meet and have a gin-tonic at the end of the day.

FAVORITE SPANISH DISH? Spanish omelet, lightly cooked.

WHAT THRILLS YOU THE MOST ABOUT SPANISH CULTURE? What excites me most about Spanish culture is how long-standing it is. This has, in turn, made it one of the most important reference points in world history. I also love the lighthearted and cheerful attitude the people have.

Top: This romantic Belle Époque hotel just celebrated its 100th anniversary in 2012; *center, left:* One of the lushly decorated guestrooms; *center, right:* The hotel's exclusive bar, the Dry San Sebastián; *bottom:* The opulent lobby.

HOTEL MARQUÉS DE RISCAL
Elciego, Spain

Deep in the Basque wine country of Elciego in Rioja, a massive curvilinear titanium structure erupted in 2006—a wild statement in an otherwise untouched province, where Herederos del Marqués de Riscal has been making wine since the nineteenth century.

By asking renowned architect Frank Gehry to design its Marqués de Riscal, the winery wanted to create "a whole world of sensations for the enjoyment of wine lovers." But persuading him to put one of his creations in the midst of these sleepy medieval hills was no easy task. The winery's owners took him to the old town, inspired him

with walks through the vineyards, and brought Gehry on an exclusive visit to the "cathedral"— an ancient subterranean vault that stores one of every bottle the winery has produced since 1860. There they opened a bottle of Marqués de Riscal Gran Reserva from 1929—Gehry's birth year—in dramatic fashion, using a special device that severs the neck of the bottle.

The result: a dramatic, swooping structure inspired by the colors of the Reserva bottle —silver, gold, and purple—and in the shape of a vine. The spectacular curves, titanium roof, and asymmetrical walls provide a dramatic contrast to

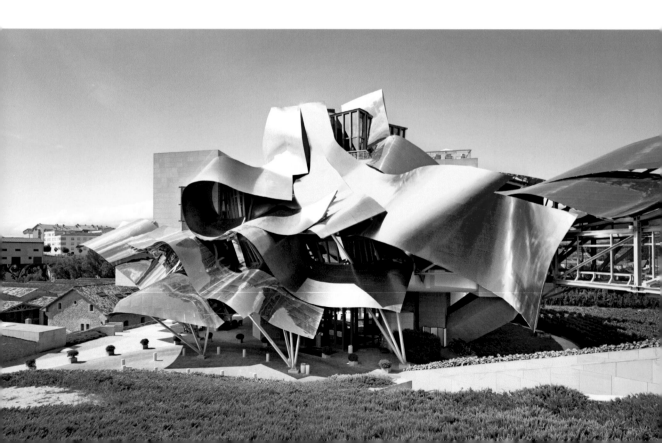

the winery's nineteenth-century cellars. The landmark hotel, Gehry's second masterpiece in Spain (after Bilbao's Guggenheim Museum) is surprisingly intimate—there are only forty-three guestrooms, including eleven suites, all designed by the architect. Clean-lined lofts furnished by the likes of Gehry and Finnish "father of modernism" Alvar Aalto, give way to walls of windows overlooking the village of Elciego, its vineyards, and the dramatic Cantabrian Mountains.

It is here that Marqués de Riscal became the first winery in the Rioja region to produce wine according to traditional Bordeaux methods. It also became the very first to create a new era of Rioja wines, the Barón de Chirel. In Bistro 1860, Francis Paniego fuses the family's Basque-Riojan culinary tradition with avant-garde techniques. In a centuries-old village whose inhabitants still drape sunflowers over thresholds to keep evil spirits away, a vanguard attitude allowed an architectural breakthrough. Wander the prehistoric monuments that dot the landscape and look out to the futuristic silver building; you may swear it has always been here.

> ❝ Architecture should speak of its time and place, but yearn for timelessness. ❞
>
> Frank Gehry

Opposite: The exterior of this one-of-a-kind, dramatic, Gehry-designed hotel. *This page, from top:* Back view of the hotel at night; one of the ancient wine cellars guests can explore in the surrounding wineries; spectacular views of Elciego can be seen from the hotel's acclaimed Bistró 1860.

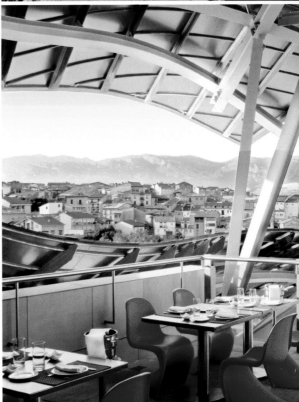

METROPOL PALACE
Belgrade, Serbia

Metropol Palace has been one of Belgrade's most prominent architectural monuments since it was designed by famous Serbian architect Dragiša Brašovan in 1953 and opened four years later. Elegant and modern, featuring 239 beautifully decorated guestrooms and forty apartments, it sits in the very heart of Belgrade, overlooking Tasmajdan Park, a uniquely tranquil base for a visit to the fast-paced city.

The hotel is perfectly situated, positioned in the old part of Belgrade, near Parliament and St. Mark's Church, and within walking distance of the great pedestrian district of Knez Mihailova Street.

But Metropol is perhaps most famous for its guests. It was the favorite of Yugoslav revolutionary and statesman Josip Broz Tito (better known simply as Tito), who entertained all of his elite guests, including Elizabeth Taylor and Che Guevara, in its modern, stylish surroundings. One need only look at the hotel's proudly displayed photos of its famous clientele to understand the role the hotel has played throughout history, from Igor Stravinsky to Jack Nicholson and Neil Armstrong.

Redesigned in 2012, Metropol Palace now intertwines its dazzling history with modern details and advanced technology, summoning and refining its distinctive midcentury modern roots.

Plush couches, royal colors, a warm ambience, and wide open space make the hotel lobby the perfect place for guests to lounge.

93

MYSTIQUE

Santorini, Greece

The location of Mystique alone, atop the famous cliffs of Oia, is enough to make it a showstopper. Dramatic white walls and traditional architecture overlooking cerulean blue waters and that famous caldera—this is the Santorini of travelers' imaginations.

But Mystique today is the product of a deep respect for the traditional architecture that inspired the original building's creation in 1987 (it was among the first hotels of Oia) and subtle changes that, in 2006, brought it into a more natural harmony with the land and today's travel aesthetic. Mystique's designers kept the exterior face of this dramatic landscape, changing its color from a stark white to creamy beige, eliminating sharp edges and giving the building a more organic, sculptural feel. Ceilings were raised, and the twenty-two bedrooms, all made from driftwood, a natural and simple material, were positioned to take full advantage of the sea view. Mystique's interiors are nothing less than effervescent, where nature-inspired design meets modern technology.

Experiencing Mystique, with its elemental design, is a seamless blend of old and new. At Charisma Restaurant, guests take convivial meals

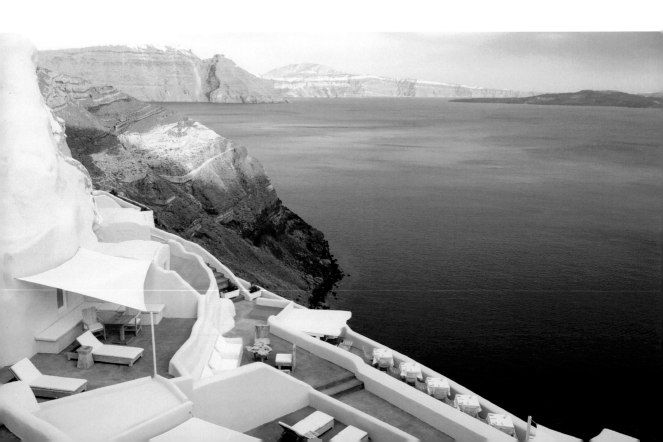

of cheese and meat from Epirus, vegetables from Crete, and fish from just below these cliffs, overlooking the crater and endless water. Atop its high perch, looking over dramatic black beaches, Mystique creates as beautifully simple an experience of Santorini as one might have had in the same place, millennia ago.

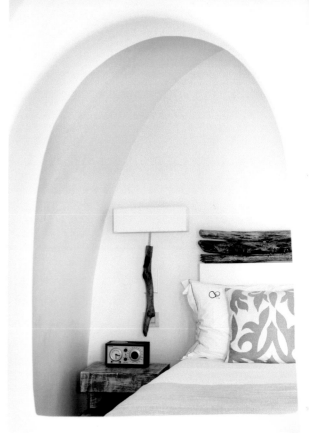

SUSAN SARANDON & EVA AMURRI
Actresses

WHAT IS YOUR MOST MEMORABLE TRAVEL EXPERIENCE? One of our most magical family trips was to Bali. We spent six amazing weeks there and were absolutely taken with the lush landscape, the people, the culture, and the food. We even considered moving there! My mom and I also love to travel together and went on a fabulous African safari that was a huge highlight.

ELABORATE ON YOUR EXPERIENCES AT MYSTIQUE. The hotel is elegant and tranquil with stunning views of the ocean, especially during the famous Santorini sunsets. The crisp, clean color palette is wonderfully Greek and plays up the timeless elegance of a Santorini vacation.

NO ONE SHOULD VISIT SANTORINI WITHOUT ... Riding up the hillside on a donkey!

WHAT THRILLS YOU THE MOST ABOUT GREEK CULTURE? The preservation all around of its rich history, and the enthusiasm for good food and drink. It is a very celebratory culture.

Opposite: The idyllic view of the Aegean Sea from the cliffside hotel terraces. *This page, from top:* The bedroom in one of the beautifully decorated Allure Suites, designed by French interior designer Frank Lefebvre; one of the many stark white churches that pepper the cliffs of Santorini; the ideal spot for sunbathing and taking in the stunning views of the island.

THE NAKA ISLAND

Phuket, Thailand

In the Andaman Sea, between the east coast of jewel-like Phuket Island and Phang Nga Bay, stunning limestone formations jut from the bay, framing the horizon and surrounding islands. Here, sixty-seven private villas and tropical gardens pepper the lush landscape, every view within the resort a perfectly framed vista.

In fact, The Naka Island resort was built to showcase the spectacular natural environment and the culture of the island. Ponds separated by steppingstones lead to natural wood villas with open-air baths. An infinity pool cascades into a pond on the beach. Even the arrival process is thoughtful, considered, and the resort itself feels special: Guests must catch a speedboat, zipping through those famous emerald green waters, to reach their exclusive destination.

Of course, though this feels like a paradisiacal wilderness, the spare, organic details of The Naka Island belie the high technology within. Every conceivable amenity lies beneath those rustic thatched roofs, and a sophisticated conservation program is at work, maintaining the resources of this magical bay. An on-site crystal water purification and bottling plant make it self-sufficient; an organic herb garden feeds

The Naka Island resort is hidden away by the lush greenery on the beautiful and private Naka Yai Island, in Phuket.

its restaurants and provides beautifully fresh ingredients to Spa Naka.

Being marooned on this island presents the opportunity to connect with the land and the culture. Kayaking around allows guests to visit private beaches, only accessible by boat. Cycling brings them to the fishing village to experience the local way of life. Thai cooking classes allow guests to learn about indigenous ingredients from the resort's chefs. And Muay Thai (Thai kickboxing) classes bring another facet of the culture to life. Here, far from even exclusive Phuket Island's crowds, guests can take a private dinner on the beach, marveling at the serenity and authenticity one can still find on a little island.

> **" Being marooned on this island presents the opportunity to connect with the land and the culture. "**

This page: The gated 1,600-square-meter Royal Horizon Pool Villa has an infinity pool that is only accessible to guests. *Opposite:* Inspired by its natural surroundings, even the driveway is private and verdant.

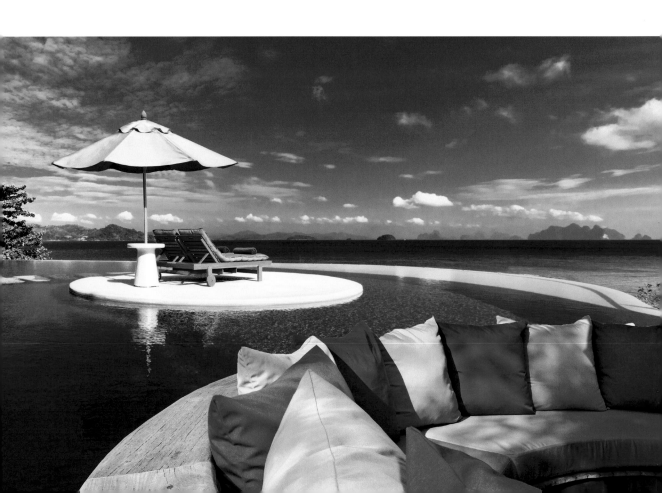

HOTEL NATIONAL

Moscow, Russia

In 1903, the first guests stepped through the door of the Hotel National in Moscow. They entered a splendid lobby created in the Renaissance style by the famous architect Alexander Ivanov and saw for the first time the majestic staircase, the glasswork, the marble, and the mosaics that are still there today. Perhaps the first traveler set his suitcase down in one of the rooms that looks out over the Kremlin and made an admiring remark.

In photographs from that time, we see people coming and going on Tverskaya Street, and cars circulating in front of the grand, magnificently worked entrance. Imagine Moscow at that time, the ferment of the start of the twentieth century, the arrival of Art Nouveau, artists such as Kandinsky, and the mythical Trans-Siberian railroad that would soon cross Russia and make the adventurers of the world dream. The National is a journey in itself and has seen everything from the October Revolution to the first Soviet government to the tumultuous events and bleak years that followed. Imagination need only follow the evolution of its décor, from the art deco design to the old furnishings, draperies, and light fixtures. It is easy to envision Leo Tolstoy in the presidential suite, the czars discussing their destiny in the subdued salons, artists and aristocrats

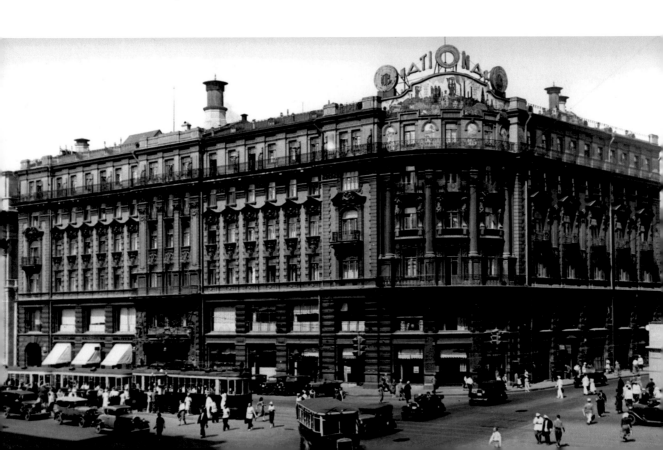

entering the same rooms with their dreams and their hopes, and Lenin addressing the crowd from the balcony of Suite 107. The hotel has been renovated since then, but its typically Russian ambience has been preserved. Today, it has a pool, a beauty salon, 202 spacious guestrooms, four restaurants, and every modern luxury, but it remains a magnificent historical showcase, an integral part of the city and of the unbelievable events that it has witnessed.

Text by Francisca Mattéoli

EMILY MORTIMER
Actress

WHAT IS YOUR MOST MEMORABLE TRAVEL EXPERIENCE? My father, who was practically blind and the worst driver ever (he was given a license without having to take a driving test during the war), driving a minivan round hairpin bends in the Swiss Alps. Children were screaming, grown men were crying, and strong women were vomiting.

ELABORATE ON YOUR EXPERIENCE AT THE HOTEL NATIONAL: I am a Russophile. I studied Russian at university and spent the most formative year of my life as an 18-year-old student in Moscow. It was 1990—the year the Berlin Wall came down. It was my coming-of-age and Russia's coming-of-age and a time I will never forget. I had been dying to show my husband Moscow ever since we first got together. I finally took him there for New Year's Eve 2010, and we stayed at The National.

WHAT ARE YOUR FAVORITE LANDMARKS OR ATTRACTIONS IN MOSCOW? I love the Patriarch's Ponds (where the first chapter of Bulgakov's *The Master and Margarita* takes place), the Moscow Arts Theatre (a beautiful Deco building where Stanislavsky put on all of Chekhov's plays), the Mayakovskaya underground station, Gorky Park, Tretyakov Gallery, and the Writer's Union, the best place for dinner.

Opposite: Hotel National, 1930. *This page, from top:* The living room of the luxurious three-room Presidential Suite; Vladimir Lenin in Moscow, 1919; the hotel entrance in 1910.

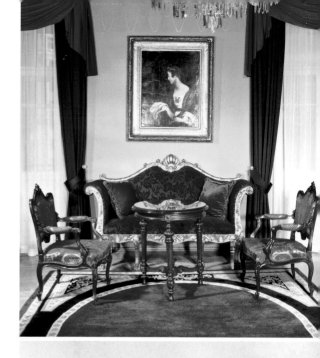

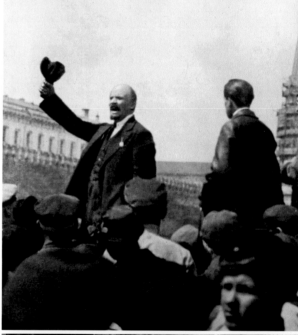

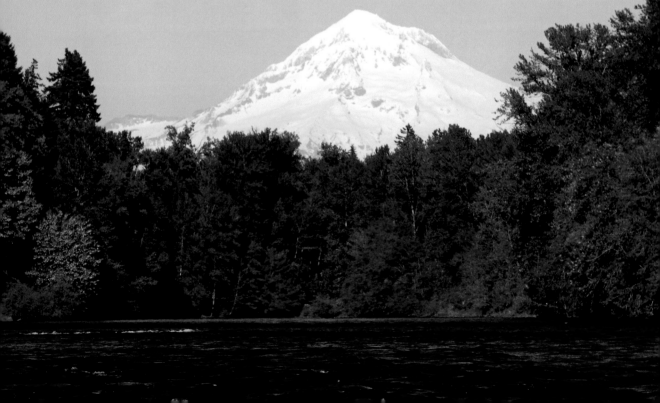

THE NINES

Portland, Oregon, USA

The historic Meier & Frank department store was once one of the largest retail outlets west of the Mississippi. Now lovingly restored and on the National Register of Historic places, it hosts—on its top nine stories—The Nines.

One might say that the style of the hotel is "nostalgic modern." It incorporates elements from the worlds of art and fashion, and makes eclectic nods to the building's retail past sprinkled throughout the hotel, in sculptures, paintings, and installations from local Portland artists. SERA Architects, who revitalized the landmark in the epicenter of the city's retail corridor in Pioneer Square, practiced their specialty—blending urban revitalization and sustainable design. Not only did they restore the elegance of the striking 1909 structure, which is flocked in glazed terracotta, but they also designed it using LEED Silver certification standards. Luxury design firm ForrestPerkins then transformed the top nine stories into The Nines.

Perhaps the most delicate balance the architects and designers had to strike was relaying the historic charm of The Nines while carrying its design far into the future. After all, this iconic monument featured the first escalator in Portland, and in 1922 also functioned as the studio for Meier & Frank's very own radio station. At its peak, the building housed everything from a pharmacy to a pet store to a deli. Clark Gable sold ties in the men's department in the 1920s, less than a decade before meeting fame and fortune as an actor.

Designers had to consider a creative approach that took into account the fact that the building was constructed in three different eras. Now, beneath a soaring seven-story-high grand atrium, the lobby is thoughtfully arranged, from the deep espresso-colored hardwood floors to the gold foil–like walls and glass ceiling. Rich, jewel-toned contemporary furniture fills the atrium, with its sheer-draped glass gazebos streaming with natural light.

Corridors to the 331 guestrooms have crystal chandelier–clad rotundas in a distinctive shade of Tiffany blue, so that one seems for a moment to be standing inside a hat box. Behind each ten-panel espresso-stained door, a foyer beckons the guest into a dramatic environment with a tall, grand-scale tufted ivory leather headboard. The sinuous lines of mercury glass lamps are reminiscent of mannequins; even the nightstand's drawer knob suggests an elegant silver bracelet. The ivory-colored satin draperies offer a background for the elegant recamier upholstered in Tiffany-blue velvet and augmented with a traditional side chair and crystal pendant light. A beautiful bonus to all this luxury: the hotel gets 100 percent of its energy from renewable sources and saves more than a half million gallons of water each year. Renewed and sustainable, The Nines celebrates its past as a timeless landmark in Portland's downtown culture.

Clockwise from top right: Dine, shop, and wander around the nearby renowned Pearl District in downtown Portland; take a day trip to the Cascade Volcanic Arc in northern Oregon; the modern and sophisticated lobby, designed by ForrestPerkins.

PALACE HOTEL

San Francisco, California, USA

In April 1906, San Francisco experienced one of the worst earthquakes ever. The Palace Hotel survived the catastrophe but was destroyed in an afternoon by the fire that followed in its wake and ravaged the city for three days. As if trying to ward off ill fortune, it was decided that the hotel should be rebuilt as soon as possible and be made a showplace able to rival the most illustrious palaces in Europe.

In 1909, the Palace Hotel, with its 553 guestrooms, reopened its doors on the same site as the original building. The painter Maxfield Parrish, who would go on to work for such prestigious magazines as *Collier's* and *Life,* was asked to paint a monumental mural on the wall of the Pied Piper Bar. There was a telephone in every room, the dining room was embellished with a sublime stained-glass dome that let in light, and one of the main attractions was the orchestra that played in the Palm Court during afternoon tea.

The new suites were the height of luxury at the time. Soon the hotel became the meeting place for San Francisco's high society. Year after year, the hotel endured the many historical events that America would subsequently go through—the War, jazz, Prohibition, and the birth of aviation with Charles Lindbergh, who was given a hero's welcome at a banquet in the Garden Court. Renovations would bring the hotel into a new era and make it what it is today. Sophisticated, with many awards for its décor, food, and history, the Palace was recognized as an official San Francisco landmark, listed with the National Trust and the California Preservation Foundation to name just two. The Palace Hotel is a fantastic blend of history and legend that truly makes the place come alive. *Text by Francisca Mattéoli*

LILY KWONG
Model

WHAT IS YOUR MOST MEMORABLE TRAVEL EXPERIENCE? Visiting my grandmother's childhood home on the Bund in Shanghai for the first time. I went to China for a shoot with Louis Vuitton and *Vogue* Australia and had one day to wander the city on my own. It was easily one of the most moving travel experiences of my life!

WHAT ARE YOUR MEMORIES OF/EXPERIENCES REGARDING THE PALACE HOTEL, AS SOMEONE WHO GREW UP IN SAN FRANCISCO? The Palace was always synonymous with old luxury: the chandeliers, the marble columns, the stained glass ceiling. Growing up in San Francisco, it was always a place that marked a celebration, an achievement, or a special occasion. It gave us something to aspire to.

NO ONE SHOULD VISIT SAN FRANCISCO WITHOUT… Eating your way through the Mission District, starting with croissants at Tartine, pizza at Delfina, and ice cream sandwiches at Bi-Rite Creamery.

WHY IS SAN FRANCISCO SPECIAL TO YOU? It gave me the best childhood I could have asked for. San Francisco taught me about empathy, gratitude, and creativity. It deeply informed who I am today, and it is where my heart still remains!

Originally the carriage entrance, after the renovations, the space was transformed into the landmark Garden Court restaurant. Its high glass-dome ceiling and beautiful décor make this a very special place to dine.

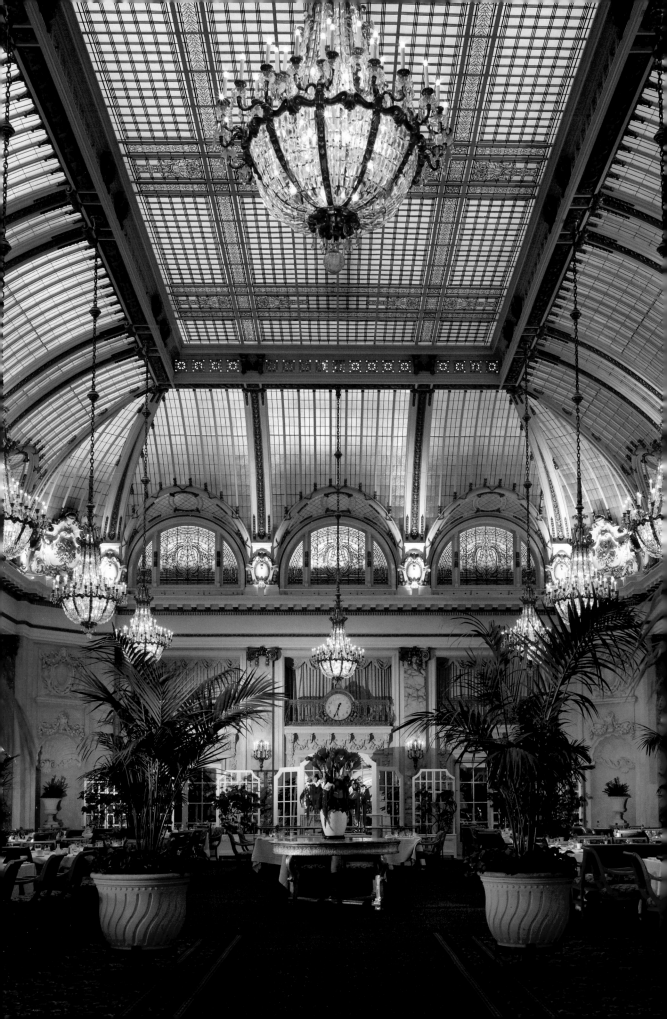

HOTEL PARACAS

Paracas, Peru

On Peru's central coast, a stunning new hotel looks, from above, like an ancient pre-Incan Paracas mantle, one of the graphic textiles this part of the country is known for. Here, in an area well-known as a starting point for flights over the mysterious Nazca Lines, the hotel pays homage to its ancient heritage with a bird and "mommy" image—mystical pictures from the sky.

This symbolism, however, is where the ancient references end. One of the most luxurious hotels in Peru, Hotel Paracas is a high-technology haven that also integrates beautifully with the nearby nature reserve, where the Paracas culture flourished for centuries. With a spalike atmosphere of clean lines and bamboo furniture, the 120 rooms are meant to be open to coastal breezes from multiple terraces.

As with any rarefied hideaway, it takes some effort to reach this place. A three-hour drive or forty-five-minute flight from Lima, Paracas is a natural gateway to the Ballestas Islands, famous for their sea lions, flamingos, dolphins, and penguins; and a haven for Nazca Lines enthusiasts, who may arrange a private jet trip through the hotel, or even a simple fishing trip to the nearly untouched Chincha Island. Its removed elegance attracts privacy seekers from Kate Moss and Mario Testino to Mario

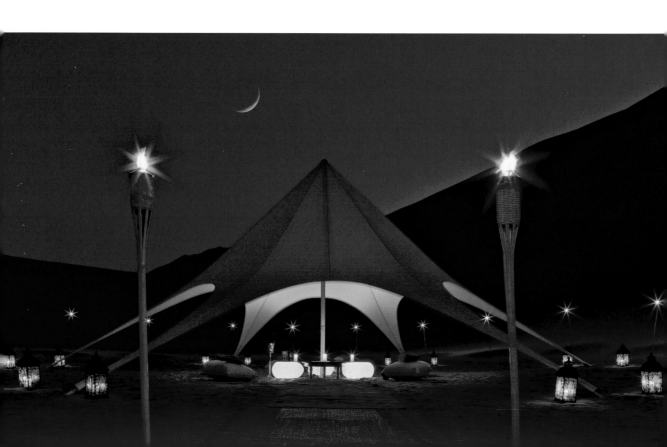

Vargas Liosa. But don't expect quiet on New Year's Eve, when Hotel Paracas becomes one of the most legendary party spots in Peru.

And though this 2009 hotel is a paragon of spare, new luxury, it nods to a not-so-distant past. It follows in the footsteps of the first Hotel Paracas, a 1943 institution and, at the time, the only hotel on the coast of Peru. For this reason, the most important Peruvians came to spend the summer, their vacations, and their holidays there. Even a damaging earthquake in 2007 couldn't dampen the country's ardor for the location or the hotel. Since being rebuilt, the sleek new property still attracts children, grandchildren, and great-grandchildren of the first guests of the Hotel Paracas. They are still coming here, asking for their same rooms and taking a bottle of pisco in Zarcillo Bar.

Opposite: Set up a romantic, delectable nighttime picnic on the desert sand. *This page, from top:* The Paracas Natural Reserve is home to an exotic mix of birds such as flamingos and Humboldt penguins; sip a pisco sour, the renowned local cocktail, by the pool in the exclusive Bar Lounge.

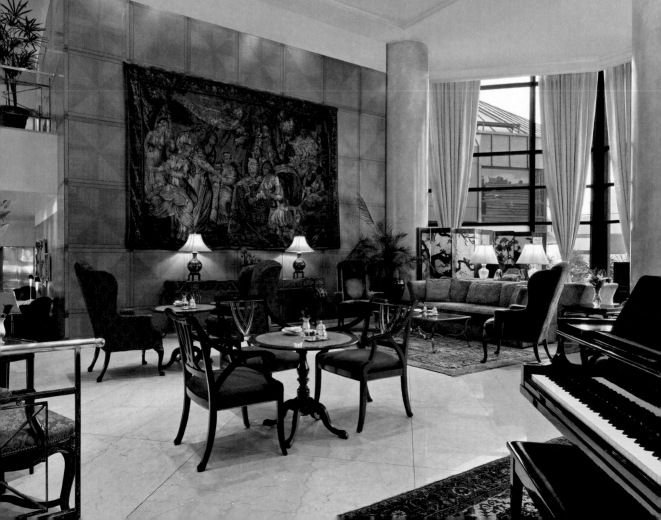

PARK TOWER

Buenos Aires, Argentina

Since its opening in 1996, Park Tower has been a strikingly modern landmark in Buenos Aires, above Plaza San Martín and in front of the city's iconic "Torre de los Ingleses" (Buenos Aires's answer to Big Ben). From the top of the twenty-three-story tower, you can see over the Río de la Plata, get bird's-eye views of Retiro and Puerto Madero, and even see as far as Uruguay on a clear day.

Park Tower has established itself as an icon, and a renovation has renewed its power as a destination address. In The Lobby Lounge you will find an original seventeenth-century treasure: a French tapestry depicting Alexander the Great paying homage to the mother of Darius, the king of Persia. Here, lit by an abundance of natural light and accompanied by the peaceful strumming of a live harpist, the space is transformed from hotel to oasis. A fragrance unique to the hotel perfumes the lobby—the aroma of sandalwood with Bulgarian roses and tangerines—soothing and exotic. Adding to the ambience are 181 Biedermeier- and antique-filled rooms (including the outsized Presidential Suite). The hotel sourced its furniture from the San Telmo antiquaries, who purchased the pieces from notable European families.

Park Tower has become something of a home-away-from-home for celebrities visiting Buenos Aires. The celebrity roster goes on and on: Bill and Hillary Clinton, Brad Pitt, Cindy Crawford, Claudia Schiffer, Gloria Estefan, Plácido Domingo, Prince Albert of Monaco, Vittorio Gassman, Geraldine Chaplin, Luciano Pavarotti, José Carreras, and Pelé have all enjoyed the unparalleled hospitality, personal butlers, and general excellence of Park Tower. King Mohammed VI of Morocco redesigned the Presidential Suite for a time with his own furniture. It is the fusion of prompt service, top-of-the-line technology, and classic luxury that has guests feeling less like guests and more like residents of their own Buenos Aires address.

> **"The lobby is transformed from hotel to oasis."**

Top: Downtown Buenos Aires; *bottom:* The Lobby Lounge, with the seventeenth-century tapestry of Alexander the Great in the background.

109

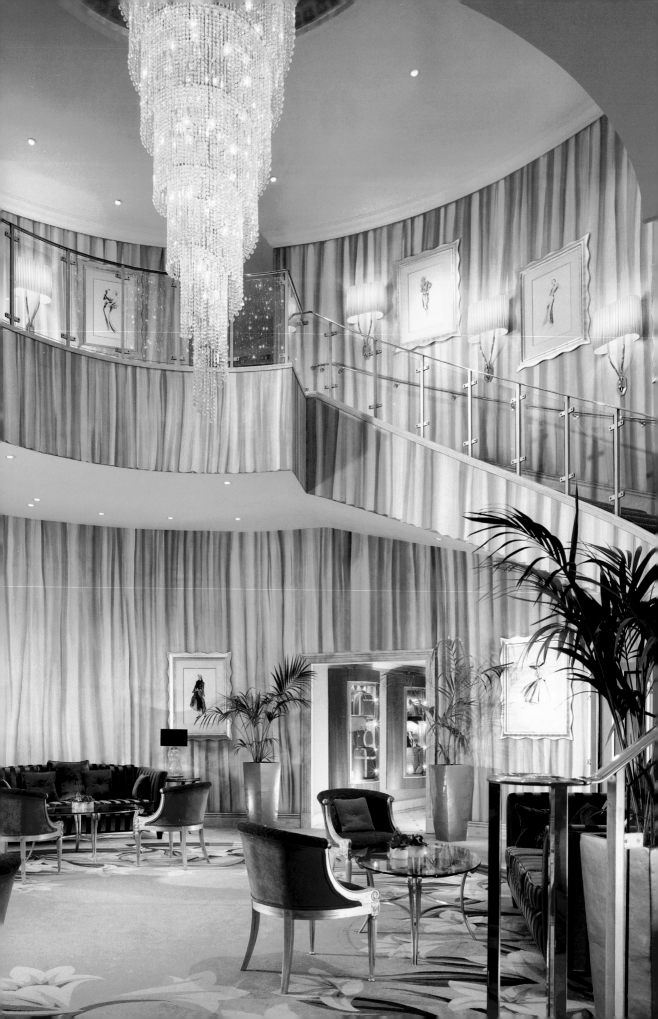

THE PARK TOWER KNIGHTSBRIDGE

London, England

To Londoners, the circular shape of The Park Tower Knightsbridge is a part of their city's architectural DNA. After all, its architect, Richard Robin Seifert, shaped 1960s and 1970s London in much the same way Norman Foster would in 1980s London and beyond. Guests experience an important era in the city's architecture from the inside out, with 360-degree views of London's skyline from the highest floors.

The 280-guestroom hotel stands elegantly among the historic streets of Knightsbridge—one of London's most stylish districts. From their eagle's nest of panoramic windows, guests can imagine the neighborhood from its Saxon days. Here, the hamlets of Chelsea, Kensington, and Charing were separated from London by a bridge that crossed the River Westbourne. A band of knights, on their way to fight in the Holy Land, traversed the bridge when two in the group fell into a quarrel. The ensuing duel cost both knights their lives, and the bridge was named Knightsbridge in honor of their untimely deaths.

Modern Knightsbridge is now the city's most coveted address; a vibrant mix of luxurious shopping, graceful living, and fabulous dining attracts visitors from around the world. From here, it is an easy stroll to shopping the streets of Knightsbridge, discovering the hidden boutiques and restaurants of neighboring Belgravia, or taking a Sunday stroll in London's Hyde Park.

Back inside, The Park Tower Knightsbridge offers a respite from buzzing London streets. Its dinner options include One-O-One Restaurant, the most acclaimed fish restaurant in the city. Personal butlers act as concierges and personal assistants, planning itineraries and unpacking clothing. As the day closes, there is no better view than that from a deep marble soaking tub, looking across to monuments like Big Ben and St. Paul's Cathedral from another of London's icons.

> **66** The circular shape of The Park Tower Knightsbridge is a part of this city's architectural DNA. **99**

The regal Knightsbridge Lounge is adorned with gilded chairs and an eighteen-foot teardrop glass chandelier, the centerpiece of this circular space.

THE PHOENICIAN
Scottsdale, Arizona, USA

A tribute to the opulence of the European grand hotel, The Phoenician combines nearly every lavish material and concept from Europe's grandes dames into one property, while still feeling inextricably grounded in the elegant austerity of its Southwestern heritage. The hotel was conceived by legendary developer and financier Charles Keating, Jr., and designing the property presented an excellent opportunity for him to take his wife, Mary Elaine Keating, on a whirlwind research tour, gathering inspiration and materials from the best hotels in Europe. In came white marble from Carrara, designers to etch the ceilings in 24-karat gold, eleven Steinway pianos for the presidential suites, and a troop of workers from the island kingdom of Tonga to create a lush tropical paradise (despite the desert conditions). To give guests the sense they were staying in a historic property, the Keatings built an exact replica of a vaulted, Renaissance-era wine cellar they had visited. Named after a nearby rock formation, the Praying Monk salon showcases antiques, artifacts, and furnishings amid rich tapestries, as well as the talents of Arizona's first master sommelier, Greg Tresner.

Dazzling imports aside, The Phoenician

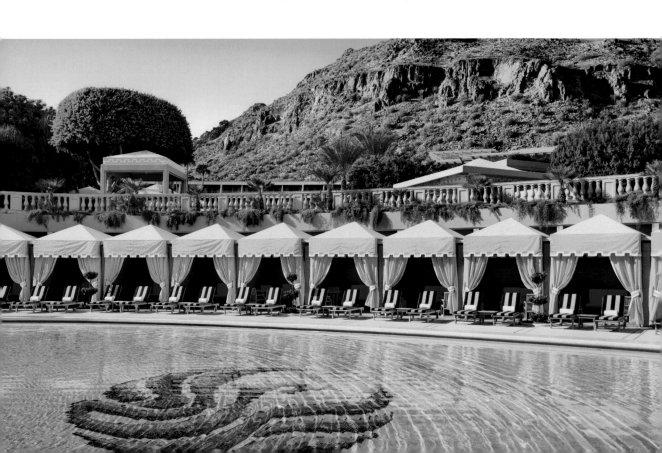

ultimately belongs to the land that inspired the Keatings to build it. It sits at the base of dramatic Camelback Mountain, combining all its rich European design elements with the spare elegance of the Sonoran Desert landscape. Inside its entrance, the 1920s adobe Jokake Inn, with its iconic twin bell towers, stands guard as a reminder of historic Southwestern hospitality. A stunning $25 million art collection—including sculptures by Native American artist Allan Houser, the first Native American to receive the National Medal of Arts—threads through the property. The 250-acre grounds hold some spots sacred to the land, such as a cactus garden devoted to 250 species. And perhaps best known to golfers, its three famed Troon courses offer pristine desert views, and the property consistently ranks high among America's top golf resorts.

Somehow, this diverse collection of cultures in the Sonoran Desert is no mishmash, but rather the ultimate fusion of disparate cultures. This is why guests of the 643-room hotel may take in a tour that includes the property's rich seventeenth-century European tapestry and its Native American collection, feeding koi at Necklace Lake Lagoon, indulging in a guided personal meditation session, dining alfresco in southern European elegance at Il Terrazzo, and winding down next to a fire pit looking over the desert landscape. No element here is out of place.

Opposite: One of the nine pools at the resort is the relaxation pool, which is hand-tiled in mother of pearl. *This page, from top:* Guests can arrange for a guided tour of the resort's two-acre Cactus Garden, where 250 varieties of cacti can be found; the historic Jokake Inn, positioned at the entrance to the resort, welcomes guests upon arrival, symbolizing the epitome of Southwestern hospitality; the lobby combines the richness of traditional European elements, such as the marble fountain, with classic Southwestern style.

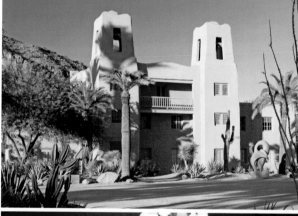

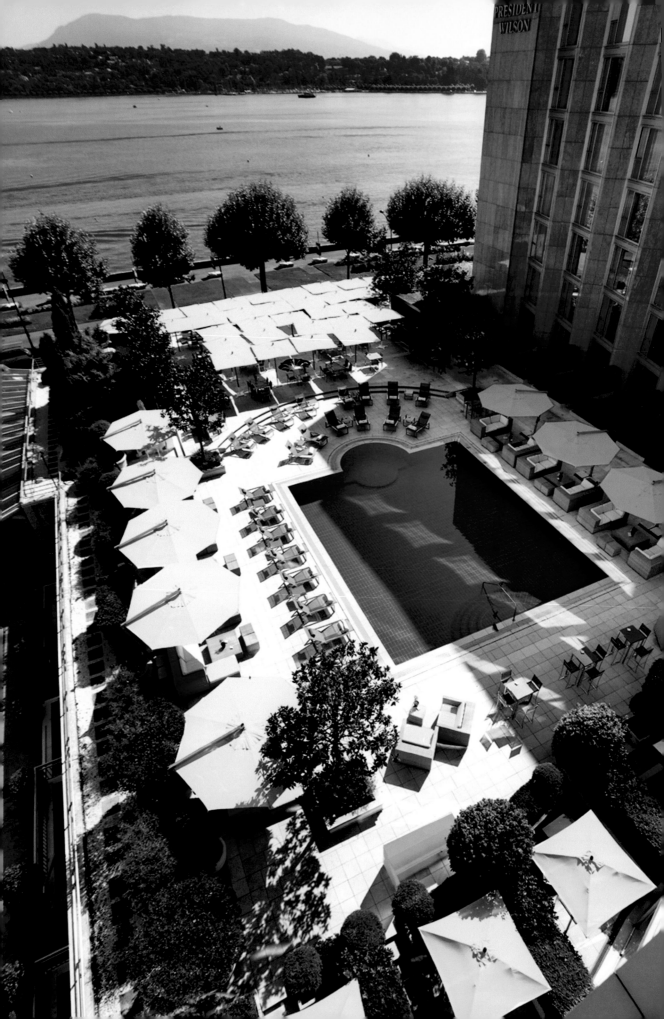

HOTEL PRESIDENT WILSON

Geneva, Switzerland

When this contemporary marvel opened in Geneva, it quickly became a city icon. Its incomparable location near Geneva's lakefront helped. Just steps from the city's most beautiful parks and close to its most important international organizations, the hotel's centrality has always been a major draw.

And while that prime location will never change, the hotel continues to strive to keep pace with the luxury demands of Geneva. Geneva is a city of more than fifty private and public museums and the epicenter of luxury timepiece making. Opened in 1963, the hotel was reopened in 1996 as the "new" President Wilson, continuing its homage to Woodrow Wilson, the 28th president of the United States, a founder and relentless defender of the League of Nations. The neighboring building, the nineteenth-century Hotel National, had been renamed Palais Wilson in 1924,

the year Wilson died, and it housed the League of Nations until 1936, when the headquarters moved to the Place of Nations.

The hotel's most recent overhaul, including renovation of its 228 guestrooms, was accompanied by instating a program to refurbish its public spaces, one that eventually gave the hotel a new image that is exceptional, original, and contemporary. The concept at work is balancing three main themes: water, the surrounding landscape, and light. In today's President Wilson, guests will find water everywhere in their immediate environment: a dramatic ceiling is shaped like a drop of water and is covered in white-gold leaf; a work by Korean artist Jae-Hyo Lee calls to mind an object falling on a sheet of water; and a stylized wave ceiling covered in white lacquer reflects the changing mood of the nearby lake, with its varied colors and changing light.

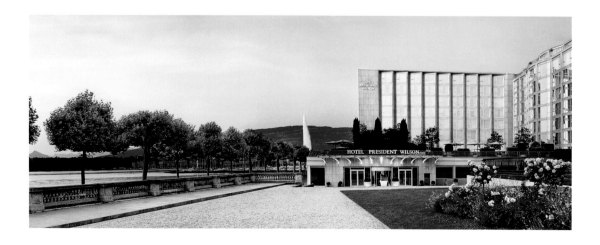

Opposite: The outdoor saltwater pool offers unobstructed views of Lake Geneva. *This page:* The beautifully manicured renovated grounds of the hotel.

EUROPE

PRINCE DE GALLES

Paris, France

In the late 1920s, a piece of land at the crossroads of scenic Avenue de l'Alma (now Avenue George V) and Avenue Pierre 1er de Serbie was put up for sale by the Paris city hall. Two businessmen fought over the purchase, each planning a luxury hotel named Hotel de l'Alma. Unable to reach an agreement, the two split the plot: Parisian businessman François Dupré developed the George V Hotel, and André Million, president of the Grand Hotel and the Meurice, built the Prince de Galles. And so, a bit of Parisian hotel history was born.

Constructed on the Chaillot quarries, from which the stones were extracted for the Arc de Triomphe, the Prince de Galles was built by architect Andre-Louis Arfvidson, a pioneer of the Modern Movement. Inspired by the Decorative Arts exhibition of 1925, he created a classical yet modern façade and a magnificent mosaic patio.

French and international luminaries were keen to experience the grand opening, and they eventually became regular guests. The Prince de Galles hosted Sir Winston Churchill, Lord Chamberlain, Marlene Dietrich, and the king of Yugoslavia from its privileged position in the Golden Triangle by the Champs-Elysées. But the hotel gained renown in the 1960s as the favorite hotel of another king—Elvis Presley. It was his favorite place to stay during his Parisian getaways until his death in 1977. Since then, new generations

COCO ROCHA
Model

WHAT INSIGHTS HAVE YOU GAINED FROM TRAVELING? Traveling extensively as a little girl was great preparation for modeling. I learned to deal with and even enjoy different languages, cuisines, and cultures from an early age. Plus I became an expert at finding my way around airports and new cities! Traveling opened my mind to different people and experiences, which has only continued as I model internationally.

ONE THING PEOPLE DO NOT KNOW ABOUT THE PRINCE DE GALLES HOTEL, PARIS. The Prince de Galles Hotel in Paris is like something out of a dream. Just walking through the lobby makes you feel like French royalty; every luxury is at your fingertips. The location could not be better: the Champs-Élysées is just outside and you are a stone's throw from the Arc de Triomphe! The hotel preserves the best of old-world style and charm while at the same time giving me all the modern conveniences I want for my stay. The courtyard is an especially peaceful and beautiful space to relax and have a drink in.

WHAT ARE YOUR FAVORITE LANDMARKS OR ATTRACTIONS IN PARIS? I love Paris. Though I have never lived there full time, I have spent a good part of my modeling career in the city, and I always feel so refreshed when I am there. Generally when I'm in Paris I walk everywhere or I rent a bike. Notre Dame is an amazing landmark that I never tire of. It's truly a work of art. I also like to roam around the Louvre and pretend like I am uncovering some grand mystery—*Da Vinci Code*-style.

From top: Guests can enjoy a traditional Parisian breakfast outside in the hotel's private courtyard; the hotel is centrally located in the heart of the unparalleled city of Paris and steps away from some of the world's most famous sites, including none other than the Eiffel Tower; Elvis Presley outside the Prince de Galles, circa 1960.

of stars have fallen in love with the hotel, from Kirk Douglas to Élie Chouraqui, and even Michael Jackson, who stayed many times.

Now the hotel is ushering in a return to its original glamour, thanks to an extensive two-year restoration. The new Prince de Galles reopens its doors this year to show off its 159 guestrooms and 44 lavish suites designed by Pierre-Yves Rochon, including a new Royal Duplex Suite with a private terrace and panoramic views over the City of Light. The restoration reinstates the special services and delights that made this 1920s landmark a Paris icon, overlaying its beautiful Art Deco bones with modern comforts. And with the help of designer Bruno Borrione, an exceptional dining experience is reborn, the beautiful mosaic patio once again the centerpiece of this treasured Parisian hotel.

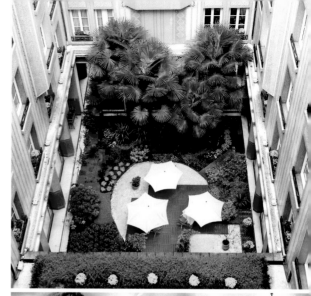

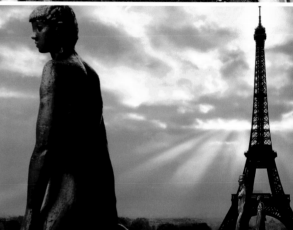

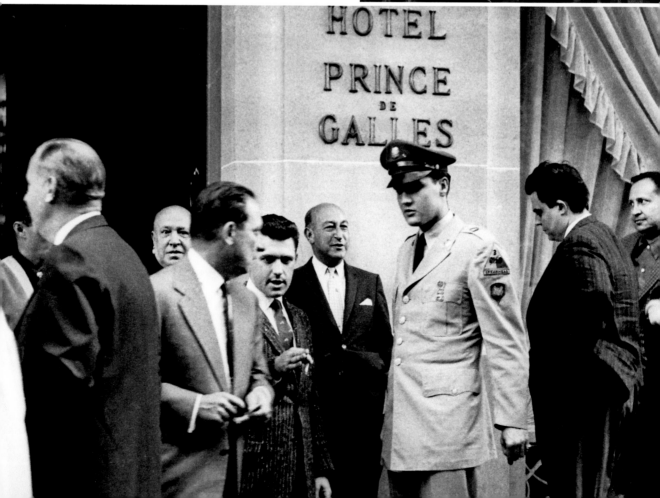

HOTEL PULITZER

Amsterdam, The Netherlands

A row of twenty-five beautiful seventeenth- and eighteenth-century row houses lines the Prinsengracht and Keizersgracht canals in Amsterdam's old center. To see them today—each with its own precious details and characteristics—one might never believe that they were a sad, dilapidated sight when they were rescued from almost certain destruction in the 1960s.

It was Peter Pulitzer, a visionary businessman and grandchild of the renowned Joseph Pulitzer, who saw the unique potential of the old canal houses. Around 1960, he bought them, gradually restoring them from twelve houses to the luxury accommodations spread among the twenty-five row houses they are today.

But it was not just the spectacular details of these centuries-old homes Pulitzer revived; he restored a bit of a way of life along this stretch of the canal. In the heart of the hotel, a secret garden reveals an elegant terrace, connecting a serene tea house, the Tuinzaal banquet hall, and an outdoor restaurant where chefs grill in the open air, just as they might have done generations ago. Outside the Prinsengracht houses, once a series of warehouses and shops, guests can catch the annual Prinsengracht concert, where artists

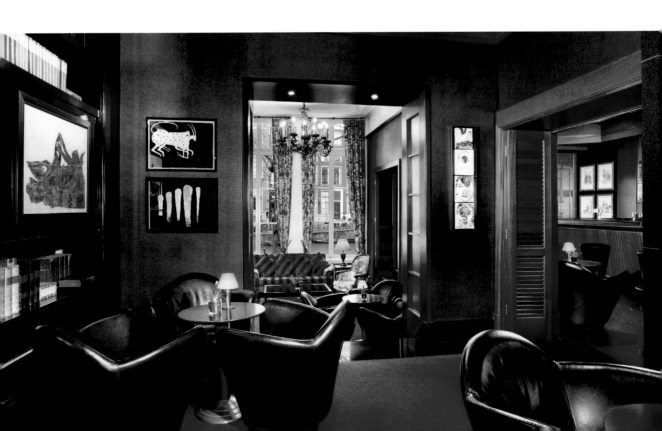

play on a pontoon in the canal in front of the hotel. These days, fifteen thousand spectators stand on the canal side, hang out of their house windows, or sit on their boats to hear the classical music wafting through the air.

Should prospective guests want a sneak preview of the 230-guestroom hotel, they may find it in Hotel Pulitzer's Hollywood debut: it starred in *Ocean's Twelve,* hosting one hundred cast and crew, including George Clooney, Brad Pitt, Matt Damon, and Catherine Zeta-Jones.

It is inside this treasure trove of historic rooms that the hotel's greatest gems lie. Guests will find, for example, "The Saxenburg" mantelpiece, built around 1750 in Louis XV style, depicting a love scene between Heracles and Deianira, and now ensconced in the imposing Saxenburg House. At one point the mantelpiece mysteriously disappeared, but it somehow reappeared in paintings of the original room, prompting restorers to make a replica of the opulent mantel during the reconstruction. The real thing was found in a bank in The Hague; knowing that they held a national treasure, the bank sold the mantelpiece back to its rightful home.

> 66 It is inside this treasure trove of historic rooms that the hotel's greatest gems lie. 99

Opposite: Pulitzers Bar, popular with the locals as well, is split up into three distinctly designed rooms: the Blue Bar for a cocktail, the Johnny Walker Black Label Lounge for whiskey, or the Red Room for views of the Keizersgracht. *This page, from top:* Rent a boat and explore the iconic Amsterdam canals; Peter Pulitzer; known as the most beautiful terrace in Amsterdam, Pulitzers Gardens is the perfect place to enjoy lunch and dinner during the summer.

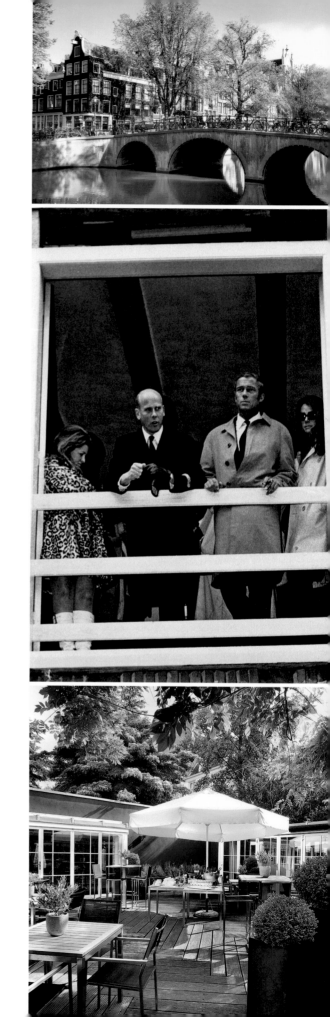

THE ROMANOS
Costa Navarino, Greece

On the Ionian Sea, in the southwest Peloponnese of southern Greece, lie the most unspoiled and breathtaking seaside landscapes in the Mediterranean, shaped by aeons of tides and 4,500 years of human history. Here are Mycenaean palaces, medieval castles, and traditional villages along a pristine coastline dotted with lush olive groves and hidden waterfalls.

Environmentalist and shipping magnate Vassilis Constantakopoulos began acquiring this land in the 1980s, with the goals of preserving and promoting his homeland, and allowing guests and native Messinians to experience its untouched beauty. The Romanos has recently been added to this beautifully considered landscape, a 321-guestroom resort with more than 5,000 square meters of planted roofs, ponds, and trees, where traditional spaces are furnished with contemporary comforts—a natural paradise.

The dining experience at the resort is locally sourced: each restaurant includes herbs and vegetables from its own garden, creating a haute cuisine with Greece's abundant natural ingredients at its core. A development? Indeed, but more than that, a study in bountiful preservation.

View of the stunning coast of the Ionian Sea from nearby Kardamyli, where guests can venture to enjoy more of the area's beautiful Mediterranean beaches.

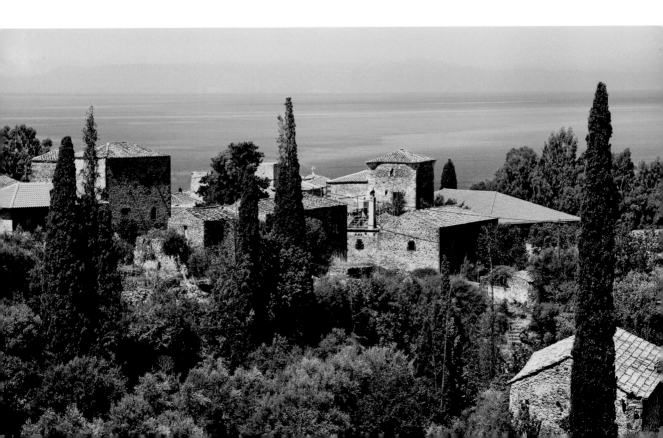

THE ROYAL BEGONIA

Sanya, China

The Sicily-sized island of Hainan in the South China Sea, legendary for its lushness, also goes by the moniker "Green Pearl." Verdant rainforests and twelve miles of broad, almost flat, sandy beaches seem custom-built for what has become the most anticipated leisure destination since Macau.

The newest hotel to alight on this paradise is The Royal Begonia. Its dignified Mediterranean-inspired main building's 142 guestrooms and suites are punctuated by eighteen villas dotting a tropical garden close to the beachfront. Limestone walls comprise a continuous arcade of arches through which the romantic blue sea and sky are always visible.

Nearby, the picturesque beaches of Wuzhizhou Island and Yalong Bay invite exploration.

Local lore plays a special part in this particular protected bay. The local tribes tell the story of fishermen unable to catch fish, despite months of tireless work. A witch told the fishermen to sacrifice a beautiful young girl to the king of the sea, and he would restore their bounty. A young girl named Begonia decided to make the sacrifice, despite her love for her boyfriend, A Min. The prosperity of the fishing island returned, and the people named the place Begonia Bay.

The Buganvillas Lobby Bar offers guests sweeping views of Haitang Bay while they enjoy an evening cocktail.

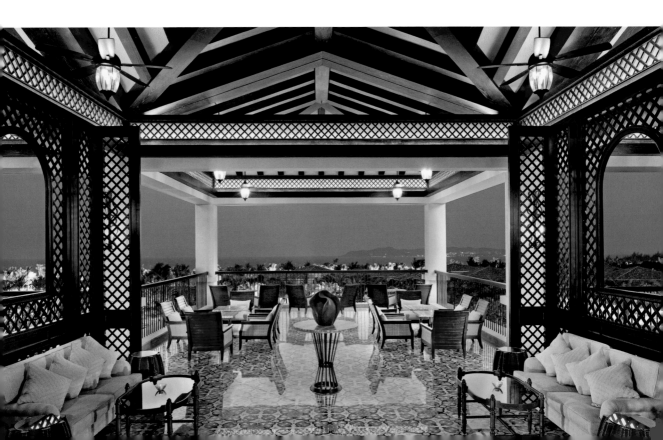

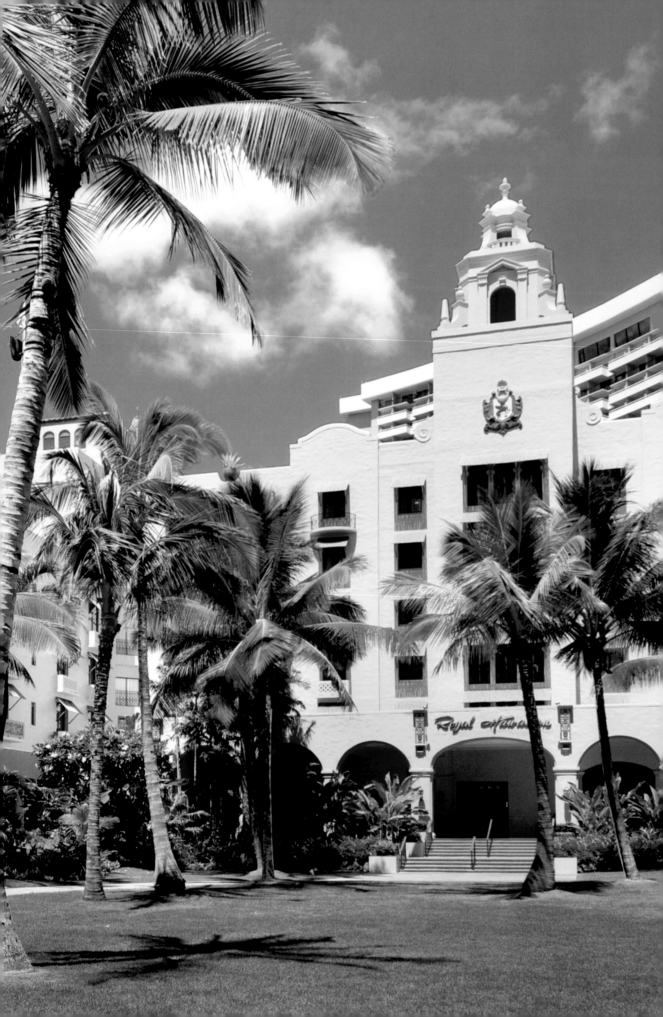

THE ROYAL HAWAIIAN

Waikiki, Hawaii, USA

Since it opened in 1927, The Royal Hawaiian—also known as The "Pink Palace of the Pacific"—has been entertaining and caring for a roster of honeymooners, celebrity guests, and royalty in high style.

The landscape on which the resort sits was once home to the Hawaiian monarchy and is truly royal land. The garden oasis that surrounds it is the stuff of legend: A phantom rooster is said to have scratched the earth at King Kamehameha I's feet while he was standing on the grounds of Helumoa. Seeing this as an omen, the king planted a single coconut in that very spot, which grew and spread, forming the entire palm-lined gardens of The Royal Hawaiian today. Unsurprisingly, the Hawaiian people view the coconut as a symbol of life, abundance, and renewal.

Whether or not guests believe in the hotel's magical origins, they will undoubtedly believe in the magic that is the latest iteration in The Royal Hawaiian's storied history. In recent years, a massive $85 million renovation has transformed and revitalized Waikiki's 528-room grande dame. New rooms combine contemporary Hawaiian furnishings in light colors with design elements that tell the story of Helumoa; Indonesian tables are carved from local tree trunks; the art of celebrated local

The striking exterior of the hotel, known as the "Pink Palace of the Pacific."

artists Solomon Enos and Carl Pao adorns spectacularly transformed Tower rooms.

Still, as chic as its makeover is, The Royal Hawaiian hasn't lost its old-school appeal. It was inspired by the Rudolph Valentino films popular at the time it was built, and copied its pink hue from a nearby home that once graced the same beach. It has been a destination for the likes of Elvis Presley, President Franklin D. Roosevelt, and the Hawaiian monarchy since it opened. It was occupied by the Navy during World War II (and restored thereafter). The complete modernization of the historic section guestrooms, and most recently of the Royal Beach Tower, equip the entire resort with contemporary amenities and luxury design, all with a distinct nod to the glory days of the 1920s.

This page, top: Surfing is one of the many popular water sports on the island; *bottom:* An aerial view of Waikiki and its spectacular Diamond Head crater. *Opposite, top row, left:* Sunbathing on Waikiki beach, 1938; *right:* The luxurious Royal Hawaiian Suite; *center row, left:* Enjoy a traditional hula dancer performance at the hotel; *right:* The beautiful waves of the Waikiki waters are ideal for surfing; *bottom:* Waikiki's beautiful white sand beach.

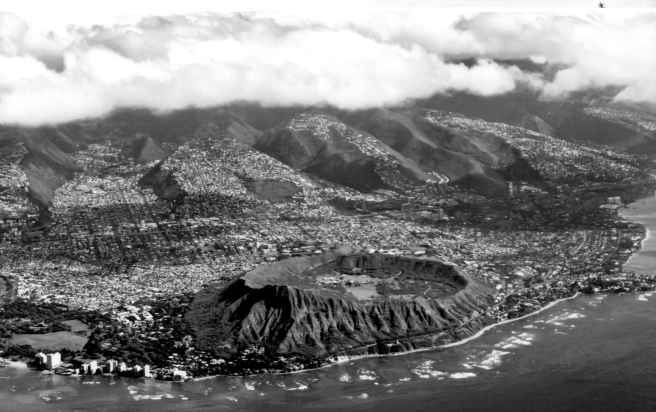

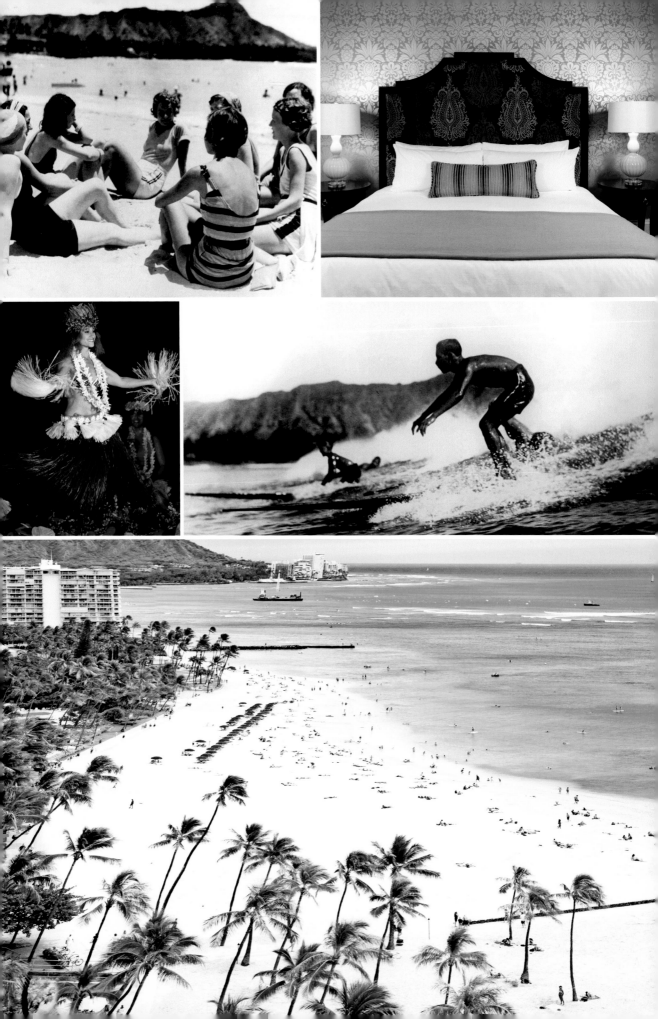

SAN CRISTOBAL TOWER
Santiago, Chile

The San Cristobal rises like a sovereign arrow in the Chilean sky. From its windows one can see the majestic peaks of the Andes, which take on astonishing shades of mauve and pink when they're covered in snow. In the summer, the same windows disclose the often celebrated *ciel azulado*. From the restaurant on the twenty-first floor, one can see the roofs of Santiago stretching off into infinity, showing yet another view—the Santiago of past and present, with its old buildings, new districts, glass-walled skyscrapers, and beautiful streets such as those of Providencia, the district around the hotel.

The San Cristobal represents Santiago well, as they both continually evolve. The 139-guestroom hotel, designed by Argentinian architect Daniel Piana, features a designer lobby, furnished in shades of gray, white, and brown, inspired by the hues found in the local natural landscape. The suites pay homage to Pablo Neruda and Gabriela Mistral, famed Chilean writers and Nobel laureates.

The Cerro San Cristóbal is quite close. In the evening, take a ride to the top, when the last rays of sun have crossed the summit of the Andes and fall on Santiago for yet another vision. *Text by Francisca Mattéoli*

The dramatic backdrop of the Santiago Andes Mountains can be seen from the hotel.

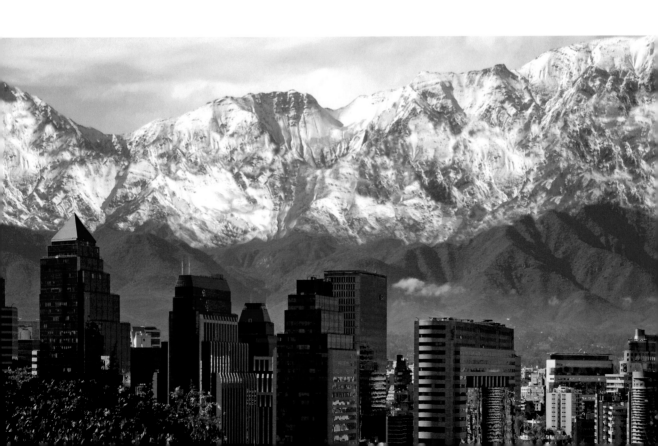

SANTA MARINA

Mykonos, Greece

The renowned and striking architecture of the Cyclades, with its whitewashed walls and low-storied buildings, was developed 5,000 years ago out of pure resourcefulness—to work with the islands' limited supply of construction materials and as a means of resisting the area's strong winds. Millennia later, what once was the architecture of necessity is now a vision of spare luxury. Santa Marina Resort & Villas, a series of Cycladic structures climbing a hill into the rolling landscape, is such a luxury.

In 1986, owner Elias Papageorgiou created ten bungalows here inspired by his love of Mykonos. Over the next twenty years, he expanded to include ninety-six rooms, suites, and villas with private pools. What was a small labor of love is now the favored host of the island, with royal families and Hollywood celebrities coming to play in its laid-back, chic atmosphere.

Soothing rooms open to views of the Aegean Sea and Ornos Bay. And while guests enjoy the sounds of the beach's private DJ and mingle with a hip, well-heeled crowd, traditional life still goes on around them, perhaps not so different, after all, from a scene 5,000 years ago.

View of Santa Marina's private beach.

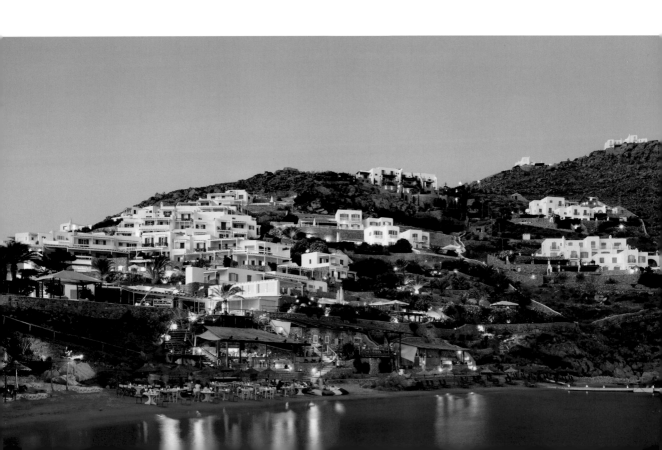

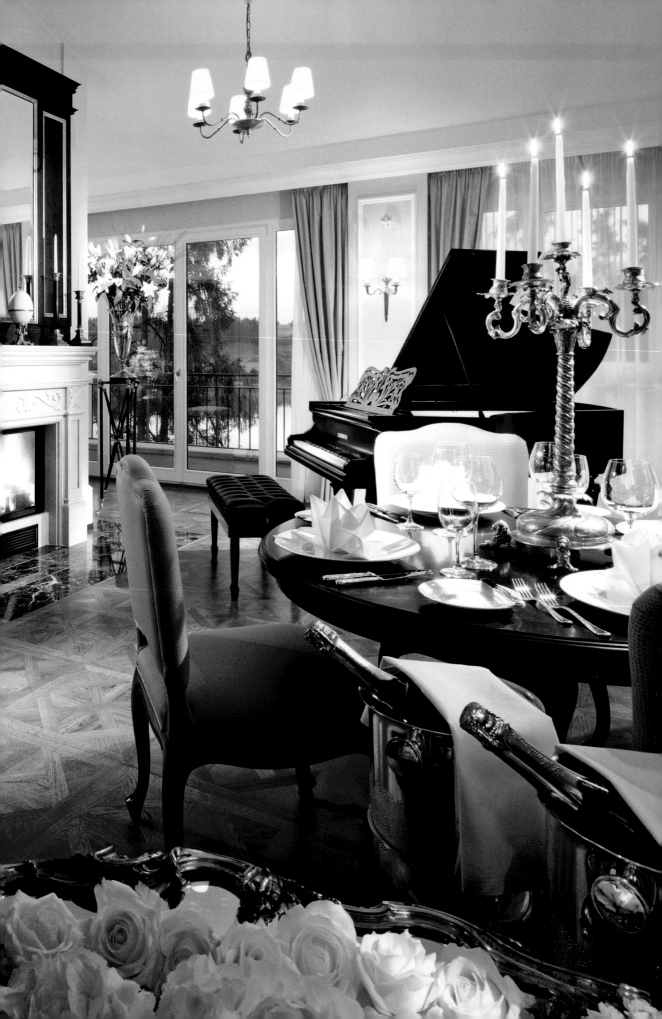

SCHLOSS FUSCHL

Salzburg, Austria

On a peninsula in Austria's grand Salzkammergut region lake, Lake Fuschl, you will find a fairytale fifteenth-century hunting lodge. Once the summer residence of the archbishops of Salzburg, as well as the hideaway of aristocrats, empresses, and film stars, this *Sound of Music*-area castle is Austria's best-known getaway spot.

The castle, of course, had a long history prior to opening as a hotel in 1954. Take a deep breath and experience the vibrant nature that surrounds it, with high mountains and nearby Alps, deep lakes, thick forests, and green pastures. Inside, Old Master paintings from, among others, the collection of Empress Elisabeth of Austria, remind guests that this place—however beautifully reconsidered in contemporary terms—has been hosting guests for nearly six hundred years.

It was in the mid-twentieth century that Schloss Fuschl realized its destiny as a hotel. The year after the 110-room hotel opened, it was used as the set for the first "Sissi" film about Empress Elisabeth, starring Romy Schneider. The hotel's role in that film is now commemorated by the luxurious Sissi Suite, with its breathtaking view over Lake Fuschl. In 1959, Bavarian "salt baron" Consul Carl Adolf Vogel purchased the hotel and married actress Winnie Markus. They became a high-profile dream couple of the German "economic miracle" period, and it paid off in spades for the hotel, which drew masses of celebrities and heads of state, including Nikita Khrushchev. Later, Egyptian President Anwar Sadat would meet here with President Gerald Ford. Prince Rainier III of Monaco, Clark Gable, Richard Nixon, and Queen Silvia of Sweden also stayed at the castle on the lake.

Now guests come for much the same reason as the first archbishops—to relax and swim in the drinking water–clean lake. They can also take spa days surrounded by nature in the glass-walled facility, or take day-trips, chauffeured in the hotel's vintage cars. The enchanting country-house rooms of the Jägerhaus (the home in the middle of Schloss Park) or the contemporary rooms of the main building provide a counterpoint to the seven tower rooms, each furnished with antique furniture, Baroque to Renaissance. This sparkling lakefront hotel, with its backdrop of Maria von Trapp's mountains and strains of Mozart in the distance, is Alpine lake's beauty epitomized for the ages.

> 66 This *Sound of Music-*area castle is Austria's best-known getaway spot. 99

The two-story Mozart Suite is the hotel's largest suite and named after the famous composer, who was born in Salzburg, just fifteen kilometers away from the hotel.

THE SHERATON ADDIS
Addis Ababa, Ethiopia

Classic Ethiopian grandeur reigns at The Sheraton Addis, on a hilltop overlooking the capital city of Addis Ababa, in the foothills of Mount Entoto. The 293-room hotel, both a sanctuary for luxury travelers and a hub for business travelers, is at the center of the city's most important attractions, including a United Nations conference center and commission headquarters.

In fact, the hotel has been one of the most important hosts for heads of state, including Angela Merkel and Tony Blair.

The Sheraton Addis goes beyond simply the requirements of a good luxury and business hotel. It supports and displays Ethiopian art, providing a venue for new talent at its Art of Ethiopia exhibition. As it promotes talent, The Sheraton Addis also promotes the balance of nature, partnering with the Ethiopian Heritage Trust to plant indigenous trees at Mount Entoto. Guests can enjoy all their hotel's little luxuries—piped-in music in the swimming pool, the nightlife of the Gaslight Night Club—knowing that when they have contributed to the Trust, they are planting a tree to contribute to the area's sustainability.

Ethiopian cottages along the road to Addis Ababa.

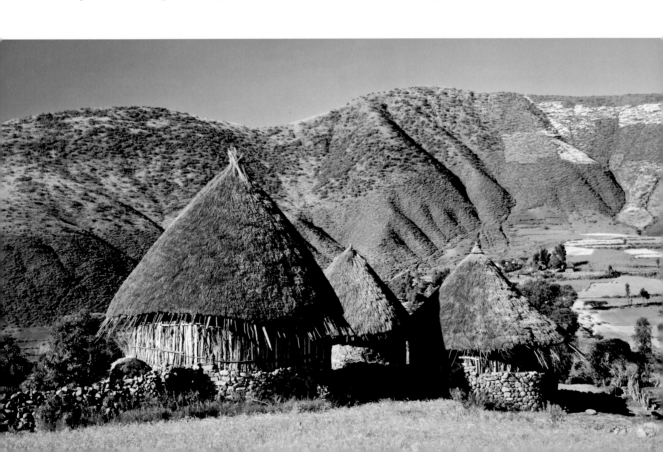

THE SHERATON ALGARVE
Albufeira, Portugal

There are few more dramatic settings than that of The Sheraton Algarve, set as it is on a cliff, surrounded by lofty pine trees, overlooking the breaking waves of the Atlantic Ocean. Its serene architecture—airy courtyards and interior terraces that create intimate spaces open to natural light—is influenced by Portugal's Arab heritage and adds to the drama of its perch. Traditional hand-painted tiles line its corridors and hang above the beds in each of the 215 guestrooms, each telling its own story of Portugal's rich heritage. Thoughtful amenities arrive: regional pastries to give guests a sense of place, and salt from the pans of Tavira—salt as it has been harvested there for thousands of years—so they may take home a small piece of the Algarve.

Since ancient times, Albufeira has been one of the most renowned maritime cities in Portugal. With the passing of the Romans, it was the Arabs who left their footprint on this important destination, naming the area "Al-Buhera," as it resembled a "sea castle."

From the aerie that is The Sheraton, guests may take the hotel's own cliffside elevator for private access to Falésia Beach. With a glass of regional wine in hand, you could pluck this moment from any in history.

Enjoy a coffee or tea at the Corda Café, which faces one of the resort's five outdoor pools.

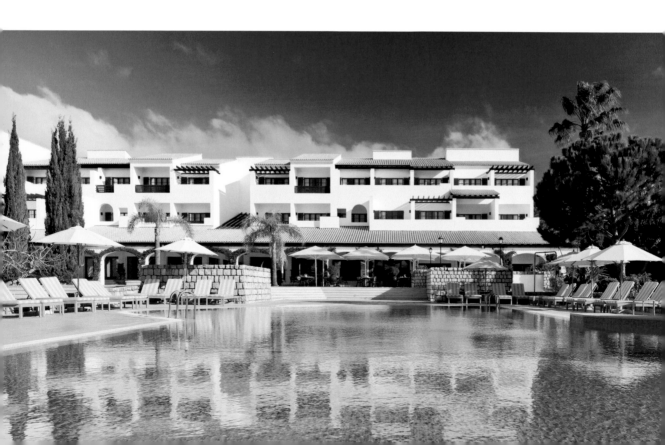

THE SHERATON GRANDE SUKHUMVIT

Bangkok, Thailand

A glistening tower in the heart of Bangkok's business and entertainment district, The Sheraton Grande Sukhumvit was planned to seamlessly combine modern elegance with Thai culture in the middle of the nation's capital. No anonymous high-rise, The Sheraton Grande Sukhumvit's 33 stories were planned not only to provide unparalleled proximity to the city's major tourist destinations, but to take advantage of the magnetic city view and soothing vistas of Lake Ratchada.

Internationally acclaimed design firm Hirsch Bedner Associates and CASA—the Bangkok-based architectural firm—painstakingly considered this mix of culture and elegance to great effect when the hotel opened in 1996. Vivid glass sculptures by artist Stephen Gormley punctuate the lobby and public spaces, their turquoise color and dramatic proportions prized by Asian art collectors worldwide.

And though the hotel's interior features are outstanding—from 420 soothing, modern guestrooms to lightning-fast technology, to a spa that combines Thailand's healing arts with the best of contemporary spa treatments—The Sheraton is perhaps best known for its unparalleled proximity. Conceived as a destination that would appeal to

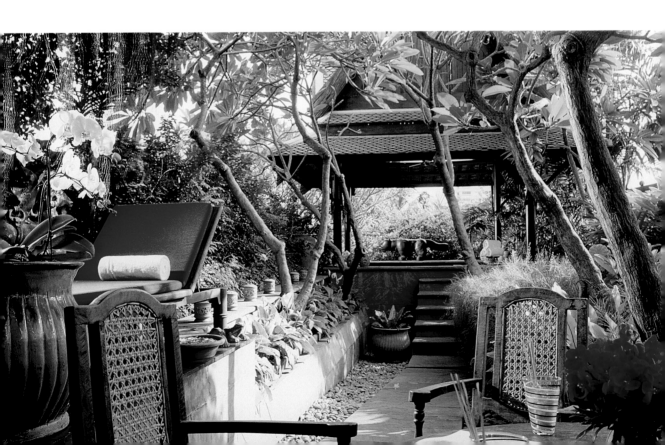

both leisure and business travelers, the hotel blazed a path when it created a stylish walkway in 2006 that goes straight from the lobby to the BTS Asok Skytrain station and the MRT subway. It is a gateway from this empire of convenience and modern technology to Bangkok's many ancient attractions, including the Temple of the Emerald Buddha and the nearby Grand Palace, a compound with more than one hundred buildings, golden spires, and glittering mosaics. The Sheraton Grande Sukhumvit is a literal bridge between past and future.

GREG SEIDER
Mixologist and Luxury Collection Global Explorer

WHAT INSIGHTS HAVE YOU GAINED FROM TRAVELING? How dramatically different lifestyles are in various countries.

WHO IS YOUR FAVORITE FICTIONAL TRAVELER? Don Quixote.

FAVORITE PART OF YOUR STAY AT THE SHERATON GRANDE SUKHUMVIT. The mornings, having a swim and delicious breakfast by the pool.

WHAT THRILLS YOU THE MOST ABOUT THAI CULTURE? The street food is absolutely amazing—the amount of work it takes to create the flavors in broth for soups.

WHY IS BANGKOK SPECIAL TO YOU? The colorful people, the electric energy of the city, and the mouth-watering food at any hour of the night.

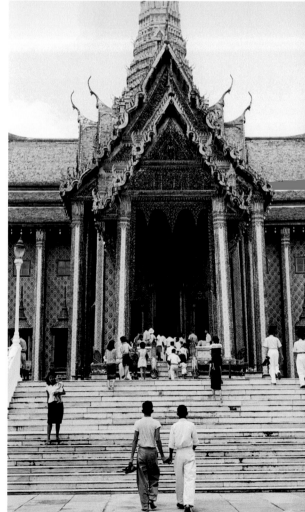

Opposite: The Rama Suite, one of the beautiful Thai-themed suites, set in an outdoor garden, with a private Jacuzzi for ultimate relaxation. *This page, top:* Detail from Wat Phra Kaew, the Temple of the Emerald Buddha; *bottom:* Another nearby Buddhist temple, Prasat Phra Thep Bidon.

THE SHERATON KUWAIT

Kuwait City, Kuwait

In 1966, the premier five-star luxury hotel in Kuwait opened. It soon became a landmark, famous for its central location in Kuwait's commercial and financial center, and for hosting foreign dignitaries and captains of industry.

Today, the hotel is renowned for its lavish suites, marble ballrooms, and local restaurants such as the Lebanese restaurant Le Tarbouche and the Indian Bukhara Restaurant. Among both expats and locals alike, the hotel is a well-known venue for weddings, buffets, and even barbecues. Because so many international guests have stayed at the hotel, it has developed a reputation for its array of cuisines to suit every visitor. Iranian and Italian offerings round out the choices, as does its English Tea Lounge (reminiscent of an English country house). Its international restaurant, Al Hambra, even features a live Chinese cooking station and a specialty sushi area.

Since its major restoration and expansion from 160 to 300 luxurious guestrooms, The Sheraton Kuwait has become one of Kuwait's iconic meeting places (friends know to link up at its roundabout, which bears its name, for the evening's activities). As one of the city's most important hosts, the hotel is famous for its local and international events to benefit education, the environment, and children's health causes. It has also become the go-to spot for foreign dignitaries visiting Kuwait, including several former U.S. presidents, former British Prime Minister Tony Blair, and former U.S. Secretary of State Condoleezza Rice.

These days, visitors come to a completely renewed hotel, where glittering chandeliers hang from inlaid ceilings and an opulent, column-filled lobby awes with its grandeur.

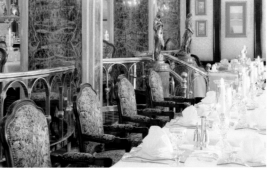

Opposite, top left: Stunning light fixtures in the opulent lobby; *top right:* The hotel's restaurant Shahrayar; *bottom left:* Place setting used for special occasions in the Diamond Grand Ballroom, big enough to hold 2,000 guests; *bottom right:* Detail of gold doors leading to the hotel's Indian restaurant, Bukhara. *This page, left:* the hotel's golden book, filled with signatures of its famous guests; *right:* The formal dining area of the hotel's restaurant Riccardo.

SLS HOTEL AT BEVERLY HILLS
Los Angeles, California, USA

When SLS Hotel at Beverly Hills opened in 2008, it represented something of a revolution in a hotel community chockablock with boutique hotels. Designer Philippe Starck, who teamed with nightlife impresario Sam Nazarian, saw the hotel occupying the space between boutique and formal five-star hotel. The result: the $230 million SLS Hotel at Beverly Hills, with 297 minimalist rooms in serene green-gray, with quirky Starck touches such as beds that "float" in the middle of the room, backed by glass headboards.

The entire concept of the hotel as a social area has been reconsidered. Culinary director José Andrés gives guests dining experiences both public and private. In Tres, the private sanctuary for in-house guests only, cozy nooks, books, and fireplaces surround leather loveseats, and small private dining rooms are a comforting backdrop for Andrés's signature Spanish dishes. In The Bazaar, both guests and the public are invited to experience modern organic cuisine and whimsical retail in an actual bazaar environment.

In the heart of Los Angeles on Restaurant Row, SLS Hotel at Beverly Hills is perfectly poised for accessibility to the city's trendiest restaurants and nightlife.

The Bazaar, by José Andrés.

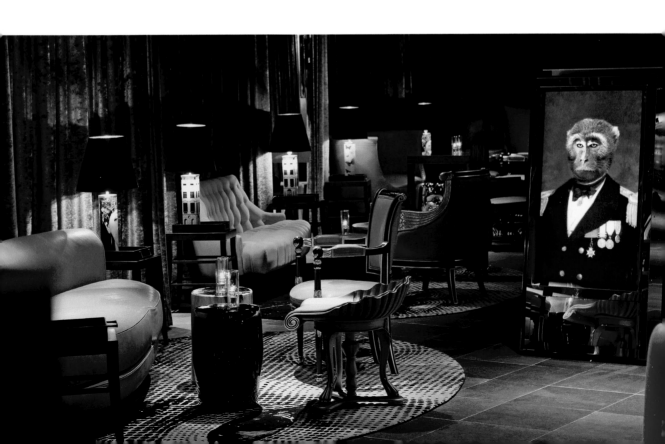

SOFIA HOTEL BALKAN

Sofia, Bulgaria

Replete with archways of high columns, imported Italian marble floors, and grand entrances, the Sofia Hotel Balkan sits in the very center of Sofia. Situated in the courtyard of the Presidency, it is part of an architectural complex built during 1950s-era Soviet rule to complement the architecture of the turn-of-the-century municipal buildings that surround it. It is a fortress of grand architecture close to Sofia's most celebrated attractions: Roman archaeological remains, the historic St. Nedelya Church, and the National Library.

Sofia Hotel Balkan is one of Sofia's architectural gems, and its Preslav restaurant (now the Stardust) has hosted heads of state from Israeli Prime Minister Yitzhak Shamir to General Secretary of the UN Ban Ki-Moon.

In 2007, the iconic hotel was renovated to reflect its importance to the international community. Its 184 rooms are appointed with Crema Marsi Italian marble and Nero Marquina vanities. Luxurious American cherrywood furniture and artwork propel this icon into the future, while keeping it firmly grounded in its heritage.

Left: The view of St. Nedelya Church from a guestroom; *right:* The elegant Lobby Grand Ballroom.

TAMBO DEL INKA

Valle Sagrado, Peru

High in the Andes Mountains, the Urubamba Valley, the Sacred Valley of the Incas, lies just beneath the ancient city of Machu Picchu. Fertile and verdant, it is fed by the Urubamba River, sacred because the Incas favored its painted landscape as a peaceful resting place.

This serene agricultural valley has long been a stopping place for travelers on their way from Cusco to Machu Picchu, and now Tambo del Inka invites them to experience the natural beauty and archaeological attractions that make the Sacred Valley a destination in its own right.

Amid the ancient valley, the 128-room hotel is a study in modernity, its LEED-certified trapezoidal structure in glass, stone, and wood integrating beautifully into the topography. Outside the windows of triple-height ceilings, there are views of the Urubamba River on one side or the cordillera and Chicón glacier on the other. Towering stone chimneys punctuate Inca-style stone walls, and oversized local pottery and pre-Incan textile patterns give visitors a sense of place and history.

Of course, should you wish to leave this spot, with its kayak adventures on the river and its massive spa with views of the Andes,

The magnificent Machu Picchu, easily accessible by the hotel's private train.

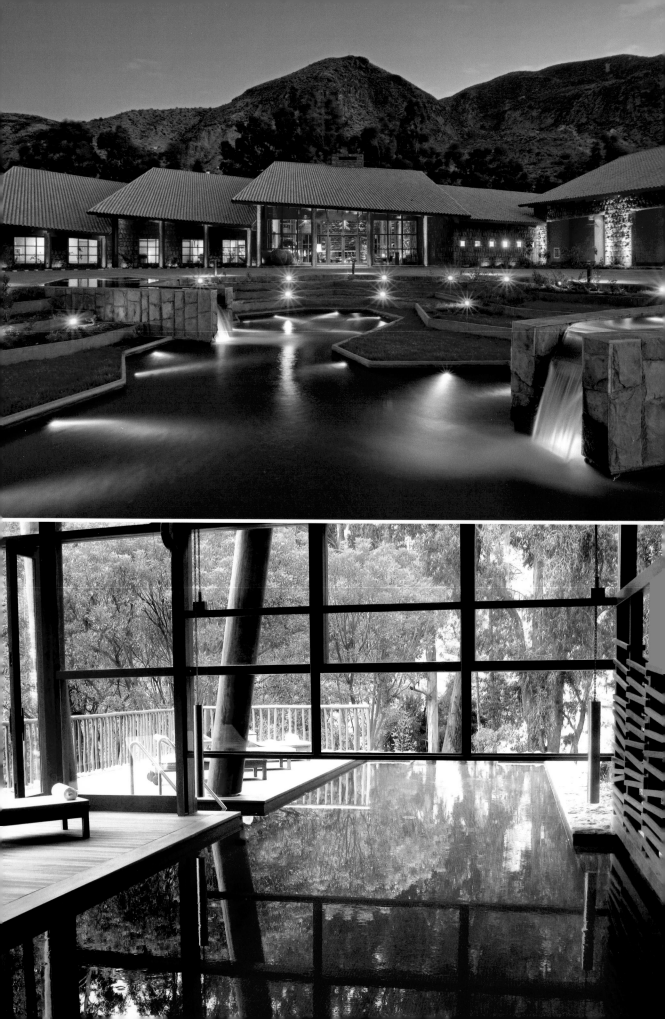

Tambo del Inka's own railway station for the Urubamba train leads to the legendary ruins of Machu Picchu.

Even dinner affords the opportunity to become one with the sacred valley of the Incas. The walls of Hawa's soaring space are replete with "talking knots" or *khipus,* historically used for Incan accounting. Organic ingredients come from neighboring farmers and are combined in innovative "novo Andean" style. (Guests may even handpick the ingredients for their meal in a special greenhouse tour.) And though a feast of lamb smoked in hickory leaves and quinoa in a champagne soufflé might be somewhat elevated from what the valley's original inhabitants would have eaten, Tambo del Inka's authenticity of flavor and feeling never wavers.

Opposite, top: The stunning entrance to the hotel; *bottom, both pages:* Relax by the indoor swimming pool or by getting a Yucamani Stones Massage at the hotel's state-of-the-art spa.

CYNTHIA ROWLEY
Designer

WHAT IS YOUR MOST MEMORABLE TRAVEL EXPERIENCE? When I was very young, I trekked through Tibet—through the monasteries, Mount Everest, and the moonlike landscape—and spent time with the beautiful Buddhist culture. It was mind-blowing.

WHO IS YOUR FAVORITE FICTIONAL TRAVELER? Gulliver from *Gulliver's Travels.*

ELABORATE ON YOUR EXPERIENCE AT TAMBO DEL INKA. It was magical! The ultimate in luxury tucked away in an authentic, rustic Peruvian town.

FAVORITE PART OF YOUR STAY AT TAMBO DEL INKA. It was a girls' trip with my mom, my two daughters, and me. We woke up at 6 A.M. and walked down a little path through a dewy glen as the sun was rising, and found an old two-car private train with little tables and lamps right out of the *Orient-Express,* and got on and rode approximately three hours through the most beautiful country to Machu Picchu.

FAVORITE PERUVIAN DISH? I love the pisco-flambéed shrimp at Fiesta in Lima.

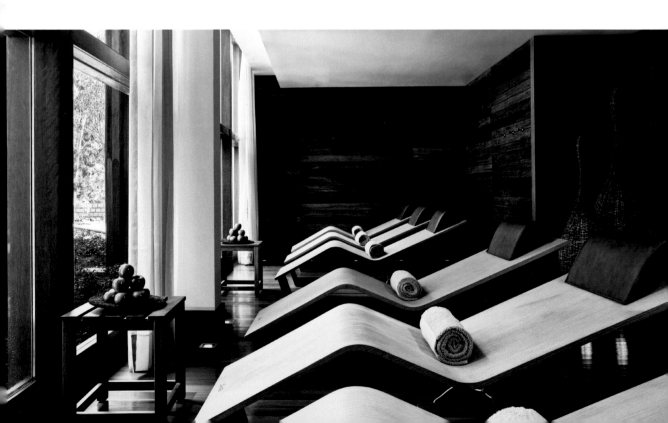

TURNBERRY

Turnberry, Scotland

Perhaps Turnberry is best known for what lies beyond its walls—the championship links of its iconic Ailsa Course, home of multiple Open Championships and host to the epic Jack Nicklaus and Tom Watson "Duel in the Sun."

But the estate itself, the onetime home of the Marquess of Ailsa, put Turnberry on the map at the turn of the twentieth century. In fact, the Marquess built Turnberry as a hotel to serve his private golf course at Culzean Castle, later taken over by the railway company in the golden age of rail, and turned into a station.

The resort's bones as a luxury golf destination were undeniable. By 1948, the railways had been nationalized, and the resort was restored under the auspices of the government's British Transport Hotels. Margaret Thatcher's election in 1979 opened the industry to private investment, and this jewel in the public domain was bought by Sea Containers Ltd., which would invest millions in its renovation for the 1986 Open. Its spa—one of the grandest in the country—was added later.

What guests experience now is a perfect blend of Edwardian tradition and contemporary luxury. Kilted doormen warmly greet each guest. Breathtaking views over the eight hundred-acre estate look over the links golf courses, the Irish Sea, the Ailsa Craig and the Isle of Arran. Inside, soft fabrics, subtle colors, and honeyed wood

COLIN MONTGOMERIE
Professional golfer

WHO IS YOUR FAVORITE FICTIONAL TRAVELER? Captain Kirk, *Starship Enterprise*.

NAME A DESTINATION THAT HAS RECENTLY INSPIRED YOU. Turkey's Belek region.

ONE THING PEOPLE DO NOT KNOW ABOUT SCOTLAND. There are more golf courses per capita than anywhere else in the world—538.

ELABORATE ON YOUR EXPERIENCE AT TURNBERRY. Great rooms, beautiful scenery, and a fantastic golf course and academy.

NAME THE MOST PHOTOGENIC SCENERY IN SCOTLAND. Ninth tee at Turnberry on the Ailsa Course.

DO YOU PREFER TRAVELING ALONE OR WITH OTHERS? Only with my wife.

WHAT TRAVEL ITEM CAN'T YOU LEAVE HOME WITHOUT? My Swiss Army knife.

WHAT IS YOUR FAVORITE GETAWAY SPOT OR WAY TO RELAX IN SCOTLAND? Skibo Castle or Gleneagles.

WHAT INSIGHTS HAVE YOU GAINED FROM TRAVELING? Travel light. You only ever use half of what you take.

WHY IS SCOTLAND SPECIAL TO YOU? It's home.

floors give rooms a natural purity, harmonious with the mystical setting of the Scottish coast. Dining, too, is a kicked-up tradition: Turnberry's signature restaurant, 1906, offers classical French dishes with a modern twist, looking out to the sea beyond.

Hidden away from the rest of the world, the 149-room resort has hosted royal family members and Hollywood's elite alike, yearning to escape the gaze of the public eye and enjoy the challenge of the links. Prince Edward, Prince Andrew, Bill Clinton, Bing Crosby, Bob Hope, Rod Stewart, Jack Nicholson, and Luciano Pavarotti have all been guests. Here, hidden away from the world, and in the shadow of the original castle, where this magnificent resort began, one might say Turnberry has returned to what it was always intended to be.

From top: The imposing exterior of the handsome estate; bagpipers signal another day's end on the championship Ailsa Course; sunset view of the Turnberry Lighthouse, a distinctive element of the coastline since 1873; the ninth hole of the Ailsa Course.

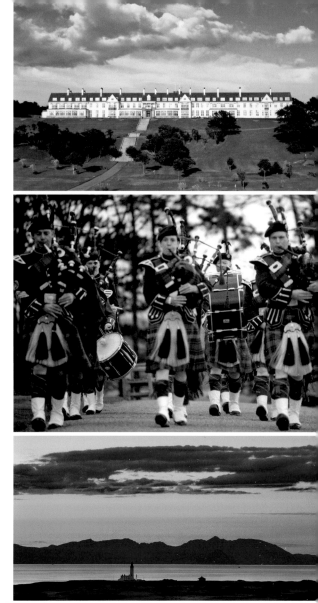

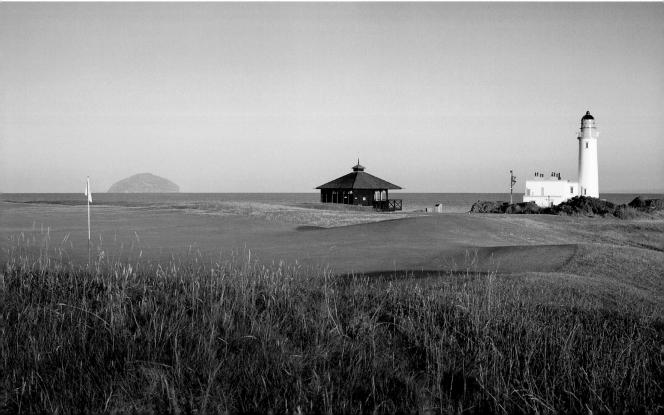

TWELVE AT HENGSHAN

Shanghai, China

The buzzy center of Shanghai, with its perfectly preserved neoclassical and art deco buildings of the Bund, its pulsating promenade, and the galleries, boutiques, and cafés that have made it "Paris of the East," has a serene new oasis: Twelve at Hengshan.

Drawn up by cult favorite hospitality designer Yabu Pushelberg and architect Mario Botta, it has an urban chic architectural concept that blends East and West in a modern terracotta building, oriented so each ground-floor space takes advantage of the lush courtyard garden. Throughout the 171-guestroom hotel, elements inspired by "the secret garden" are a romantic and emotional contrast to the strong, minimalist architecture. The building itself provides a thrilling counterpoint to the neighborhood's preserved classic charm.

A keen eye will find all the ways in which the hotel's designers have blended cultures. The Shanghai Living Room (lobby) curates a collection of Chinese screens and furniture, mixed with Western pieces. In 12 Hengshan— the hotel's Cantonese restaurant—large porcelain chandeliers create a soft, luxurious glow in a room whose curved wall shows an abstracted, modern version of Chinese folklore. All these elements are fitting statements in a city whose very heritage is an elegant cultural blend.

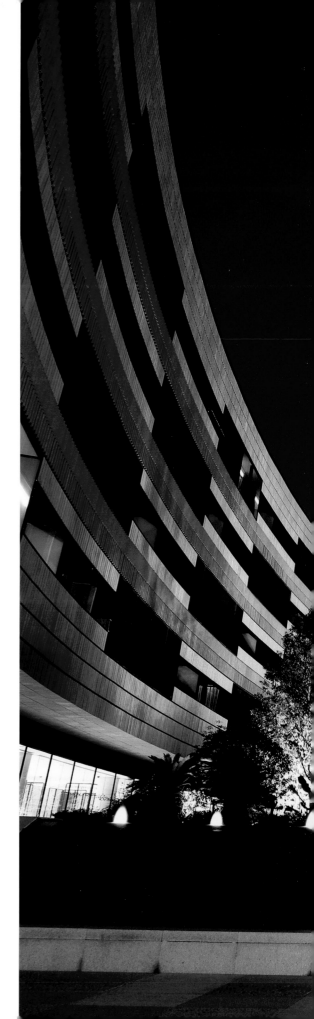

The hotel's courtyard illuminated at night.

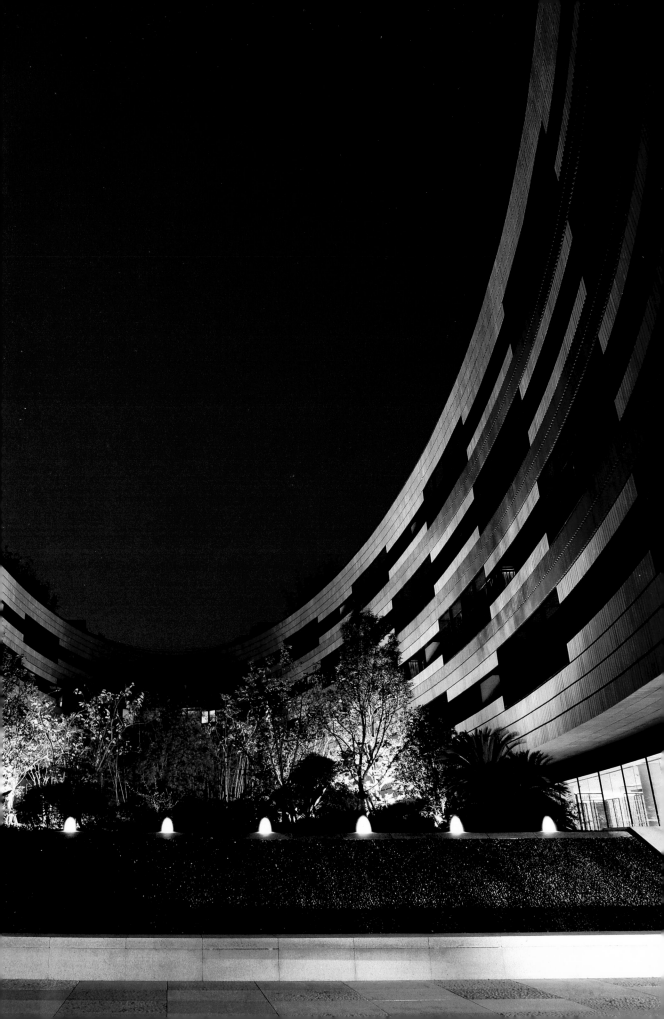

THE US GRANT

San Diego, California, USA

In 1870, a luxury hotel opened, the figurative cornerstone of downtown San Diego. The Horton House, a three-story wood structure, was the finest accommodation south of Los Angeles and operated for 25 years until it was purchased by the wife of Ulysses S. Grant Jr. In 1905, it was demolished to make way for her husband's dream of building a luxury hotel in memory of his father, the 18th President of the United States and a Civil War hero.

The hotel that opened in 1910 was a 270-room luxury palace, its architecture both classic and timeless, with arcadia windows, balcony balustrades, and imposing dentil cornices. Inside, a white marble staircase capped by a carved alabaster railing led visitors to their luxurious rooms—many of which received worldwide acclaim for having private baths. Among other lavish amenities was a garden terrace designed by Kate Sessions (today, the Presidential Ballroom) and a Moroccan bath. The hotel's most historically-themed space, the Celestial Ballroom, opened as the Bivouac Grill, decorated with murals of the world's famous battles in honor of the Civil War legacy of the hotel's namesake. The hotel has seen banner events in its century as a San Diego cornerstone. When Prohibition was

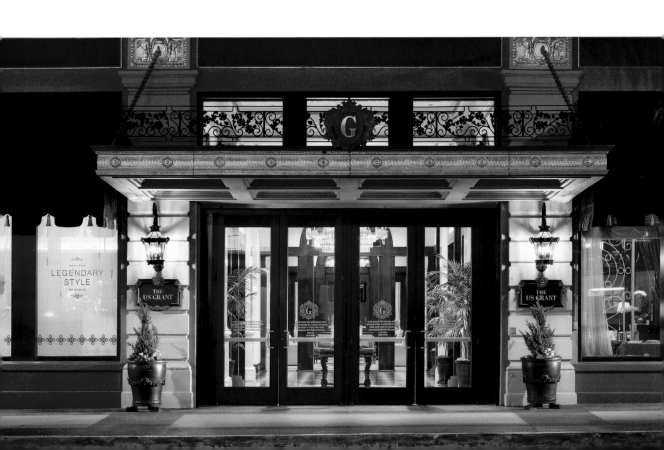

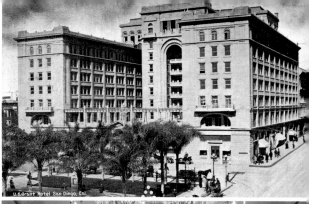

repealed in 1933, San Diegans sang "Happy Days Are Here Again" on the sidewalk outside the hotel. The World War boom of the 1940s transformed its club, the Little Club, into one of California's liveliest venues where traveling stars and big bands, including Benny Goodman and Glenn Miller, performed for servicemen and their families.

At nearly 70 years old in 1979, the hotel (and downtown) had fallen on hard times, and the building was slated for the wrecking ball. Developer Christopher Sickels purchased it, and after an unprecedented $80 million renovation, reopened it in 1985, marking the rebirth of San Diego's downtown. Thoroughly modernized, its restoration of original features included importing more than 1,000 yards of silk and damask and nearly 150 tons of marble from Europe.

But this was not the US Grant's only grand refurbishment. In 2003, the Sycuan Band of the Kumeyaay Indians—one of San Diego County's indigenous Native American tribes— purchased the hotel and committed $56 million to its dramatic new iteration. The tribe, which had suffered enormously at the hands of Westerners, remembered Grant's gift of 640 acres for them and wanted to pay tribute to a man they regarded as forthright and generous. Today, opulent details fill the hotel, such as a $250,000 rug in the Grand Lobby, hand-milled in Thailand in shades of gold and presidential blue. And an ornately gold-framed oil painting of President Ulysses S. Grant greets all guests who ascend the grand white marble staircase, beckoning them in to appreciate the decades of history his image has witnessed.

Opposite: The classic hotel occupies an entire block. *This page, from top:* The US Grant when it opened in 1910; the sparkling crystal chandelier rounds out the Grand Lobby's elegance; lieutenant General Ulysses S. Grant, circa 1864.

VANA BELLE

Koh Samui, Thailand

Koh Samui, fifty miles off the eastern coast of southern Thailand, holds some of the most rarefied landscapes in the transparent Gulf of Thailand. Situated on a serene bay, Vana Belle is fringed by coconut trees and sparkling turquoise waters. The unspoiled island is encircled by sixty additional islands, comprising the Ang Thong National Marine Park. Below the surface of the water, caves, tunnels, and vibrant coral reefs, teeming with sea life, promise spectacular snorkeling.

Surrounding islands—including Koh Phangan, Koh Tao, and Koh Nang Yuan—offer more insight into this unspoiled region.

Vana Belle itself—whose name means "beautiful forest" in a combination of Thai and French—was built to create as low a threshold as possible between the indoors and the natural grandeur outside. The eighty-room resort pays homage to the green paradise that is its home—a destination alive with waterfalls, natural bathing pools, and rainforests. Open, airy spaces seamlessly blend the soothing neutral tones of the interior with the tropical palm hideaway that surrounds it.

View from a luxury suite terrace at dusk.

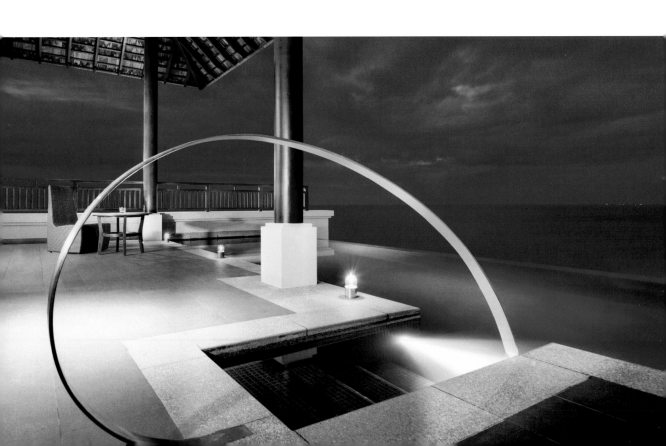

VEDEMA

Santorini, Greece

Few would dispute that Santorini is the most beautiful of the fifty-six islands of the Cyclades. Black-sand beaches and sugar-cube-white buildings, blue-domed churches and stone paths twisting down to the stunning Aegean Sea define its striking cliffs and dramatic coasts.

It is here that Vedema pays homage to traditional Cycladic architecture, its pure white walls replicating those of an ancient village (with the luxury amenities of a five-star resort). Owner Antonis Eliopoulos built the resort as a love note to the area. He became so enthralled with the island's beauty that he bought the neoclassical mansion of a notable captain, with its land, vineyards, and the fifteenth-century winery. Later, he decided to share his treasure, and Vedema the resort was born, with forty-five beautifully furnished guestrooms.

Vedema, which means "harvest," was and still is a vineyard. Its complex of villas, hand-crafted in the style of the island, is adjacent to the vineyards and is built over and around ancient cellars. The neoclassical mansion is now the Presidential Villa, its stark white furnishings offset by Aegean blue—as timeless as any place on this dramatic island.

The resort's beautiful outdoor pool.

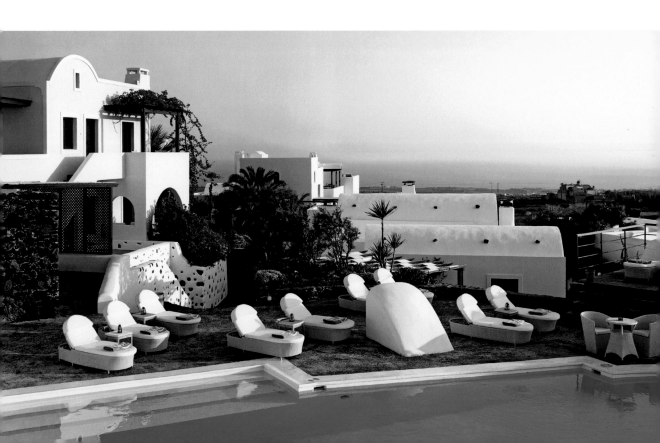

VILLARRICA PARK LAKE

Villarrica, Chile

Set against the stunning backdrop of a magnificent snowcapped volcano, Villarrica Park Lake is a seventy-room resort that is purpose-built for admiring the Araucanía Region's lush green vegetation, mountain views, and hot springs, many of which are part of the region's national parks. Surrounded by seven crystalline lagoons and lakes, and perched at the edge of a vast, deep blue lake, the resort is a sophisticated base for climbing one of the most active volcanoes in South America, as well as for dogsledding, fly-fishing pristine waterways, and flying in canopy adventures over the centenary oaks, cinnamon trees, and copihues that crowd the landscape.

The hotel itself is oriented toward admiring the outdoors. Private guestroom balconies, floor-to-ceiling windows, and terraces seem to sit right atop Lake Villarrica, with its coastline of ancient forests and dramatic peaks. Even the cuisine in Aguas Verdes restaurant offers the opportunity to deeply experience this part of northern Patagonia. Combining international cuisine with that of the native Mapuche community, the restaurant is a serene spot in which to try Chile's most famous wines. And after a day of exploration, the Aquarius Spa invites guests to connect with nature through regional products and comforting surroundings in native stone and wood—looking out to beautiful gardens and Lake Villarrica.

From the peaks of the Andes Mountains to the glimmering Lake Villarrica, the Villarrica Park Lake hotel is surrounded by never-ending stunning views. *Pages 158–159:* Restaurant Terrazza Danieli at Hotel Danieli.

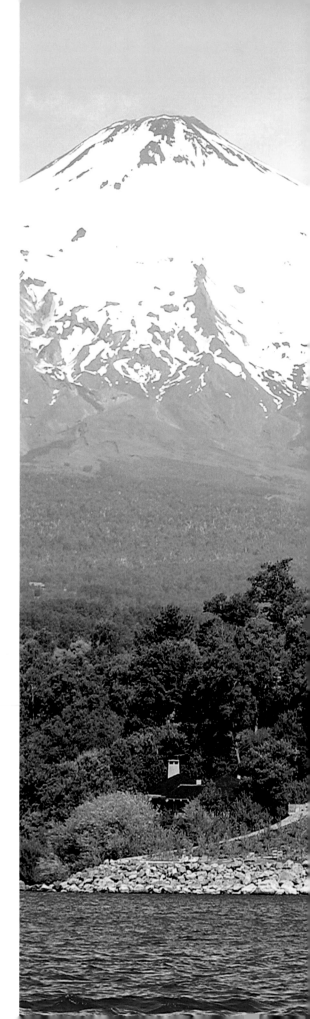

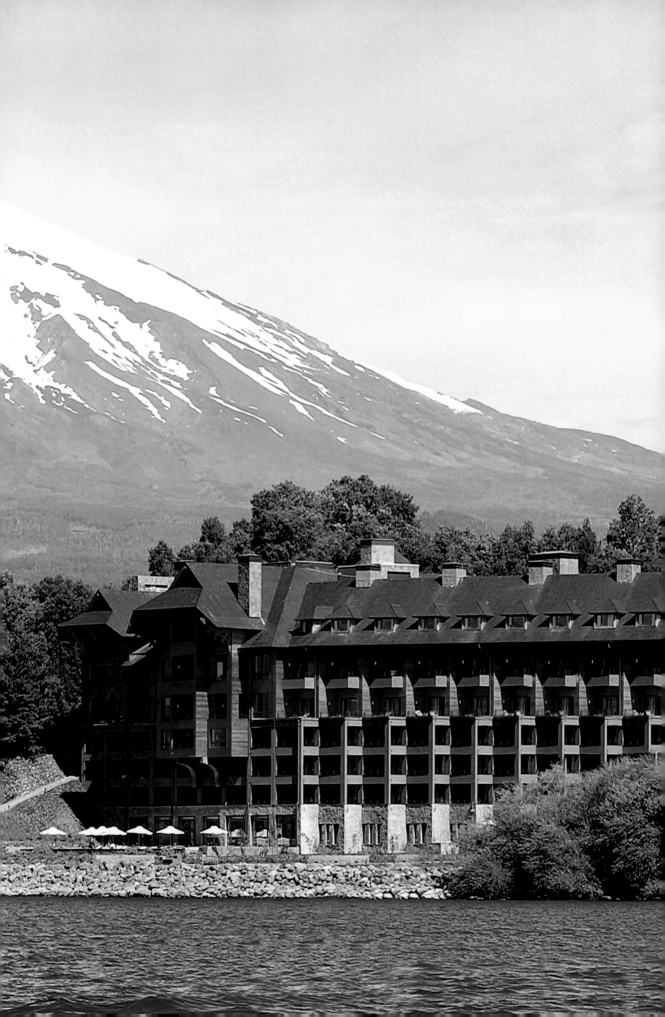

DIRECTORY

AFRICA

ETHIOPIA
THE SHERATON ADDIS

From the crystal clear pool with soft underwater music to the yearly Ethiopian art exhibition, the hotel is the perfect place to indulge and experience the culture of Addis Ababa.

Taitu Street, P.O. Box 6002
Addis Ababa
telephone 251 11 517 1717
facsimile 251 11 517 2727

theluxurycollection.com/addis

ASIA

CHINA
THE ASTOR HOTEL

Located in the heart of Tianjin, this architectural gem offers guests access to amenities such as a water-based treadmill and a hotel museum. It is also in walking distance to the Xiao Bai Lou, a pedestrian mall that guests can explore.

33 Taier Zhuang Road, Heping District
Tianjin 300040
telephone 86 22 2331 1688
facsimile 86 22 2331 6282

theluxurycollection.com/astor

CHINA
THE HONGTA HOTEL

Sweeping views of Shanghai, personalized butler service, and a state-of-the-art health club make one's stay at the Hongta Hotel a first-class experience.

889 Dong Fang Road, Pudong District
Shanghai 200122
telephone 86 21 5050 4567
facsimile 86 21 6875 6789

theluxurycollection.com/hongta

CHINA
THE ROYAL BEGONIA

Local culture is on display inside the resort's own gallery, as well as through a showcase of traditional and modern Chinese art, sculpture, and pottery.

Haitang Beilu, Haitang Bay, Sanya
Haitang Bay, Hainan 572013
telephone 86 898 3885 9999
facsimile 86 898 3885 7777

theluxurycollection.com/royalbegonia

CHINA
TWELVE AT HENGSHAN

Located on the beautiful tree-lined Hengshan Road, this modern, stylish newcomer is a stone's throw from the city's trendy shopping area, restaurants, parks, and museums.

12 Hengshan Road, Xuhui District
Shanghai 200031
telephone 86 21 3338 3888
facsimile 86 21 3338 3999

theluxurycollection.com/twelvehengshan

INDIA
ITC GRAND CENTRAL

This five-star hotel offers guests stunning views of the city from its rooftop lounge, Point of View, as well as ultimate relaxation at its spa, Kaya Kalp, the largest in the state.

287, Dr Babasaheb Ambedkar Road,
Parel, Mumbai
Maharashtra 400012
telephone 91 22 2410 1010
facsimile 91 22 2410 1111

theluxurycollection.com/itcgrandcentral

INDIA
ITC GRAND CHOLA

In homage to South India's Imperial Cholas, the architecture, ornate design, and ambience of the ITC Grand Chola call upon its grand roots.

No. 63 Mount Road, Guindy, Chennai
Tamil Nadu 600032
telephone 91 44 2220 0000
facsimile 91 44 2220 0200

theluxurycollection.com/itcgrandchola

INDIA
ITC KAKATIYA

An array of delectable in-room amenities, including hot chocolate and pillow menus, is sure to keep guests satiated in this five-star hotel.

63-3-1187, Begumpet, Hyderabad
Andhra Pradesh 500016
telephone 91 40 2340 0132
facsimile 91 40 2340 1045

theluxurycollection.com/itckakatiya

INDIA
ITC MARATHA

Influenced by the Maratha Dynasty and Maharashtrian hospitality, the hotel fuses elegance with history through its thoughtfully designed interior and extensive art collection.

Sahar Airport Road, near International Airport
Andheri (East)
Mumbai, Maharashtra 400099
telephone 91 22 2830 3030
facsimile 91 22 2830 3131

theluxurycollection.com/itcmaratha

INDIA
ITC MAURYA

A true example of Mauryan design, this landmark hotel offers amenities such as an outdoor pool with sun deck and a Travel House desk, a special lounge where guests can book daily adventures to the city.

Diplomatic Enclave, Sardar Patel Marg
New Delhi, New Delhi 110 021
telephone 91 11 2611 2233
facsimile 91 11 2611 3333

theluxurycollection.com/itcmaurya

INDIA
ITC MUGHAL

Opulent and exquisite, the ITC Mughal is located near the Taj Mahal and other historic city sites, such as the Agra Fort, Fatehpur Sikri, and the Bharatpur Bird Sanctuary.

Taj Ganj, Agra
Uttar Pradesh 282001
telephone 91 562 402 1700
facsimile 91 562 233 1730

theluxurycollection.com/itcmughal

INDIA
ITC RAJPUTANA

Home to the exclusive "Palace of Mirrors" bar, Jharokha Poolside lounge, and a 24-hour restaurant, the ITC Rajputana is the ideal place to decompress in the "Pink City," where the palaces and other historical buildings are blushed pink.

Palace Road, Jaipur
Rajasthan 302006
telephone 91 141 510 0100
facsimile 91 141 510 2102

theluxurycollection.com/itcrajputana

INDIA

ITC ROYAL GARDENIA

From vertical gardens in the lobby to
housing the city's first restaurant to be
lit with natural sunlight during the day,
environmental awareness is key to this
five-star location.

No. 1 Residency Road
Bengaluru, Karnataka 560025
telephone 91 80 2211 9898
facsimile 91 80 2211 9999

theluxurycollection.com/royalgardenia

INDIA

ITC SONAR

Nestled among a forest of trees, the ITC
Sonar is the perfect haven to retreat to
and escape from the hustle and bustle of
everyday life.

JBS Haldane Avenue (Opp Science City)
Kolkata, West Bengal 700046
telephone 91 33 2345 4545
facsimile 91 33 2345 4455

theluxurycollection.com/itcsonar

INDIA

ITC WINDSOR

Perfect for business or pleasure, this stately
hotel is located steps from the business
center of Bangalore and across the way
from the Bangalore Golf Course.

Windsor Square, 25, Golf Course Road
Bangalore, Karnataka 560052
telephone 91 80 2226 9898
facsimile 91 80 2226 4941

theluxurycollection.com/itcwindsor

INDONESIA

KERATON AT THE PLAZA

This beautiful hotel celebrates the richness
of Indonesian culture and local Javanese
traditions through its art gallery and
cuisine.

Jl. MH. Thamrin Kav. 15
Jakarta, Jakarta 10350
telephone 62 21 5068 0000
facsimile 62 21 5068 9999

theluxurycollection.com/keraton

INDONESIA

THE LAGUNA

Nestled on Bali's finest white sand beach
overlooking the majestic Indian Ocean and
infinite swimmable lagoons, The Laguna is
situated perfectly in the enchanting Nusa
Dua enclave.

Kawasan Pariwisata Nusa Dua Lot N2
Nusa Dua, Bali 80363
telephone 62 361 771327
facsimile 62 361 772163

theluxurycollection.com/bali

MALAYSIA

THE ANDAMAN

Stunning sunsets, crystal blue waters,
rainforest hikes, and coral reef walks are
just some of the extraordinary experiences
this hotel offers guests.

Jalan Teluk Datai
Langkawi, 07000
telephone 60 4 959 1088
facsimile 60 4 959 1168

theluxurycollection.com/andaman

THAILAND

THE NAKA ISLAND

With endless views of the Phang Nga Bay
and Phuket landscape, this five-star island
retreat is private, romantic, and idyllic.

32 Moo 5, Tambol Paklok
Amphur Thalang, Naka Yai Island
Phuket 83110
telephone 66 76 371 400
facsimile 66 76 371 401

theluxurycollection.com/nakaisland

THAILAND

THE SHERATON GRANDE SUKHUMVIT

Located in the heart of Bangkok, this hotel
carries live jazz in its renowned venue, The
Living Room, and award-winning cuisine
at its restaurant Rossini's.

250 Sukhumvit Road
Bangkok 10110
telephone 66 2 649 8888
facsimile 66 2 649 8000

theluxurycollection.com/grandesukhumvit

THAILAND

VANA BELLE

Poised overlooking the breathtaking Gulf
of Siam, Vana Belle offers an enchanting
getaway and memorable experiences in one
of Thailand's most beautiful locations.

9/99 Moo 3, Chaweng Noi Beach, Surat Thani
Koh Samui 84320
telephone 66 77 915 555
facsimile 66 77 915 556

theluxurycollection.com/vanabellesamui

AUSTRALIA

AUSTRALIA

ECHOES

Breathtaking views of the Jamison Valley
and its lush landscape, coupled with
spa treatments, hikes, and horse riding,
make this resort the perfect setting for a
romantic vacation.

3 Lilianfels Avenue
Katoomba, New South Wales 2780
telephone 61 2 4782 1966
facsimile 61 2 4782 3707

theluxurycollection.com/echoes

AUSTRALIA

LILIANFELS

Located in the vicinity of its sister resort,
Echoes, this hotel provides guests access
to the same stunning views over the Jamison
Valley, along with indoor and outdoor pools,
tennis, a billiards room, and spa treatments.

Lilianfels Avenue
Katoomba, New South Wales 2780
telephone 61 02 4780 1200
facsimile 61 02 4780 1300

theluxurycollection.com/lilianfels

EUROPE

AUSTRIA

HOTEL BRISTOL

Located near the Vienna State Opera in
the heart of the city, this luxury hotel
provides an oasis from the bustle of a busy
metropolis.

Kaerntner Ring 1
Vienna 1010
telephone 43 1 515 160
facsimile 43 1 5151 6550

theluxurycollection.com/bristol

AUSTRIA

HOTEL GOLDENER HIRSCH

Sip the signature Susanne cocktail, eat
the famous Rigo Jancsi dessert, and live
in luxury while attending nearby summer
festivals in Salzburg.

Getreidegasse 37
Salzburg 5020
telephone 43 662 80840
facsimile 43 662 843349

theluxurycollection.com/goldenerhirsch

AUSTRIA

HOTEL IMPERIAL

Transport back to nineteenth-century
Vienna by enjoying a cup of specially
brewed Imperial tea and a slice of the
renowned torte at this elegant and
beautiful hotel.

Kaerntner Ring 16
Vienna, 1015
telephone 43 1 501100
facsimile 43 1 50110410

theluxurycollection.com/imperial

AUSTRIA

SCHLOSS FUSCHL

Enjoy a valuable collection of Old Masters,
a lush golf course, and fresh fish from the
castle fishery at this hotel.

Schloss Strasse 19
Hof bei Salzburg 5322
telephone 43 6229 22530
facsimile 43 6229 2253 1531

theluxurycollection.com/schlossfuschl

BULGARIA

SOFIA HOTEL BALKAN

Located in downtown Sofia, this luxury hotel offers an exceptional experience of Bulgaria's finest culture and service.

5 Sveta Nedelya Square
Sofia 1000
telephone 359 2 981 6541
facsimile 359 2 980 6464

theluxurycollection.com/sofia

GREECE

ARION RESORT & SPA, ASTIR PALACE

A private beach, captivating sea views, and a concierge who can arrange a magnificent expedition to the Temple of Poseidon are all here for guests at this unique resort.

40 Apollonos Street-Astir Palace Complex
Athens-Vouliagmeni 16671
telephone 30 210 890 2000
facsimile 30 210 896 2583

theluxurycollection.com/arion

GREECE

SANTA MARINA

A paradise within a paradise, this hotel is a tranquil oasis where one can indulge in spa treatments and fine dining surrounded by the natural beauty of Mykonos.

Ornos Bay
Mykonos, South Aegean 84600
telephone 30 22890 23220
facsimile 30 22890 23412

theluxurycollection.com/santamarina

FINLAND

HOTEL KÄMP

Guests have the opportunity to visit the world-famous Kämp Bar and Brasserie Kämp during their stay at this beautiful hotel.

Pohjoisesplanadi 29
Helsinki 00100
telephone 358 9 576111
facsimile 358 9 5761122

theluxurycollection.com/kamp

GREECE

BLUE PALACE

Discover beauty in this hotel's emblematic views, tranquillity at its Elounda Spa on the beach, and fun at the nearby Crete Golf Club.

P.O. Box 38
Elounda, Crete 72053
telephone 30 2841 065500
facsimile 30 2841 089712

theluxurycollection.com/bluepalace

GREECE

VEDEMA

Surrounded by historical sites, beautiful beaches, and hot springs, this luxury resort has plenty to explore.

Megalohori
Santorini, South Aegean 84700
telephone 30 2286 081796
facsimile 30 2286 081798

theluxurycollection.com/vedema

FRANCE

PRINCE DE GALLES

Just steps away from the Champs-Elysées, this hotel is located in the heart of the city and offers elegant hospitality with trademark Parisian flair.

33 Avenue George V
Paris 75008
telephone 33 1 53 237777
facsimile 33 1 53 237878

theluxurycollection.com/princedegalles

GREECE

HOTEL GRANDE BRETAGNE

With unsurpassed views of the Acropolis and Parthenon, Constitution Square, and Lycabettus Hill, this hotel offers unrivaled access to Athens's mythical history.

Constitution Square
Athens 105 64
telephone 30 210 3330 000
facsimile 30 210 3228 034

theluxurycollection.com/grandebretagne

ITALY

HOTEL CALA DI VOLPE

Horse riding, tennis, and golf are just some of the fun outdoor activities to enjoy at this hotel.

Costa Smeralda
Porto Cervo 07020
telephone 39 0789 976111
facsimile 39 0789 976617

theluxurycollection.com/caladivolpe

GERMANY

HOTEL ELEPHANT

Fine dining, cooking lessons with Michelin Star Chef Marcello Fabbri, and guided cultural tours are all offered at this unique hotel.

Markt 19
Weimar 99423
telephone 49 3643 8020
facsimile 49 3643 802610

theluxurycollection.com/elephant

GREECE

MYSTIQUE

Guests can visit the Secret Wine Cave, take in the beauty of the surrounding views, and restore at the spa while visiting this luxury resort.

Oia
Santorini Island
Santorini, South Aegean 84702
telephone 30 228 607 1114
facsimile 30 228 607 1115

theluxurycollection.com/mystique

ITALY

HOTEL PITRIZZA

Experience local traditions and cuisine firsthand with the hotel's full immersion opportunities, including local artisan demonstrations.

Costa Smeralda
Porto Cervo 07020
telephone 39 0789 930111
facsimile 39 0789 930611

theluxurycollection.com/hotelpitrizza

GERMANY

HOTEL FUERSTENHOF

Relax in the AquaMarin spa, the landscaped pool, the Finnish sauna, or the Roman steam bath and restore harmony to your body at this luxury hotel.

Troendlinring 8
Leipzig 04105
telephone 49 341 1400
facsimile 49 341 1403700

theluxurycollection.com/fuerstenhof

GREECE

THE ROMANOS

Enjoy special bath amenities at Anazoe Spa, tours from Navarino Outdoors, and scuba diving with Navarino Sea—all experiences guests can have at this spot.

Navarino Dunes, Messinia
Costa Navarino 24001
telephone 30 272 309 6000
facsimile 30 272 309 6500

theluxurycollection.com/theromanos

ITALY

HOTEL ROMAZZINO

Enjoy local food and activities such as horse riding and sailing at this beautiful resort.

Costa Smeralda
Porto Cervo 07020
telephone 39 0789 977111
facsimile 39 0789 977614

theluxurycollection.com/romazzino

ITALY
HOTEL DANIELI

Located within walking distance of Saint Mark's Square, this legendary hotel allows visitors to shop, dine, and experience Venice to the fullest.

Castello 4196
Venice 30122
telephone 39 041 522 6480
facsimile 39 041 520 0208

theluxurycollection.com/danieli

POLAND
HOTEL BRISTOL

This hotel lies right on the Royal Route, a road that leads through the historic district of the city and is dotted with examples of stunning architecture from the sixteenth century to the present day.

Krakowskie Przedmiescie 42/44
Warsaw 00-325
telephone 48 22 551 1000
facsimile 48 22 625 2577

theluxurycollection.com/bristolwarsaw

SPAIN
HOTEL ALFONSO XIII

This hotel is one of the most monumental landmarks in Seville, embodying the city's layered history, architecture, and authentic cuisine in a luxurious atmosphere.

San Fernando 2
Seville 41004
telephone 34 95 491 7000
facsimile 34 95 491 7099

theluxurycollection.com/hotelalfonso

ITALY
HOTEL EXCELSIOR

The Neapolitans' love of excellent food can be experienced in this hotel's restaurants, including the La Terrazza roof garden restaurant.

Via Partenope 48
Naples 80121
telephone 39 081 764 0111
facsimile 39 081 764 9743

theluxurycollection.com/excelsiornaples

PORTUGAL
CONVENTO DO ESPINHEIRO

Enjoy wine-tasting sessions, bread-baking classes, Alentejo folk-singing performances, and Gregorian chants at this luxury resort.

Convento do Espinheiro
Évora 7000
telephone 351 266 788200
facsimile 351 266 788229

theluxurycollection.com/convento

SPAIN
CASTILLO HOTEL SON VIDA

A first-class beauty spa, breathtaking golf courses, and a Kids' Club equipped with a separate pool area and playground are all offered at this hotel.

C/Raixa 2, Urbanizacion Son Vida
Mallorca 07013
telephone 34 971 493493
facsimile 34 971 493494

theluxurycollection.com/castillo

ITALY
THE GRITTI PALACE

Enjoy tailor-made services, such as tours to the northern lagoon islands of Murano, Burano, and Torcello, or helicopter tours of the lagoon.

Campo Santa Maria del Giglio
Venice 30124
telephone 39 041 2961 2222
facsimile 39 041 2961 100

theluxurycollection.com/grittipalace

PORTUGAL
THE SHERATON ALGARVE

Enjoy breathtaking views of the surroundings, warm weather year-round, and beautiful golf course, including its famed and most challenging golf hole Devil's Parlour, at this luxury hotel.

Praia de Falesia, Apartado P.O. Box 644
Albufeira 8200
telephone 351 289 500100
facsimile 351 289 501950

theluxurycollection.com/algarve

SPAIN
HOTEL MARIA CRISTINA

Indulge in a mouthwatering local culinary experience when visiting this charming hotel, near the Michelin-starred restaurants of San Sebastián.

Paseo Republica Argentina 4
San Sebastián 20004
telephone 34 943 437600
facsimile 34 943 437676

theluxurycollection.com/mariacristina

THE NETHERLANDS
HOTEL DES INDES

This luxury hotel is located in the heart of The Hague and is an ideal starting point for exploring local attractions such as the Royal Picture Gallery Mauritshuis and the antique market.

Lange Voorhout 54-56
The Hague 2514 EG
telephone 31 70 361 2345
facsimile 31 70 361 2350

theluxurycollection.com/desindes

RUSSIA
HOTEL NATIONAL

Exploring Moscow was never easier, as this hotel offers spectacular views of the Kremlin and Red Square, while being only steps away from attractions such as the Bolshoi Theater.

15/1 Mokhovaya Street
Moscow 125009
telephone 7 495 258 7000
facsimile 7 495 258 7100

theluxurycollection.com/national

SPAIN
HOTEL MARQUÉS DE RISCAL

Frank Gehry's design houses a collection of wines that any wine lover will enjoy. The hotel offers guided cultural tours to truly take in the surrounding area.

Calle Torrea 1
Elciego 01340
telephone 34 945 180880
facsimile 34 945 180881

theluxurycollection.com/marquesderiscal

THE NETHERLANDS
HOTEL PULITZER

Unique tours, such as the boat tour, the concierge tour, and the gardens tour are offered at this luxury hotel.

Prinsengracht 315-331
Amsterdam 1016 GZ
telephone 31 20 5235235
facsimile 31 20 6276753

theluxurycollection.com/pulitzer

SERBIA
METROPOL PALACE

This hotel has always been the heart of Belgrade's social life and is an indelible landmark in the city skyline, overlooking Tasmajdan Park.

Bulevar Kralja Aleksandra 69
Belgrade 11000
telephone 381 11 3333100
facsimile 381 11 3333300

theluxurycollection.com/metropolpalace

SWITZERLAND
HOTEL PRESIDENT WILSON

Located minutes away from Geneva's lakefront, this luxury hotel allows one to explore such local attractions as the Jet d'eau, Flower Clock, and St. Peter's Cathedral.

47, Quai Wilson
Geneva 1211
telephone 41 22 906 6666
facsimile 41 22 906 6667

theluxurycollection.com/presidentwilson

TURKEY
LUGAL

Immerse yourself in local culture, as original paintings by local artists are found throughout this luxury hotel.

Noktali Sokak No. 1, Kavaklidere
Ankara 06700
telephone 90 312 457 6050
facsimile 90 312 457 6150

theluxurycollection.com/lugal

CHILE
VILLARRICA PARK LAKE

Enjoy breathtaking views while climbing one of the most active volcanoes in South America. Experience thrills while bungee jumping, and relax in nearby hot springs while at this hotel.

Camino Villarrica—Pucon Km 13
Villarrica
telephone 56 45 45 00 00
facsimile 56 45 45 02 02

theluxurycollection.com/villarrica

MEXICO
HACIENDA UAYAMON

Bulbous pegs set into stone walls can be found throughout this hotel, allowing guests to hang woven cotton hammocks and sleep in the Mayan style.

KM 20 Carretera, Uayamon-China-Edzna
Uayamon, Campeche
telephone 52 981 813 0530
facsimile 52 999 923 7963

theluxurycollection.com/uayamon

UNITED KINGDOM
THE PARK TOWER KNIGHTSBRIDGE

Dine at the patriotic Grenadier Pub, visit the vibrant Serpentine Gallery, and sip London's most expensive and glamorous cocktail, the Diamond Martini, while at this hotel.

101 Knightsbridge
London, England SW1X 7RN
telephone 44 207 235 8050
facsimile 44 207 235 8231

theluxurycollection.com/parktowerlondon

MEXICO
HACIENDA PUERTA CAMPECHE

This hotel is a collection of restored seventeenth-century historical houses, allowing one to enjoy the beauty of a Mexican hacienda with excellent personal service.

Calle 59, No. 71 por 16 & 18
Campeche, Campeche 24000
telephone 52 981 816 7508
facsimile 52 981 816 7375

theluxurycollection.com/
puertacampeche

PERU
HOTEL PARACAS

A bottle of local pisco, wind-surfing lessons, and private jet flights over the Nazca Lines are all offered at this luxury hotel.

Av. Paracas S/N
Paracas
telephone 51 56 581 333
facsimile 51 56 581 778

theluxurycollection.com/hotelparacas

UNITED KINGDOM
TURNBERRY

Site of the famous "Duel in the Sun" by Jack Nicklaus and Tom Watson, this hotel is an outdoorsmen's sanctuary with quadbiking, horseback riding, and offroading offered.

Turnberry Ayrshire KA26 9LT
Scotland
telephone 44 165 533 1000
facsimile 44 165 533 1706

theluxurycollection.com/turnberry

MEXICO
HACIENDA SAN JOSE

An authentic Mayan experience can be had in the "Mayan Villas," while luxury can be found through massages in the privacy of the spa area.

KM 30 Carretera
Tixkokob-Tekanto
Tixkokob, Yucatán 97470
telephone 52 999 924 1333
facsimile 52 999 924 1534

theluxurycollection.com/sanjose

PERU
TAMBO DEL INKA

Enjoy views of the Vilcanota River while swimming in the hotel pool. Take a guided trip to the Sacred Valley and escape to Machu Picchu from the hotel's private train station.

Avenida Ferrocarril S/N
Sacred Valley, Urubamba
telephone 51 84 581 777
facsimile 51 84 581 778

theluxurycollection.com/tambodelinka

LATIN AMERICA

ARGENTINA
PARK TOWER

Unparalleled service, an in-hotel shopping arcade, and a heart-of-the-city location set this luxury hotel apart.

Avenida Leandro N. Alem 1193
Buenos Aires 1001
telephone 54 11 4318 9100
facsimile 54 11 4318 9150

theluxurycollection.com/parktower

MEXICO
HACIENDA SANTA ROSA

Bird watching, Mayan lessons, cocktail demonstrations, and tours of the botanical garden are all offered at this luxury hotel.

KM 129 Carretera Merida Campeche
Santa Rosa, Yucatán 97800
telephone 52 999 923 1923
facsimile 52 999 923 1653

theluxurycollection.com/santarosa

MIDDLE EAST

KUWAIT
THE SHERATON KUWAIT

Situated in the middle of Kuwait's commercial center, the hotel boasts a health club that offers a variety of revitalizing, relaxing, and pampering treatments.

Safat 13060 / Fahd Al-Salem Street
P.O. Box 5902 Safat
Kuwait City 13060
telephone 965 2242 2055
facsimile 965 2244 8032/4

theluxurycollection.com/kuwait

CHILE
SAN CRISTOBAL TOWER

A bicycle tour of the bohemian Bellavista neighborhood, picnics at the nearby Concha y Toro Vineyard, and skiing on the best slopes in South America are all offered at this luxury hotel.

Josefina Edwards De Ferrari 0100
Santiago
telephone 56 2 2707 1000
facsimile 56 2 2707 1010

theluxurycollection.com/sancristobaltower

MEXICO
HACIENDA TEMOZON

Explore the unique Hol Be Spa, where one can experience individual spa treatments in a beautifully preserved cavern.

KM 182 Carretera Merida-Uxmal
Temozon Sur, Yucatán 97825
telephone 52 999 923 8089
facsimile 52 999 923 7961

theluxurycollection.com/temozon

U.A.E.
AL MAHA

Arabian wildlife—with Arabian oryx and gazelles as the star attractions—can be seen from the temperature-controlled infinity pools or sundeck areas of all villas.

Dubai-Al Ain Road
Dubai
telephone 971 4 832 9900
facsimile 971 4 832 9211

theluxurycollection.com/almaha

U.A.E.

GROSVENOR HOUSE

The first hotel to be launched in Dubai Marina, this is a prominent lifestyle destination in a cosmopolitan area, with a wide range of fantastic restaurants and bars.

Al Sofouh Road
P.O. Box 118500
Dubai
telephone 971 4 399 8888
facsimile 971 4 317 6980

theluxurycollection.com/grosvenorhouse

UNITED STATES

HOTEL IVY

The Hotel Ivy is a luxurious spa destination in Minneapolis that hosts the Ivy Spa Club and connects guests by climate controlled skyway to attractions such as the Orchestra Hall and world-class shopping.

201 South Eleventh Street
Minneapolis, MN 55403
telephone 612 746 4600
facsimile 612 746 4890

theluxurycollection.com/ivy

UNITED STATES

THE ROYAL HAWAIIAN

Experience Hawaiian hospitality to its fullest, with views of the Diamond Head Crater and the hotel's brand-new signature drink, the Smokin' Mai Tai, at this ultraluxe "Pink Palace."

2259 Kalakaua Avenue
Honolulu, Hawaii 96815
telephone 808 923 7311
facsimile 808 931 7098

theluxurycollection.com/royalhawaiian

NORTH AMERICA

UNITED STATES

THE BALLANTYNE

Located on a championship PGA golf course, this Southern beauty features signature cocktails, luxurious lodging, and spa treatments.

10000 Ballantyne Commons Parkway
Charlotte, North Carolina 28277
telephone 704 248 4000
facsimile 704 248 4005

theluxurycollection.com/ballantyne

UNITED STATES

THE LIBERTY

Guests of the beautiful hotel are exposed to the best of Boston, from sweeping views of the skyline to complimentary Liberty-branded bicycles for riding around town.

215 Charles Street
Boston, Massachusetts 02114
telephone 617 224 4000
facsimile 617 224 4001

theluxurycollection.com/libertyhotel

UNITED STATES

SLS HOTEL AT BEVERLY HILLS

Designed by Philippe Starck, the hotel challenges every traditional convention of luxury hospitality, from a culinary program crafted by Spanish chef José Andrés to a unique spa concept at Ciel Spa.

465 S. La Cienega Boulevard
Los Angeles, California 90048
telephone 310 247 0400
facsimile 310 247 0315

theluxurycollection.com/sls

UNITED STATES

THE CHATWAL

This Stanford White landmark was once home to the famed Lambs Club and now offers guests the same glamorous treatment with luxurious accommodations and striking art deco interior design.

130 West 44th Street
New York, New York 10036
telephone 212 764 6200
facsimile 212 764 6222

theluxurycollection.com/chatwal

UNITED STATES

THE NINES

Known for its creative and unique personal service, this hotel offers guests a customized nightly turn-down, and a seasonal and tasty snack.

525 SW Morrison
Portland, Oregon 97204
telephone 877 229 9995
facsimile 503 222 9997

theluxurycollection.com/thenines

UNITED STATES

THE US GRANT

A presidential landmark nestled amid the vibrancy of downtown San Diego's famed Gaslamp quarter, the hotel weaves its storied history into an oasis of fine art and epicurean innovation—including The US Grant's 100-day barrel-aged Centennial Manhattan.

326 Broadway
San Diego, California 92101
telephone 619 232 3121
facsimile 619 232 3626

theluxurycollection.com/usgrant

UNITED STATES

THE EQUINOX

With beautiful mountain views, horse-drawn wagon rides, and suites with fireplaces, enjoy cozy days and nights at this Vermont treasure.

3567 Main Street
Manchester Village, Vermont 05254
telephone 802 362 4700
facsimile 802 362 4861

theluxurycollection.com/equinox

UNITED STATES

PALACE HOTEL

Commanding its location in the heart of vibrant San Francisco, this hotel provides guests with hospitality on a grand scale.

2 New Montgomery Street
San Francisco, California 94105
telephone 415 512 1111
facsimile 415 543 0671

theluxurycollection.com/palacehotel

UNITED STATES

THE FAIRFAX AT EMBASSY ROW

Located in the center of Washington D.C., this hotel serves high diplomatic guests and offers luxurious dining at its new restaurant, 2100 Prime.

2100 Massachusetts Avenue
Northwest Washington, D.C. 20008
telephone 202 293 2100
facsimile 202 293 0641

theluxurycollection.com/fairfax

UNITED STATES

THE PHOENICIAN

Golfing, swimming, tennis, and first-class spa treatments are some of the activities guests can enjoy at this awe-inspiring Sonoran destination.

6000 East Camelback Road
Scottsdale, Arizona 85251
telephone 480 941 8200
facsimile 480 947 4311

theluxurycollection.com/phoenician

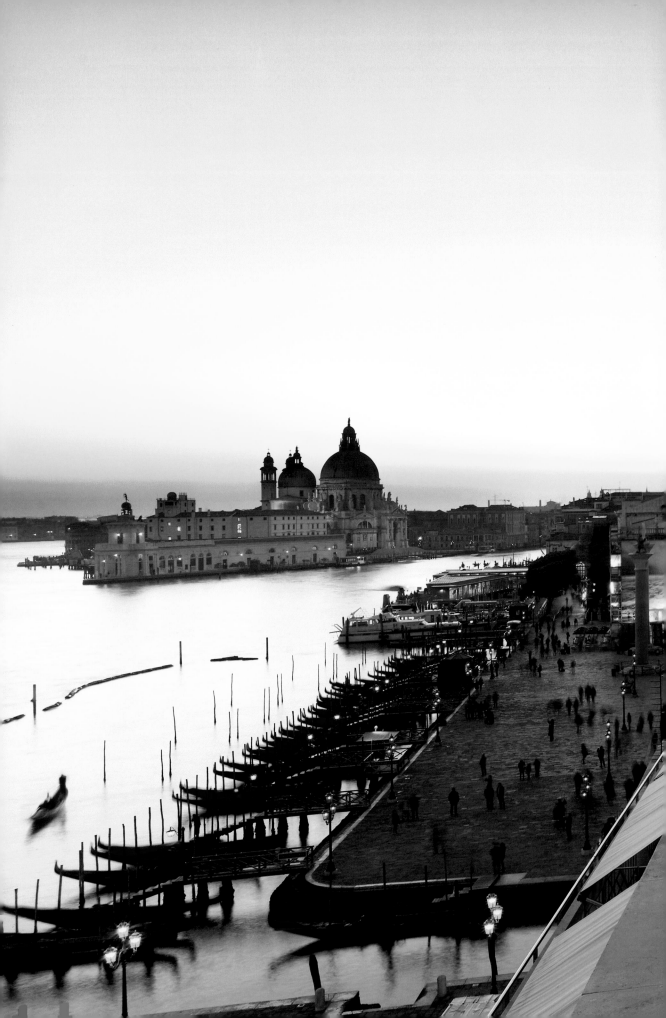

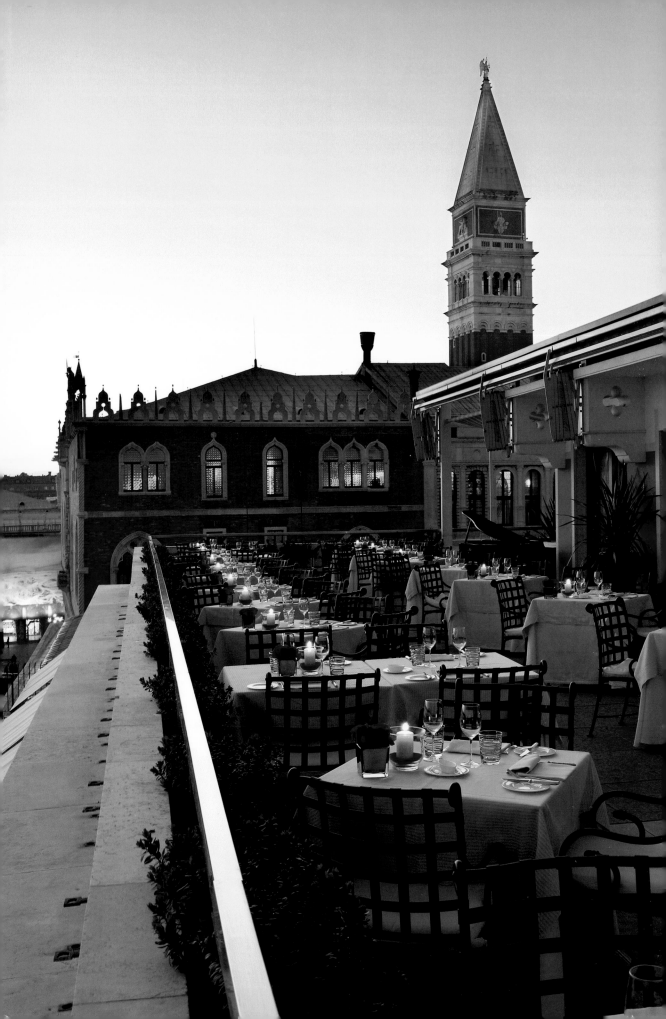

FRANCISCA MATTÉOLI

Chilean, with a Scottish mother, Francisca Mattéoli spent her childhood in Latin America. After living in Brazil, she now resides in Paris and is the author of numerous travel books published in more than ten countries and translated in several languages. As a travel writer, she has also been published in, among others, *National Geographic France* and *Condé Nast Traveller.*

ACKNOWLEDGMENTS

The publisher would like to thank Andrea Bennett; Oscar Espaillat, Corbis; Alex Harrison, Elvis Presley Enterprises, Inc.; Mary Scholz, Getty Images; Sophie Fels; Jukka Haltimo; and Cheryl Della Pietra.

CREDITS

All images property of Starwood except the following:
Page 6: Julio Piatti; page 13, top right: © Corbis; page 24: © Gamma-Keystone via Getty Images; page 25, bottom: © Shutterstock; pages 28-29: © Andrea Fazzari; page 32, top: © Corbis; bottom: © Atlantide Phototravel/Corbis; page 33: © Gamma-Keystone via Getty Images; page 34, top right: © *NY Daily News* via Getty Images; bottom right: © Underwood & Underwood/Corbis; page 37, middle: © Shutterstock; bottom: © Hans Georg Roth/Corbis; page 47, top: © Time & Life Pictures/Getty Images; middle left: © H.-P. Haack; middle right: © U. Baumgarten via Getty Images; page 55, top left: © Larry Lee Photography/Corbis; page 58: © Eric Charbonneau; page 59, middle left: © Time & Life Pictures/Getty Images; middle right: Courtesy National Gallery of Art, Washington. Samuel H. Kress Collection; bottom: © Shutterstock; page 73, middle left: © Olaf Krüger/Image Broker/Aurora Photos; middle right: © Christopher Pillitz/Getty Images; bottom left: © Noah Seelam/AFP/Getty Images; page 75: © Christophe Rihet; page 79, middle: © Jaakko Haltimo; page 81, top: © Jose Fuste Raga/Corbis; page 101, middle: © Getty Images; page 104: © Phil Oh; page 117, bottom: Photo Jean-Marie Pouzenc. Elvis image used by permission, Elvis Presley Enterprises, Inc.; page 124, top: © Getty Images; bottom: © Laszlo Podor Photography; page 125, top left & middle right: © Getty Images; bottom: © Monica and Michael Sweet/Getty Images; page 133, top: © Lonely Planet; bottom: © Horace Bristol/Corbis; page 147, bottom: © Getty Images.